SEMINAR

PROCEEDINGS

Issues in

Discipline-Based Art Education:

Strengthening the Stance,

Extending the Horizons

May 21 – 24, 1987

Cincinnati, Ohio

An invitational seminar

Sponsored by The Getty Center for Education in the Arts

The Getty Center for Education in the Arts
1875 Century Park East, Suite 2300
Los Angeles, CA 90067

Seminar proceedings prepared by
Keens Company, New York, New York
 William Keens, President
 Bruce Peyton, Project Director
 Adam Bellow, Project Associate

Kurt Hauser, Designer, J. Paul Getty Trust
Publications

Library of Congress cataloging-in-publication data.

Issues in discipline-based art education.

 1. Art—Study and teaching (Elementary)—United
States—Congresses. 2. Art—Study and teaching
(Secondary)—United States—Congresses. 3. Visual
perception—Congresses. 4. Learning, Psychology of—
Congresses. I. Getty Center for Education in the Arts.
N362.I87 1988 707'.1273 88-4303
ISBN 0-89236-136-0

Table of Contents

Foreword

THE GETTY CENTER FOR EDUCATION IN THE ARTS is pleased to share the proceedings from its first seminar on some of the challenging theoretical issues confronting discipline-based art education. They reflect the ideas and issues discussed and debated by forty-two academic art educators over two and one-half days last May in Cincinnati, Ohio. Although written proceedings can never fully capture the intensity, passion, and spirited delivery of the remarks from presenters and respondents, we have attempted to capture their ideas and comments as clearly and objectively as possible.

Two sets of recommendations were produced by the seminar. One set can be found under the headings "Written Recommendations Collected at the Final Plenary" and "Recap of Recommendations from Each Small-Group Discussion." The personal recommendations of the Seminar's Director, Dr. Hermine Feinstein, can be found in her introduction. Each set provides a rich vein of provocative themes and research questions for graduate theses and dissertations for years to come. They also demonstrate how much more systematic thinking and discussion about the theoretical underpinnings of DBAE needs to occur if we are to avoid building this conceptual house on sand. If DBAE is to influence and inform classroom practice and teacher training, its theoretical underpinnings must constantly be developed and challenged. This is an evolutionary process,

and one which the Center intends to nurture by sponsoring opportunities for the presentation and discussion of issues central to the development of this approach to teaching art education.

Leilani Lattin Duke
Director
Getty Center for Education in the Arts
Fall, 1987

Introduction

Site and Participants

The seminar, "Issues in Discipline-Based
Art Education: Strengthening the Stance,
Extending the Horizons," took place on
May 21-24, 1987, at the Hyatt Regency in
Cincinnati, Ohio. There were thirty-seven
participants at the full weekend. In
addition, there was the four-member
planning committee and myself, three
Getty Center personnel, four recorders,
and one photographer. Of the thirty-seven
participants, four were speakers and four
were respondents delivering their papers
at the plenary sessions, and four were
discipline representatives presenting their
views during the small-group discussions.
Of the twenty-five remaining participants,
there were twenty art educators, one
discipline representative, and four graduate
students. Attending the last session and
lunch on Sunday were seventeen local art
educators. In preparation for the seminar,
all participants were provided with a copy
of *The Journal of Aesthetic Education*,
Vol. 21(2), Summer, 1987, devoted exclu-
sively to articles pertaining to DBAE.

Rationale and Goals

The rationale for the seminar was to
strengthen the DBAE stance and extend its
horizons. Insofar as possible, the emphasis
was to be more on philosophical/conceptual
concerns and less on preservice, inservice,
or pedagogical concerns. The goals for the
seminar were to clarify further four major
conceptual issues deriving from the
DBAE stance, to reach resolution where

possible, and if possible, to develop plans
for action.

My committee and I identified the four
issues, culling them primarily from the ten
papers which now appear in *The Journal of
Aesthetic Education*. To identify the issues,
we used descriptor-guidelines, such as:
those propositions, points, assertions,
conclusions, and so on that were in
question, controversial, unresolved,
problematical; that required additional
examination and evidence; and that
would generate ramifications for further
discussion and inquiry. Once having
identified the four issues, we formulated
one question for each issue. Four speakers
were asked to address the point and
counterpoint of one of the four issues and
take a position; four respondents were
asked to defend or refute the position. Each
speaker was allotted forty minutes; each
respondent ten minutes. Following the

Hermine Feinstein

presentation of each issue, the participants were assigned to discussion groups, facilitated by a committee member. During those discussions, a representative from each of the disciplines contributed his or her perspective. In the pages that follow, you will find the issues identified, the questions posed, and the papers presented by the speakers and respondents. You will also find the discipline representatives' commentaries made during the group discussions and summaries of those group discussions which include specific recommendations for further inquiry.

Achievements and Recommendations
Recall that the goals for the seminar were to clarify further four major conceptual issues deriving from the DBAE stance, to reach resolution where possible, and if possible, to develop plans for action. Consider that only four issues were identified, that any single issue could generate more than one question, and that only one question per issue was formulated for each speaker. Given those constraints of focus, certain aspects of the issues were discussed, some aspects expanded upon and further clarified, and areas of needed research designated. From that standpoint, the goals were achieved.

From my point of view, however, there was a more important achievement. As the weekend came to a close, most participants realized that the discussions raised numerous questions and uncovered other aspects of the issues that require further

study. As they began to think about *what* needed research in relation to *what* recommendations would strengthen and extend the conceptual stance of DBAE, their concerns moved beyond the issues discussed. In effect, they formulated a full research agenda whose topics could be explored through individual and collaborative research, commissioned papers, monographs, and subsequent seminars. It should be noted that many excellent recommendations were made regarding preservice, inservice, pedagogical concerns, curriculum models, and teaching materials. However, since this seminar was intended to emphasize philosophical/conceptual concerns, I'll summarize only those recommendations:

1 Explicate the epistemological grounds for DBAE so that there is a fundamental connection to knowledge.
2 Formulate an overarching rationale that stems from epistemological ground from which sub-rationales can be derived.
3 Specify the cognitive contributions that art can provide in general and with respect to children's stages of development and their different cognitive styles in particular.
4 Provide definitional clarity, differentiation, and consistency regarding the terms "theory," "approach," "rationale," "goals," "concepts," "means," and "ends."
5 Strengthen the "connective tissue" among goals, objectives, and outcomes such that they directly reflect an overarching rationale.
6 Analyze the theories used from the

social sciences and other fields of study for purposes of synthesizing and building theoretical frameworks that will provide conceptual guides for research.

7 From those theoretical frameworks, accumulate empirical evidence that will explain why and how DBAE programs foster learning.

8 Specify the interrelationship among the four disciplines.

9 Determine criteria for selecting art exemplars (writ large).

10 Establish criteria for distinguishing DBAE from other forms of art education.

Even with omissions, for which I apologize, we are looking at more than one lifetime of work. I am pleased to report that the level of discourse which took place and brought forth those recommendations reflected the energy and conceptual rigor necessary to move us in the direction of developing our much needed scholarship.

In closing, I'd like to reiterate some of my remarks that opened the seminar. The seminar was in gestation close to nine months. To view its making as gestation is, of course, to view it metaphorically. It is through metaphor that we understand one kine of thing or experience in terms of another of a different kind. The value of such an understanding lies in its power to generate deeper insights and different perspectives. It is through metaphor that I understand our position as art educators. Because of the eclectic nature of our field, the metaphor I have chosen is both mixed and rich.

As art educators, we are in the adolescence of evolving into a mature community of scholars. Communities, however, don't just happen; they are not, to borrow a phrase from Eisner, an automatic consequence of maturation. Communities are begun by visionaries and pioneers, and later developed by others of like mind.

Columbus was such a visionary and pioneer. He imagined a new territory, explored it, named and mapped it. Our Columbus was Lowenfeld. Since his time, which was not too long ago, numerous pioneers settled in the territory of art education: Logan, Barkan, McFee, Eisner, Feldman, Lanier, Chapman—to mention a few. They began to build a community of scholars. We are members of that developing community and want it to grow into a mature one. But as communities don't just happen, neither does age bring maturity. Developing a mature scholarly community demands a spirited and focused vision. It demands inquiring minds, ego-strength, intellectual integrity, rigor, commitment, and a willingness to extend horizons.

There are three pioneers in our growing community, namely Clark, Day, and Greer, who have built on the work of our predecessors. I refer to their article, "Discipline-Based Art Education: Becoming Students of Art," in *The Journal of Aesthetic Education*, Vol. 21(2), Summer 1987. In that article they have reclaimed, renamed, and remapped our territory; they have given conceptual focus to our scholarly evolution.

DEVELOPING A MATURE SCHOLARLY COMMUNITY DEMANDS A SPIRITED AND FOCUSED VISION. IT DEMANDS INQUIRING MINDS, EGO-STRENGTH, INTELLECTUAL INTEGRITY, RIGOR, COMMITMENT, AND A WILLINGNESS TO EXTEND HORIZONS.

It is in our best interest to strengthen and expand further that conceptual focus. To be sure, that effort is both challenging and demanding. This seminar was one small piece of that effort which will help promote our growth from adolescence to a mature community of scholars.

Throughout the ages there have been patrons who have supported visionaries, pioneers, and the new territories in which they've settled. The Getty Center for Education in the Arts is one such patron. Their generosity has made many of our ventures possible. This seminar was but one of them. I would like to thank Mrs. Lani Lattin Duke, Director of the Center, for the opportunity to have directed the Seminar, to thank Dr. Marilynn J. Price, Project Consultant, and to thank my committee for their conscientious work and support: Drs. Mary Erickson, Kutztown University; Hilda Lewis, San Francisco State University; Nancy MacGregor, The Ohio State University; and Denis Phillips, Stanford University. Lastly, I would like to thank the attending participants whose contributions were impressive and to acknowledge those art educators whose absence was due to project constraints but whose presence, nonetheless, was felt.

Hermine Feinstein
Seminar Director

Program of Events

Sunday, May 24

8:00–9:00 a.m.	Breakfast
	PLENARY SESSION
9:10–9:30	• Brief summary and introduction of local guests
	• **Issue 4: Boundaries of DBAE**
9:30–10:10	Speaker: Brent Wilson, Pennsylvania State University
10:10–10:20	Respondent: Rogena Degge, University of Oregon
10:20–11:00	Questions to speakers from participants and guests
11:00–11:30	Coffee and writing of recommendations for future action by participants
11:30–12:00 p.m.	Concluding remarks
12:00–2:30	Lunch

Proceedings

Issue 1: Child Development and Different Cognitive Styles

DBAE requires that children learn concepts and skills associated with the four disciplines: studio art, art history, aesthetics, and criticism. In view of what is known about child development and different cognitive styles, to what extent is such learning possible in student groups at various age levels?

• • •

A Summary of Dennie Wolf's Address
What does developmental psychology have to say about the capacity of children, at different ages, to acquire basic concepts in the four component disciplines of DBAE? To answer fully "is the work of a lifetime," said Wolf. Consequently, in her paper she limited herself to an examination of her own particular approach, central to which are three notions:

1 The acquisition of concepts is founded on the "formation and mutual development" of three *stances* or "ways of interacting" with art—that of maker, perceiver, and inquirer.
2 Over time each stance develops in ways which affect our understanding of visual art, specifically "the advent of picture-making, [a grasp of] visual systems, and the understanding of artistic choice."
3 These developments offer a framework for the kinds of aesthetic learning in which students may engage.

Different disciplines view works of art from the perspective of their interests. But long before these specialized viewpoints are acquired, children engage directly in visual experience. The basic activities (stances) of making, seeing, and wondering about art may provide a basis for learning across disciplinary lines.

As "makers," we think about how to translate an experience into visual terms, which materials to use, and how to employ visual elements to create a certain mood or effect. As "observers" we focus on noticing and comparing, asking what elements in a work convey the intended experience, and what other works or visual experiences have similar effects. As "inquirers" we stand back and ask general questions about how a painting works, how it is different from a sign or illustration, and whether other viewers respond to it in the same way.

Native speakers of a language rely on a set of informal intuitions that differ from the intuitions of linguists, scholars, or authors. In the same way, perceptual stances unconsciously structure our inter-action with visual works. These stances are "attitudes" rather than disciplined bodies of knowledge. By examining their growth and interaction, we can learn much that is applicable to more formal aesthetic learning. If we rely too much on the struc-ture of developed disciplines to assess what children know about visual art, we may miss earlier important but undisciplined forms of aesthetic knowledge.

A discipline is "a distinct form of knowing." Yet we find that in naturally occurring, informal interactions with art objects, most viewers move easily among the several stances. When these stances

SPEAKER
Dennie Wolf
Harvard University

RESPONDENT
Enid Zimmerman
Indiana University

work together in an integrated way, they can greatly expand the experience of visual art, enhancing and confirming the integrity and multiplicity of visual experience.

How do the three stances develop, and what basis do they offer for the acquisition of discipline-like knowledge? For her examination, Wolf divided childhood into three broad developmental phases, each with its distinctive way of making, observing, and inquiring. She noted that her research pertained only to *visual* perception and experience, because she believes that knowledge is "more local than general."

Four to Seven: The Understanding of Pictures
The storehouse of sensations, routines, and expectations built up during infancy forms the experience by whose light children make sense of the world. Then, between two and five, most children take the leap from "exploratory animal" to "symbol-using human being." They acquire the rudiments of their native language, a number system, and music, and they go from being "picture-readers" to "picture-makers." Thereby, they begin to understand the technical demands and the communicative power of visual representation.

With these skills, children gain a new dimension of perception. They begin to observe images as makers—noticing how large a canvas is, what kind of marks are used, how well it represents a given subject. Young viewers tend to "look

through, rather than at," works of art; they rarely notice style or composition or appreciate multiple meanings. But their remarkable alertness can permit them to move beyond mere decoding of pictures to a more advanced interpretative level. When children are encouraged to take in whole scenes by means of their natural feel for situation, characters, narrative, and scene ("their richest form of knowledge"), they may show surprising skill at drawing what must be recognized as pictorial inferences. Although we think of "reading" a painting in purely visual and formal terms, children's responses remind us that interpreting art involves being drawn into a particular time, space, and light."

We know the least about children's capacities for reflective inquiry—the basis for a developed understanding of aesthetics. Even young children can pursue long arcs of questions about visual phenomena that puzzle them, but these inquiries are limited by a relative inability to distinguish between pictures and the objects they represent. Further, the judgment criteria of children in this developmental phase tend to be based on rudimentary preferences. What may underlie these limits is a basic inability to "second guess" experience, to see things as either more or other than they seem. The absence of any hypothetical frame suggests why children's inquiries about art are "limited to the images as they are, rather than how else they might be."

Young children also seem unable to

classify different types of "visual activity." They make few distinctions between aesthetic and non-aesthetic objects. For example, although they may be able to identify one object as a map and another as a drawing, they do not see the two as different types or classes of images. Thus, even though young children enjoy making and looking at visual images, "they may not spontaneously pose specifically aesthetic questions" at all.

Eight to Twelve: The Understanding of Visual Systems

In most cultures, formal adult training begins by age seven, and in the years that follow we require children to adopt explicit versions of the thinking codes and skills they will need to survive in their particular society. These include counting, reading, and writing skills and an understanding of the major categories for understanding human action: right and wrong, play and work, possibly even mundane and aesthetic. During this literal or conventional stage of education, children acquire the ground-level knowledge of the world which is essential to aesthetic understanding. As makers, children at this stage begin to learn representational conventions and "tricks of the trade." But this kind of attention to the making of things can be harnessed, and preadolescents can become "alert to the craft, not just the depictive obligations, of rendering visual experiences."

Learning visual conventions makes children aware of the various systems or

Dennie Wolf

genres of image-making in their culture, and this new awareness of the systematic nature of visual images has an interesting effect. The learning of rules brings on an intolerance of works that *break* the rules. Children find visual representations puzzling, weird, or ugly when they fail to meet criteria of value that apply to other aesthetic objects such as poems, or even buildings and machines. On the other hand, the "sensitivity to system" can be tapped in ways that help preadolescents understand how aesthetic objects work, in particular by extending the concept of

STUDENTS AT DIFFERENT AGES HAVE QUALITATIVELY DIFFERENT SKILLS IN MAKING, OBSERVING, AND INQUIRING ABOUT ART.

depiction to one of rendition. They can be taught to look for the style or mood of the work, to recognize that images function in a variety of ways. Wolf termed this the beginning of a "pictorial attitude."

Children at this stage begin to think about experience more flexibly and richly, clearly distinguishing between appearance and reality and better understanding human motives, which can open them to questions of artistic intention.

The raw data that children accumulate about the world involves the inculcation of a rich repertoire of formal and informal techniques for a variety of operations, from math and grammar to visual representation. This knowledge contains implicit "oughts"—conventions or stereotypes about the way people and things should look and be. Awareness of *craft* is informed by a dawning awareness of *style*; these are the raw materials from which an appreciation of the more complex and demanding aspects of aesthetic experience can be fashioned.

Thirteen to Eighteen: The Understanding of Artistic Choices
Adolescents undergo certain changes that affect their judgment and their understanding of choice. There is the turbulence of puberty, bringing with it independence and a search for personal identity. Another change, quieter but just as profound, derives from new capacities for abstract thinking, in particular the power to

imagine detailed and novel alternatives both to what *is* and to accepted ideas of what *should* be.

Students at this stage begin to think about selecting "a powerful means" to convey their ideas. Along with the medium, they start to choose the "message" of their work, using it not merely to denote scenes or images but to communicate attitudes. They make up symbols for abstractions like peace, freedom, envy, and evil. This new awareness leads to a reexamination of the tools of visual expression.

Most students know a number of "stock moves" or signs of visual expression, but the student who will be an artist or performer must get beyond them and produce new signs for new messages. He or she must develop an authentic, rather than an imitative, personal style. As adolescents seek to alter their own works, to convey moods and messages, or to create specific effects, they become more sensitive to the work of adult artists; they learn to read the surface of a painting for particular forms, materials, techniques and to see how these are matched to meanings.

While this would seem to characterize adolescents as aesthetically sophisticated, only those who have received consistent, thoughtful instruction throughout high school reach this level, Wolf said. Further, though they may appreciate works from different traditions, they are often bound by their personal likes and dislikes as standards for excellence.

Still, whether or not it is realized, adolescents do have the capacity for abstract thought—for comparing and contrasting, for speculating and making inferences, for examining a range of possibilities—all of which are brought to bear in their search for broader principles. This speculative turn of thought affects what young people at this stage produce, what they perceive, and the kinds of questions they can raise about works of art. They begin to think in terms of artistic choices, to distinguish between technical and expressive skills. Criteria of meaning and effectiveness replace realism, size, and value. Adolescents begin to see the difference between what they like and what is good, and it is at this stage that their judgment comes closest to that of "experts."

The challenge for aesthetic education during adolescence lies in making the potential developments *occur*. A central problem is designing art experiences that offer not just more techniques or facts about art history but genuinely different ways of thinking about the arts. Adolescents can be engaged by what goes on "behind" a painting—symbols, messages, and meanings. Yet, while many secondary-level curricula focus on techniques and styles, often the process of "reading world-views" in artworks is neglected. Students can reason about messages in art; they can draw on their knowledge of structure and content to defend views about meaning or value. These capacities should not be ignored.

Conclusion

Students at different ages have qualitatively different skills in making, observing, and inquiring about art. These distinct perceptual levels were captured by an exercise in which students at the three developmental stages were asked to complete a partial illustration from the Persian *Book of Kings*.

Wolf presented the drawings of three of the students who took part. A drawing by a six-year-old showed a sensitivity to finishing a picture; the lines established in the illustration's head and shoulders were carefully matched and continued in the child's addition of a body. Missing was any awareness of the kind of person depicted, or the set of artistic choices implied. A nine-year-old saw "clues that his drawing must work within." Having come to understand that drawings are "particular systems or marks or connotations," he perceived the man in the illustration as "a fancy bad guy"; he added a goatee to the face and equipped the man with a sword, a bloody dagger, and boots with spurs. The fifteen-year-old demonstrated a deeper and richer understanding of the qualities of the work—how it was made and why it was made that way, not just what it was.

But the above represents only one exercise with one group of students, and Wolf cautioned against curricula based

too wholly on what we currently know. Until we have more diverse samples, and individual attention is paid to patterns of growth, it will remain unclear whether we are looking at universal or widely dispersed patterns of development. Efforts to teach aesthetic skills have often been short-term, underfunded, and poorly supported by schools and communities. It is hard to tell whether a young child's inability to see stylistic or expressive properties in art derives from a fundamental cognitive or aesthetic immaturity or from a failure to understand that these concerns are relevant to painting—a failure that may be traced to limited interaction with artworks. Until we have children who have benefited from consistent opportunities to make, observe, and inquire about visual arts, "we will not know whether the phases I have described are all that is possible or only the beginning of what is potential."

A Summary of
Enid Zimmerman's Response

The task assigned to Dennie Wolf, began Enid Zimmerman, was formidable: to explain, in forty minutes, how current research in child development and cognitive styles applies to concept-acquisition in the context of DBAE. Zimmerman felt, therefore, that Wolf's choice to narrow the focus of her paper to the relationship of developmental psychology to DBAE was an understandable one.

Zimmerman saw Wolf's summary of three stages in a child's development— understanding pictures, understanding visual systems, and understanding artistic choices—as "a very good contribution to the literature about the development of children's aesthetic responses to a variety of visual stimuli." At each stage, a child experiences differently the three basic approaches to aesthetic experiences. Wolf characterizes these approaches as the distinctive "stances" of the maker, the observer, and the inquirer, which she sees manifest in the various components of DBAE: making in studio art, observing in art history and criticism, inquiry in aesthetics. "It would appear to me, however," said Zimmerman, "that observation and inquiry would play vital roles in all four disciplines."

Wolf describes the stances as "easily integrated," "informal," and offering "multiple entry points" into aesthetic experiences. At the beginning level, the content of what "should" constitute DBAE

does not involve a separation of the disciplines; art making and observation (through the scanning method) are informal and integrated, and beginning students are not expected to perceive discretely as artists, art historians, art critics, or aestheticians.

Wolf's preference for art appreciation over art education is evident in her emphasis on "aesthetic response" to artworks rather than on "developing knowledge about art and art making skills." She stresses the importance of grasping qualities presented by an *artwork* over the ability to theorize about *art*. If DBAE were based *only* on acquiring techniques, information, and concepts related to theory, "then aesthetic experience would be bypassed." To avoid this, DBAE should "develop knowledge, skills, and valuing related to making and studying works of art as well as to develop students' sensory capacities to have aesthetic experiences." Wolf emphasizes that only students who receive "consistent, thoughtful instruction" develop aesthetically sophisticated understandings in high school. Zimmerman thought it would be interesting to speculate how Wolf's developmental stages "might be accelerated and altered through early intervention by directed teaching of discipline-based art education curricula."

Wolf's research references are mainly from Project Zero, where she is an associate, and she admits that the children studied are mainly white, middle-class students from the "core culture." Although

cognitive development exhibits "universal, stage-like changes," individual and cultural differences (including educational intervention) are common. Only under certain conditions does development occur in clearly observable stages. Developmental theories often lend themselves to ethno-centrism unless they allow for individual and cultural diversity.

The designers of DBAE curricula should be sensitive to the varying perceptual capacities of children as they move through the developmental stages described by Wolf. They must be no less sensitive to cultural and individual differences. "This is a very difficult task," Zimmerman acknowledged, one that provides a challenge for both the designers and the teachers of DBAE.

THE DESIGNERS OF DBAE
CURRICULA SHOULD BE
SENSITIVE TO THE
VARYING PERCEPTUAL
CAPACITIES OF CHILDREN.

Enid Zimmerman

Issue 1: Small-Group Discussions

GROUP LEADER
Hilda Lewis

PARTICIPANTS
Margaret Battin
Margaret DiBlasio
Stephen Dobbs
Arthur Efland
Kerry Freedman
George Geahigan
W. Dwaine Greer
Richard Salome
Jeffrey Seibert
Maurice Sevigny
Dennie Wolf

After the presentations by speaker Dennie Wolf and respondent Enid Zimmerman, the seminar participants were divided into four small groups to discuss and respond to the plenary presentations. Each small-group session also included the reading of a prepared response by a representative of one of the four DBAE disciplines. By the end of their sessions, the groups had developed sets of recommendations or questions, and these were presented at a later plenary session by the group leaders. The discussion summaries below are based in part on summaries given by the group leaders.

• • •

Summary of Prepared Response: Margaret Battin, Discipline Representative, Aesthetics

Battin began her remarks by complimenting Wolf for her "extraordinary good sense" in including "reflective observation" as one of her three stances. This way of describing aesthetics avoids that "quite artificial conception" of the discipline as something distinct, different, somewhat mysterious and arcane, something that is only understood by "initiates." If we have failed to understand aesthetics correctly, it is because we have made it too mysterious—and professional aestheticians are as guilty as anybody of making their discipline less accessible than it really is. Wolf has wisely treated aesthetics as straightforward and accessible, something that ordinary people ordinarily do all the time, and from the earliest stages of their development.

Additionally, implicit in the paper is the sense that reflective observation is not only an ordinary activity but a valuable one. And finally, although it doesn't attempt to do so directly, the paper dispels some of the myths about aesthetics. One of these is that aesthetics is equivalent to aesthetic scanning. But unlike the scanning process, aesthetics is not a way of seeing perceptual features; it is a "cognitive posture" intimately connected with other cognitive functions, a way of approaching something, rather than a formalized body of knowledge.

Battin did, however, have four questions for Wolf. First, "How good is the evidence that development requires careful teaching?" Wolf explicitly asserts that careful teaching accelerates, hastens, and improves children's aesthetic development. Battin feels that the claim requires more supporting evidence. Second, to what degree does teaching bias or warp development? If we grant that teaching can influence the process, then we must also grant that it can do so in undesirable ways, and we must think carefully about whether or not we are steering development in the right direction.

Battin said that her third and fourth questions related to her first two. She pointed out that although Wolf's developmental scheme reached only from early childhood to late adolescence, in Lawrence Kohlberg's work on *moral* development "you find a theory which claims that moral development begins not much before

the point where we left off," continuing through various stages through age twenty-one or beyond. How does *aesthetic* development continue in adulthood?

Kohlberg's work describes six distinct stages, Battin observed. At the earliest, a child sees the morality of possible actions in terms of punishment and reward for himself. The intermediate stages involve conventional notions of fitting into the group, being thought a good person, and so forth. At the next to last stage comes thinking of morality in terms of a kind of social contract; confronted with a moral dilemma, the individual asks himself what would be in the interests of society as a whole. Finally, the very highest stage is a "Kantian-flavored principled moral autonomy, in which you simply know that it is wrong to steal or to kill."

Stressing that an essential ingredient of Kohlberg's claim is that not everyone reaches the final stages, Battin rephrased her previous question: What do we need to know about aesthetic development beyond the teaching stages that DBAE is concerned with in order better to determine the direction it should take?

She noted that this question, as rephrased, is related to a more interesting philosophical question which applies both to Kohlberg's theory and to the scheme of aesthetic development put forth in Wolf's paper. Kohlberg, in describing his third level as consisting of the two *highest* stages of moral development, suggests that this is what we ought to attain. But in recent years

there has been some dispute about whether Kohlberg got the upper stages right. On what basis do we assume that they are the "highest" or "best"?

Wolf makes several claims to which this problem seems relevant. At one point, for example, she talks about a range of responses to a dance performance: an eight-year-old views the piece as a story; a young adolescent views it as a composition; an adult critic judges the merit of the particular performance. Is the critic doing something *better* than the child or adolescent? It is not entirely clear that we have any basis for saying that, Battin said. The critic is doing what this society demands of adult critics, but we may wonder whether those demands are warranted on any independent grounds.

Wolf states that adolescents are often bound by their personal likes and dislikes, while adults look for more objective standards of excellence. Battin noted that we tend to think of what adults do as representing progress or improvement, but on what basis, the aesthetician will ask, do we say that personal preference is irrelevant in judging art? "What *is* art if it isn't in some way connected with whatever experience it creates in the viewer?"

The question about developmental claims, then, is really one of whether development can be understood as "a history of progress in these matters."

What comes after the stages outlined by Wolf? Does "what we do to kids" bias their development? Do the stages as we are

AT SPECIFIC LEVELS OF DEVELOPMENT, TEACHERS MUST KNOW WHAT KINDS OF QUESTIONS ARE APPROPRIATE, AND THEY MUST BE PREPARED TO WORK WITH THE ANSWERS AS THE STUDENTS CONSTRUCT THEM.

considering them constitute progress, or are they merely an artificial construct? In concluding, Battin stated that these questions were a request for a further look at underlying justifications "and, as usual, the philosopher's way of making more trouble."

Discussion

In view of what is known about child development and different cognitive styles, to what extent can students at various age levels grasp the concepts and skills associated with the four disciplines?

This question dominated much of the discussion, and ultimately the group decided that, from the research data available at this point, it is impossible to derive a reliable answer. Developmental psychology, everyone felt, does not really say how far along the continuum DBAE can travel at any of the given age levels within which its students are grouped.

But neither did the participants feel that developmental psychology can be ignored. It provides a valuable backdrop for the educational experience, and development must be understood in order to provide for appropriate organization and sequencing. The major lesson of developmental psychology is that, because at different ages children tend to have minds that are organized in different ways, art education will be far more effective if educators are cognizant of those differences and plan curricula accordingly.

The group noted that Wolf's paper

plotted cognitive orientation within three age groups. She cautioned repeatedly that developmental psychology only tells what happens without any special intervention —that is, without teaching in the areas of the four art disciplines. It does not suggest what might happen if children were given educational opportunities that are not currently provided. She describes her data as a floor; developmental psychology, she says, does not tell educators how far above that floor they are likely to find the ceiling.

Among the participants in the group, there was concern and controversy over how to approach curriculum with the developmental stages in mind. Should DBAE begin with the assumption that a way must be found to teach the four disciplines to particular age groups? Or should DBAE begin with an assumption about the end-point, about how the educated adult engages in artistic enquiry or appreciation?

It was observed that educators are concerned with a balanced, sequential curriculum. But the balance might be achieved overall, rather than year by year. For children at different ages, the relative emphasis on each of the disciplines could change, so that although time allocations at different stages might vary, by twelfth grade the cumulative training in the four disciplines would be equal.

The end-point question, however, was seen as extending beyond twelfth grade, beyond the direct reach of DBAE training,

beyond the stages outlined by Wolf. Educators need a model of the educated adult. Michael Parsons' developmental work assumes that there is an underlying premise about what the end looks like, "a value position" that there is something required by the education. Without the assumption of a general education end-point, the interactions of education and development are not being considered.

Aesthetic scanning was also discussed at some length. Is it a technology appropriate to development or a gimmick that gives *apparently* successful results? Again, development was felt to be an important consideration. The point is not whether scanning is the way to teach children aesthetics, but how it might help prepare them for understanding aesthetic concepts at a later stage in their development.

The effects of teachers' expectations on their students was another concern. There can sometimes be a conflict between what a teacher wants and what good teaching is. For students at specific levels of development, teachers must know what kinds of questions are appropriate, and they must be prepared to work with the answers as the students construct them.

But what kinds of questions about art *are* appropriate for children at different developmental levels? As with most of the concerns addressed during the discussion, the group felt that resolution was impossible without further DBAE-specific research.

Recommendations

Study children who have had the advantage of a DBAE program and compare their responses to some of the Project Zero kinds of questions with the responses of the children in the original Project Zero sample.

Study the interface among the four disciplines and developmental psychology in order to determine what can be learned by children about the disciplines at varying grade levels.

Consult the various research journals for what has already been learned about child development in general, and cull the information that might help determine realistic expectations for Discipline-Based Art Education.

Conduct research on different teaching strategies, materials, and so on in order to determine the relative effectiveness of various approaches.

• • •

Questions for Consideration

Is it desirable to work for the acceleration of development?

Should what older children do be viewed as being better than what younger children do, or as simply different?

GROUP LEADER
Nancy MacGregor

PARTICIPANTS
Anne Lindsey
Howard Risatti
Jean Rush
Jon Sharer
Karen Thomas
Brent Wilson
Enid Zimmerman

**Summary of Prepared Response:
Howard Risatti, Discipline
Representative, Criticism**

Taking Wolf's three broad periods of child development into consideration, Howard Risatti asked what the expectations might be for teaching criticism at each level. He stated that in his opinion criticism can be taught at all three levels. "It is a matter of the kind of criticism and our conception of criticism," he said. He suggested as a model "the standard way literature is taught," the major parallel being that DBAE, like literature, should not be rigidly compartmentalized. DBAE is a serious process, the end result of which is to understand art and visual imagery. This purpose is not served by a model in which—especially at the lower levels—strict divisions between the disciplines are enforced.

Risatti noted that the temptation to keep the disciplines separate would probably be greatest among teachers who lack a clear conception of what the disciplines are, especially criticism. Students can learn across the art disciplines, as Wolf's remarks demonstrated; the knowledge they acquire from art instruction can inform their critical judgments.

There are virtually no "quantifiable data" in art, and this is one of its most important lessons. "In a world of uncertainties, it teaches students to question what appears certain." At its simplest level, criticism is the asking of questions; in art criticism, the questions are about art.

Keeping this in mind, along with the

idea that art and criticism both involve "discourse" (the latter inter-personal, the former intra-personal), one can see how the critical process can function in all three stages of child development. In the first stage, it might consist of simple descriptions of each child's work followed by the child's explanation of intended meanings. Guessing games, discussions, and other activities can help children to understand how visual elements suggest one meaning rather than another, to imagine plausible alternative meanings, and to verbalize their ideas about art. The goal should be to get students to talk about works of art and to develop the idea that visual works convey information.

In the second stage, children's ideas of right and wrong—based on their desire to emulate adults and their interest in "approved methods"—could be used as critical tools in discussions of naturalistic works. From this, students could begin to explore the formal structure of the works and to see "how pose and imposed action are carried through even in static images." Comparisons of naturalistic and "illusionistic" works could lead to questions of which work is more "correct" and why. The goal is to help preadolescents articulate their value judgments so they become aware of how and why they like and dislike particular works of art.

At the adolescent level, the students' sense of independence and their search for personal identity can be exploited as critical tools. Discussion of the style as well as the

content of their own work and comparisons with works by artists whom they admire can develop critical awareness, and a workbook or art diary in which students record their impressions can document changing attitudes. Discourse at this stage conforms more nearly to that of professional criticism, but it need not be separated or compartmentalized.

As students progress from early school to adolescence, their critical responses to works of art are enriched not only by courses across the curriculum but also by their experience of the world and by learning to read visual images as one reads a book.

Discussion

The fact that cognitive psychology and art education are two distinct fields, each with its own unique mission and set of goals, was stressed repeatedly throughout the discussion. Said Nancy MacGregor in her discussion report, "We should not think

that folks in psychology can do our work. We have to do our own."

The group determined that the task for DBAE's designers is twofold: first, to stake out the different kinds of developmental questions that are pertinent to art education and, second, to proceed with appropriate research.

One of the aims of the research would be to inform the sequencing of curriculum content—within each of the four disciplines—so that the content is appropriate to the position of students on the developmental continuum. In art history, for example, the two-step procedure might be first to decide what is to be covered in the program overall and then—*after* that decision—to determine at what age children can most readily comprehend specific art-historical concepts and interpretations. Discipline-based activities would be chosen to suit the "inquiry modes" of students at different age levels.

Members of the group questioned several aspects of Project Zero, the organization with which Wolf is associated and from which she drew the research findings used in her paper. Most of the questions had to do with the degree to which Project Zero's findings are, or are not, appropriate to DBAE.

For example, the point was made that, in art education—perhaps more than in other fields—a child's socio-cultural background has a significant influence on his ability to grasp the concepts being taught. The children used as research

subjects by Project Zero are all from the Boston area, and their socio-cultural backgrounds are essentially uniform. This contrasts sharply with the multi-ethnic, multi-lingual classrooms in Los Angeles and most major cities.

Further, the Project Zero studies seem to be interested in pure, non-interventional development. Educators, on the other hand, as Jean Rush noted, "act as change agents, to produce what otherwise would not be produced randomly."

Rush also commented that people who are not in the visual arts are naive about the cognitive abilities required to read images. In the Project Zero work, imagery is used in a very unsophisticated way, she said.

Brent Wilson expressed a different view. In his experience, even very young children can be surprisingly observant of details in the imagery used by artists. They may not be able to express what they see in a sophisticated way, he said, but they do apprehend.

Similarly, Howard Risatti has found that students at a very early level can be instructed in criticism. "'Do you like this painting? Why?' That's criticism," he said. The student's perspective can then be widened, and his inquiry directed, simply by asking, "What about looking at it this way?"

Developmental psychology, it was felt, could be most helpful to educators by providing a *framework* within which art curricula can be sequenced. Curriculum designers need to know what children can do at different ages; it is just as important to know what they *cannot* do. And physiological limitations are as significant as psychological ones. For example, based on the knowledge that six-year-olds are nearsighted, it makes sense to use large reproductions, rather than slide projections viewed from a distance, in first-grade classrooms.

There was general agreement that children think and develop in different ways at different ages, and that curriculum design should reflect a full understanding of the development continuum. Not enough can be learned from the research currently available, and future research must embrace the concerns of arts educators.

• • •

Recommendations

In order to strengthen DBAE, well-thought-out theoretical discussions—or theoretical concepts—should be devised for each of the disciplines, with regard to both the discipline activities and the inquiry modes.

The designers and supporters of DBAE are obligated to determine what youngsters can and cannot do at the various ages within each of the disciplines. Because child development and art education are two separate realms, DBAE is responsible for its own inquiry and its own research.

Financial support is needed both for research—which inquiry requires— and to foster information gathering and exchange.

Questions for Consideration

At what age can a child grasp the essence of varying historical accounts and come up with his own account?

Given a good art criticism model, at what ages can children follow it and begin to model after it?

At what age can children begin to deal with aesthetic issues?

What kinds of response can be anticipated for children at different age levels?

• • •

Summary of Prepared Response: Kristi Nelson, Discipline Representative, Art History

Nelson agreed with Wolf that each of DBAE's components can best be taught in terms of its relation to the others, seeing all four as mutually interdependent and complementary. Taking Wolf's outline of the three broad periods of child development as givens, Nelson stated that her intention was to "review aesthetic development as it relates to the productive, perceptual, and reflective skills of children from the viewpoint of art history in an effort to get at what children can learn about art history and when."

Children enter kindergarten having already acquired the capacity for numerous forms of symbolic expression and inventiveness. But while they may hit upon engaging solutions to artistic problems, they do not think in terms of alternative realities or multiple meanings. Their reading of artworks tends to be literal, and they are usually limited to their own egocentric point of view. Art and art-historical ideas must be rendered concrete with carefully selected material.

As preadolescents, children acquire the thinking skills they will need to survive in their culture. In the visual arts, they begin to focus more on the product than the process. They develop an appetite for facts, a systematic understanding of the world, psychological awareness, and a grasp of multiple meanings. Children at this stage can understand structure and style, the

GROUP LEADER
Mary Erickson

PARTICIPANTS
Gilbert Clark
Rogena Degge
Ronald MacGregor
Sharon Hill
Judy Koroscik
Kristi Nelson
Michael Parsons

formal qualities of artworks, and their sensuous properties. These new interests and capacities should be considered in the choice of art-historical materials introduced into the classroom. Education should involve the structured and integrated introduction of appropriate terms, formal qualities, concrete facts, and organized concepts, enabling young students to verbalize their impressions and to formulate skills and ideas for use in their own work.

Adolescents can think abstractly, reason about ideas and principles, and imagine alternatives both to what is and to conventional notions of what should be. The new skills increase their ability to reflect upon works of art. But students will not learn to apply this ability effectively without consistent and thoughtful instruction in the arts.

High school students can acquire the basics of art history, including both intrinsic and extrinsic methods of the discipline, as identified by Kleinbauer. Intrinsic elements encompass materials, techniques, stylistic aspects, iconography, and function. Extrinsic elements include artistic biography, patronage, and social or cultural context. As Kleinbauer suggests, this kind of study should focus on pertinent artworks, and comprehensive art-historical surveys should be avoided until students have received "adequate training in Western civilization."

In concluding, Nelson summarized Wolf's cautions regarding the use of developmental perspectives: Human knowledge is highly specific, and the information that has been gathered is primarily for middle-class, largely Caucasian children; art and the nature of creativity vary among cultures; developmental sequences are abstractions from a variegated pattern of skills, and within a particular domain, the processes used may vary significantly.

Discussion

The group talked extensively about the relationship between stance and discipline. It was even suggested at one point that there might be a conflict of interest between the *formal* idea of disciplines and the *informal* idea of stances. Whether or not the conflict exists, it was agreed that the two concepts are not the same, since in one way or another, all the stances can be represented in each of the disciplines.

Some felt the three stances to be useful concepts, but others found them either unworkable or conceptually indistinct. Many disagreed with the specific labels given to the stances by Wolf; for example, there was consensus that "perceiver" is a better term than "observer," since one can observe a thing and yet not understand it.

A model illustrating the interrelationships of the disciplines, the learner, and the culture—and making use of the "stance" concept—was introduced by Judy Koroscik. She drew two interlocking circles representing, respectively, the disciplines and the learner. The

stances, she suggested, describe the intersection between the two, an intersection which occurs within the larger circle of cultural context. As the discussion proceeded, the group decided that a third interlocking inner circle should be added, one representing the teacher. The point at which all three circles intersect is the point of intervention, of education. It is this intersection—and how it is affected by the cultural context—that needs to be researched. What is the impact of the culture on the learner, on the teacher and the teaching system, on the discipline itself?

A contrast was observed between David Feldman's view of development as particular and Wolf's more general view. The group felt strongly that DBAE's developmental research must be specific to the individual being taught, the kind of educational intervention taking place, the disciplines as defined in the curriculum, and the cultural context. It was also felt that Wolf's stages are too tidy. The cognitive modes which some children use at one stage may be used by others at different stages.

In sympathy with Wolf's paper, Michael Parsons speculated that young children do not think in terms of disciplines; they work more holistically. He feels that children should learn whatever helps them understand art: "It is more important for them to have a decent understanding of style, for instance, than to worry if it's art history or aesthetics." But this was chal-

lenged by other members of the group, particularly as a research priority.

Gilbert Clark raised a very strong objection to the notion—which he felt was implicit in Wolf's paper—that development builds toward late adolescence, at which point everything is crystallized. He warned against using adult-based outcomes as a goal in research. Within the group, there was general agreement on this.

One of the key areas that Mary Erickson felt the paper did not address—and which educators need to know more about—was how a child's concept of time develops over the years. She described "notions of the passage of time" as the basis for a sense of history. Judy Koroscik suggested that more attention should be given to teacher training in this area. Too many art teachers see art history as simply a body of facts.

The discussion ended with a debate about pedagogy. Point: Teachers should allow children to free-associate in order to stimulate their sense of inquiry. Counterpoint: Teachers should make judgments as to whether a child's answers are right or wrong. Gilbert Clark spoke for free association. Children cannot be expected to give "right" answers, he said. Expectations and sanctions discourage inquiry. "If we want children to speculate, we must be willing to accept a lot of weird speculations." Judy Koroscik spoke for judgment. But she felt that "relevant" and "irrelevant" or "appropriate" and "inappropriate" were better classifications than right and wrong. Everyone agreed

YOUNG CHILDREN DO NOT THINK IN TERMS OF DISCIPLINES; THEY WORK MORE HOLISTICALLY.

that the ability to *pose* questions that are stimulating and unambiguous—and appropriate to the developmental level of the student—is essential to good teaching.

• • •

Recommendations
DBAE concepts need a stronger research base, and research areas need to be studied and prioritized.

Whatever developmental research is prescribed, and whatever theories are developed, should be informed by an awareness of the interrelationships of the learner, the teacher, the disciplines, and the culture.

In contrast to Feldman's view of development as particular, Wolf's view was more general. In DBAE, we need to make more particular our concerns for the individual, for educational intervention, for the disciplines, and for the culture.

The DBAE literature needs more clarity regarding the distinction between verbal understanding and such terms as "visual intelligence," "visual concepts," and "visual understanding."

• • •

Questions for Consideration
DBAE and developmental psychology are very general. What is unique to the learning experiences of children from non-core cultures? How is development affected by educational intervention?

**Summary of Prepared Response:
Derrick Woodham, Discipline
Representative, Studio**

Wolf's three phases in children's aesthetic development parallel priorities in "the motivating, conceptualizing, action planning, implementation, and reflective evaluation of the artist." Her "stances" and "age-based sequencing," along with the "incremental refocusing of the stance concept" suggested by Zimmerman, imply a structure that is complex enough to encompass the discipline of art production.

In Woodham's experience in art education, personal preference and interest were stressed above other motives, and work drawn from the child's imagination was stressed above that drawn from other sources. Applying a developmental conception of the artist—or the critic, the aesthetician, or the historian—to art instruction, as Wolf suggests, would provide a more insightful understanding of society's view of the artist and the artist's view of himself.

Woodham was struck by the fact that, so far, no research had addressed the impact of instruction on conceptual models relevant to art. This is "an obvious area of needed attention."

Woodham stated that he would like to see a DBAE curriculum that addressed Wolf's maturation process, with follow-up testing of its effectiveness and, based on the results, a selective acceleration or broadening of this model.

Last, Woodham wondered whether DBAE "field achievements" might offer any evidence relevant to Wolf's idea of "concept sequencing" and how this sequencing compares in relevance and complexity with other curricula.

Discussion

In the summary session, Denis Phillips reported that his group had "a fairly strong, healthy sense of skepticism" about developmental psychology. Kohlberg's theory was thought to be in disarray, and there were "massive" criticisms of Piaget—primarily for his failure to deal with cultural differences in learning and for the biases upon which his research techniques are based.

Hearing the summaries of the other three discussions, Phillips felt that his group had concurred with them on most points and would support their recommendations. Like the others, he said, his group seemed to feel that it is "much too early to be talking about proven constraints to development—although, of course, it hasn't been shown that there *aren't* developmental constraints that are going to be relevant to the curriculum." Louis Lankford thought that Wolf had provided "a line of risk for instruction: When are we pushing kids beyond what they are capable of?" But exactly where that line is located at different levels remains unknown.

One criticism of developmental psy-

GROUP LEADER
Denis Phillips

PARTICIPANTS
Carmen Armstrong
D. Jack Davis
Michael Day
June McFee
Jan Maitland-
 Gholson
Louis Lankford
Lois Petrovich-
 Mwaniki
Robert Russell
Marilyn Stewart
Mary Stokrocki
Derrick Woodham
Bernard Young

[DEVELOPMENTAL] STUDIES ARE VALUABLE FOR CASTING UP POSSIBILITIES FOR LEARNING, NECESSITIES FOR LEARNING RATHER THAN ABSOLUTE SEQUENCES OF ANY KIND.

chology pursued by the group was that it has tended to be culturally insensitive in a number of ways. For example, serious, sustained attention has not been given to the influence of culture on individual development. For another, the children used in the studies have tended to come from majority cultures. As June McFee said, "We're still using WASP standards." But development follows different patterns in different cultural groups; different skills and attributes are valued and nurtured, or ignored, or actively discouraged. This is understood as a general principle, but there is not enough knowledge about how specific cultures and subcultures affect development, and so it is difficult at this point to plan culturally sensitive curricula.

When this sensitivity is lacking, and when some students fail to learn because they are not being approached in an appropriate manner, art education fails in one of its most important responsibilities: as Jane Maitland-Gholson put it, "to help the children get the cultural heritage" that is their birthright as citizens of the culture.

There was strong concurrence with the other groups regarding the need for additional research. But research is "assumption driven," said Lankford. "Prior research ought to be toward identifying what art educators think is pertinent." The other participants were also concerned that research be neither biased nor haphazard. It should be planned and prioritized, and to that end, a small group might be formed to supervise the process. One of the goals of

a planning conference might be to determine which questions would have the most payoff if researched very quickly.

Teacher training was another major concern. It was observed that many burdens of introducing an educational innovation are borne by teachers; consequently, the psychological and cultural content of teacher-training courses should be considered carefully.

• • •

Recommendations
Hold a planning conference to establish research priorities.

Consider very carefully the psychological and cultural content of teacher-training courses, in order to ease the special burdens borne by teachers in introducing innovations into the classroom.

Dennie Wolf's Response to the Summary Session

After all the group leaders had presented their discussion summaries and recommendations, Dennie Wolf again addressed the full assembly, this time in order to clarify her views on three aspects of the stage theory.

First, in describing three stages of development, she did not mean to suggest that "later is higher is better. That's the commonplace assumption of stage theory; it's not, however, an assumption that I'm making."

Second, a common assumption about the stage theory is that later stages *replace* earlier ones. "In fact, I'm making a counter assumption, which is that what one is building is a repertoire of ways of responding to work." Younger children develop, "or have naturally, perhaps," a strong and immediate sensory response to works. This is complemented, not replaced, by the understanding of cultural iconography and systems, for example, which children acquire in middle school. Then, during adolescence, comes an understanding of choice, message, and craft. "In the end what you have is a complex response which involves all of those . . . and still later the discipline response, which is what comes to you by virtue of being a practicing member of the discipline."

"Finally, I don't think developmental psychology has a corner on the knowledge market in any sense," said Wolf. But she does feel that research in this field is valuable, insofar as it points out the kinds of things that need to be learned, and that can be learned, by students at different ages. "I think the studies are valuable for casting up possibilities for learning, necessities for learning, rather than absolute sequences of any kind."

Issue 2: Art and Society

SPEAKER

June King McFee
Emeritus, University
 of Oregon

RESPONDENT

Stephen Mark
 Dobbs
San Francisco State
 University

DBAE is focused on the fine arts. To what extent is it desirable to include other art "categories," such as television, video, film, advertising, computer art, product design, crafts, and folk art?

• • •

A Summary of June King McFee's Address

In order best to answer the question of what arts should be included in DBAE, it is necessary to examine the social and cultural context in which is the educational program operating, McFee said.

She made three points in this connection. First, the study of fine art or studio art is not inclusive enough to meet the needs of students living in a multicultural democracy. Second, it must be acknowledged that the critical disciplines of DBAE are bounded within Western culture, hence inadequate for studying the art of other cultures. Third, she would argue that a fifth discipline, "a socio-cultural study of art," should be added.

McFee went on to offer definitions of art, society, and culture and to advance a series of propositions about what constitutes and differentiates the varieties of art in our society. Art is universal (found in all cultures), but varieties are governed by the different socio-cultural contexts in which they develop and whose values they reflect. The different arts have subcultures of their own, made up of artists and others who support their work. Valuation of the different kinds of art in our society is governed by a system of collectors, curators, historians, critics, and educators, as well as the general public.

The definition of fine art in Western civilization has changed over time as the supporting subcultures and cultural backgrounds have changed. Ideas of taste have undergone continuous modification as individual artists break the bounds of the acceptable and support groups form to promote the new ideas.

Most art fulfills some social purpose, and most cultures define the roles in which artists carry out various social purposes. Street art, protest art, and some forms of graffiti make social statements and represent groups that seek recognition through their art. When we limit the kinds of art taught in a multicultural society, we limit the transmission of some of the subcultures. Our society has many distinct indigenous and old immigrant art cultures, including American Indian, Eskimo, Mexican Indian, Polynesian, Spanish, and Russian. Our ethnic art cultures—which for a long time had European, African, Asian, and Middle Eastern backgrounds—now include art by persons from most parts of the world. All of these cultures are part of the art environment in which students need to develop and exercise critical judgment.

The new video and computer technologies are such pervasive communication art forms that we should consider them

as independent forces, changing society as well as the cultures of art. Specifically, they "enculturate" children with new "cognitive styles" for interpreting experience.

The American "ideological pendulum" keeps swinging as population size and diversity continue to increase, McFee said. The present generation faces a threat of declining prosperity and growing social stratification. Changes in the overall society are being effected by a renewed concern for ethnic, racial, and gender identity, by a reaffirmation of cultural heritage, and by the immigration of new cultural groups. (In Los Angeles, for example, eighty-two different languages are spoken by children in the public schools.) Changes in the core of American society are being wrought by changing mores, patterns of family structure, child-rearing practices, sex roles, life goals, and life styles. Discussion of art in the schools must take account of these changes.

Based on these assessments, McFee advanced four positions:

First, in addition to fine art, the study of art should include fine and applied crafts, folk arts, costume, television, computer graphics, advertising and product design, architecture, environmental design, graphic design, art of other countries, and, where appropriate, street art and comics. Furthermore—"and this may be the most important statement I'll make here"—for many children in this country the study of fine or studio arts should be a "cross-

June King McFee

cultural" affair. Since television is unrivaled as a medium of exposure to art, teachers should use it to help build "bridges of respect" to unfamiliar cultures.

Second, design should be upgraded to the level of fine and studio art, and considered as a factor in critical, historical, and aesthetic studies. Students need to know how visual and design qualities influence their attitudes and judgments. Multicultural design studies can help them become independent critics of the images projected in the media, and can be "foundational" to comprehending other forms of art.

Third, attention to folk and other subcultural art forms need not diminish the ability of students to discriminate quality in fine arts. Aesthetic and critical skills can be applied to all forms of art, with each work judged in the appropriate context of the belief and value systems that have motivated the artists. Some criteria of quality may be found in many art cultures;

The socio-cultural aspects of art should be included as a foundation for art education, curriculum development, and teacher education.

others may not. This kind of study involves a degree of cross-cultural relativism, but we can uphold aesthetic preferences that remain stable in a given culture over a long period of time. When cultures change, aesthetic innovations can help us understand what is happening.

Finally, DBAE should add a fifth discipline to its program: "socio-cultural art." DBAE's existing disciplines have been developed around studio arts. Though some critics, aestheticians, and historians are considering cultural factors, they have yet to recognize how much their disciplines "are culturally embedded in Western modes of thought." The interrelationships of art, the artist, and the audience must be approached in terms of their specific cultural value system.

This proposed fifth discipline would include explorations of: how art expresses concepts of reality, values and belief systems, and patterns of behavior; how design and artistry develop in different cultures; how artists are conditioned and rewarded by cultural mores; how art transmits culture and how a single artist can transform a culture; how the values of the different art subcultures direct the development of art and artists; how aesthetic responses can be studied cross-culturally, both within and outside the U.S.; and how teachers can adapt curricula to the cultural and psychological aptitudes of their students.

The socio-cultural aspects of art should be included as a foundation for art education, curriculum development, and teacher education. This kind of training can make students aesthetically, visually, and culturally more literate and better prepare them to respond to "the rich stew" of American diversity. It can prepare more of them to be responsive to the fine arts and crafts, to respect the folk and ethnic arts of their own and other cultures, to be active critics of mass media, and to care more deeply for our shared environment.

A Summary of
Stephen Dobbs' Response

Though DBAE is, as this session's premise states, focused upon the fine arts, this is not necessarily the way it ought to be. The paradigms and exemplars of DBAE derive from traditional art categories like painting, sculpture, and architecture. This is so because scholars, historians, and critics usually draw the line at the various electronic media, which are taught not in art but in film and broadcasting departments. Despite the feasibility of convergent studies of such arts as painting and film—emphasizing the relation-ships between different forms of visual expression—the boundaries remain fixed.

Dobbs remarked that McFee's argu-ments, and his own, are intended to suggest new and "expansive" possibilities. "But it is, to a degree, an uphill struggle."

The academic distinction between high and low culture is an unmistakably elitist notion consigning film, television, adver-ising, and design to "a visual purgatory" outside of fine art. Academic interest in these areas has recently broadened, but traditionalists still oppose giving equal time in our museums to these art forms.

Yet, as critic Morris Weitz argues, there can be no final comprehensive statement on the nature and essence of art. Yester-day's experiment is today's new master, as once daring styles are transformed from boundary breakers into establishment darlings. This is especially true in a society like ours in which there is general confusion about who is an artist and what an artist is. In their own spheres, Michael Jackson, Julia Child, and Vidal Sassoon are all considered artists; Andy Warhol went out of his way to cross the line, and blur the distinction, between commercial and fine art. Is it arbitrary or "culturally ignorant" to exclude one form from the realm of art and include another because of the different use to which each is put?

To rephrase the question, how can we justify *excluding* art categories such as television, video, film, advertising, computer art, product design, crafts, and folk art from DBAE? Artists themselves lead the way in breaking formal bound-aries, from Marcel Duchamp to Nam June Paik, and our criteria of judgment are in constant flux. Today's artists blend styles and mix media; their methods vary widely, from action painting to performance art.

Stephen Mark Dobbs

As major vehicles for the transmission of subcultural values, the alternative visual formats of television, product design, folk art, and others are entitled to our attention in DBAE.

Likewise, we should be "casting a wider net in search of art content" for DBAE. Offering students a wide range of visual forms is sound both artistically and educationally, Dobbs argued, citing Rudolf Arnheim's advice that perception begins with gross and general differentiation, and proceeds to what is complex and subtle.

Aside from these advantages, Dobbs said, the most compelling reasons for broadening DBAE's art content are those stated by McFee: her concern for social context and "the real world in which students learn about art." She reminds us of our aspiration for a truly egalitarian educational system which respects and inquires about cultural differences, and she insists that we acknowledge the rich spectrum of expression in this multicultural democracy.

As major vehicles for the transmission of subcultural values, the alternative visual formats of television, product design, folk art, and others are entitled to our attention in DBAE. Further, DBAE requires legitimation and support from a wide range of American communities, and "we cannot ignore the multicultural equivalents of fine arts for the millions of minority and ethnically diverse youngsters in American schools." A community's existing—but often untapped—cultural resources should be harnessed to make art more accessible, and the process of art education more attractive, to students.

For students, the media, the folk arts and crafts, and other visual categories are important sources of information and feeling. This is "their real world, and I think it ought to be ours as teachers as well."

Issue 2: Small-Group Discussions

After the presentations by speaker June King McFee and respondent Stephen Dobbs, the seminar participants were again divided into four small groups to discuss and respond to what they had heard in plenary. Group assignments were different from those that followed the first plenary session. Again, spontaneous discussion was complemented by the prepared responses of representatives from the four DBAE disciplines. The group leaders reported the recommendations and questions developed by their respective groups at a later plenary session. The discussion summaries below are based in part on the reports presented in plenary by the group leaders.

• • •

Summary of Prepared Response: Howard Risatti, Discipline Representative, Criticism

Risatti drew attention to three points argued by June McFee: that fine art as currently defined is not inclusive enough for students in a multicultural democracy; that the academic components of DBAE are bounded within Western culture; and that a fifth discipline, the socio-cultural study of art, should be added to the program.

Rather than argue these points, Risatti stated that he would respond to the issues and principles on which they are founded. He stood firm against the limiting notion that the study of art offers a solely aesthetic pleasure. To the contrary, art plays a role in forming and changing cultural ideology and values. "Not only art, but the total visual and built environment communicates to the individual." The values art

embodies need not be overtly political. They can represent a wide variety of human aspirations and ideals. Given the increasing power and importance of visual images communicated through electronic media, instruction in how these images work within society must be considered a necessity.

Risatti agreed with McFee that art disciplines have tended to focus on the "aristocratic" or high art tradition. But today, high art constitutes a much smaller proportion of our visual culture than everything else. Further, there is a direct and real connection between high art and this "everything else," and the influence moves both ways. It makes sense, as McFee suggests, to include the widest range possible of images, media, and cultural sources in the study of visual art, not least because exposure to kitsch can provide the critical tools with which to distinguish fake from authentic art. Students should be taught to discern the values promoted by their visual environment, so that they can both "appreciate the highest form of visual communication—art—and understand the messages of lesser forms."

As to McFee's second point, Risatti said that although it is not inaccurate to view the DBAE disciplines as bounded within Western culture, it is wrong to infer that they are incapable of dealing with art of other cultures. The answers we get from critical disciplines are determined by the questions we ask; the limits are not characteristic of the disciplines themselves,

GROUP LEADER
Mary Erickson

PARTICIPANTS
Gilbert Clark
D. Jack Davis
Margaret DiBlasio
Jane Maitland-
 Gholson
Louis Lankford
Anne Lindsey
Howard Risatti
Marilyn Stewart
Mary Stokrocki
Karen Thomas
Dennie Wolf
Bernard Young

but of the object under scrutiny and the attitude of the scrutinizer.

McFee's call for recognition of cultural diversity and a socio-cultural approach to art is typical of the present Postmodernist intellectual environment, with its particular matrix of philosophical, psychological, political, economic, semiological, and deconstructive ideas. Critics are paying attention to Third World issues, feminism, minorities, and questions of "knowledge and the self," but this is specifically in response to the work of those con-temporary artists who are addressing these issues.

The critic must ask the proper questions: What does a particular visual work mean? How does it signify its meaning? How do I know it means this? What other things can it mean? Answers lie both within the work and without. They are a part of each work's "cultural connections."

Discussion

Mary Erickson reported her group's dis-cussion as wide-ranging, with many topics on the floor at the same time. They came up with three agreements, one major disagreement, ten unresolved questions, and four recommendations.

The participants agreed that although discipline-based art education is emphasizing the content to be taught, rather than the needs of the learner or the needs of society, DBAE does not overlook the importance of these needs. There is a focus on the former area, yet there is no intention to diminish the significance of the latter two. But this may be misunderstood in the field and needs to be communicated.

It was also generally agreed that the disciplines themselves do not restrict the kinds of art that can be studied. Rather, they provide avenues for inquiry into whichever art is selected.

Everyone felt that teachers have a responsibility for the implicit definition of art that is exhibited in their classrooms by their choice of objects. This conceptual development of the notion of what art is should not be treated casually.

On what Erickson characterized as "probably the major issue under discussion"—that is, that for many children the study of fine or studio arts should be cross-cultural—the members of the group "agreed to disagree." Individual participants took polar positions on the role of art in society and the role of the other arts in relation to fine art.

Much of the group's time was spent on questions that remained unresolved at the end of the discussion, all of which are listed below. Chief among these was the issue of which arts should be included in DBAE and how they should be selected.

Gilbert Clark felt that there is confusion about the Getty monograph, which he said does *not* reject other art forms. But he supported the idea that choices must be made, no matter how difficult; other-wise the task of art education becomes

impossible. Anne Lindsey, leaning toward the fine arts, observed that school may be the only place where students are exposed to them. But as Margaret DiBlasio pointed out, "Children form concepts whether we want them to or not." Living with Coke bottles and graffiti, they will accept these as art, she said, and teachers must dissuade them or teach them how to articulate and defend their perceptions. Gwen Waldron suggested that the question of what is and isn't art could be posed to the kids to "make an object lesson out of our dilemma." Everyone agreed on the necessity of making choices, but there was widespread disagreement as to how and why.

• • •

Recommendations
There is a need for more dialogue and more research about all the above questions.

Despite DBAE's focus on the content to be taught, communication regarding the program should strongly and directly acknowledge the importance of the learner's and the society's needs.

Art instructors should not be casual about the *concept* they are presenting to students when they introduce an artwork. Teachers have a responsibility to confront the question "Is this art?" and to teach this to students.

The Getty Center needs to address strongly and directly questions of what DBAE is going to include and what it is going to exclude, rather than leave this chance. Examples include pedagogical issues and the pop-versus-fine arts controversy.

The Getty Center needs to make it clear that even though DBAE focuses on content, it does not overlook the needs of the learner in society.

• • •

Questions for Consideration
Are the art disciplines themselves culture-bound?

To what extent is the understanding of popular art transferred to fine art?

What are the goals of discipline-based art education? If they include such things as the clarification of values, consumer education, and social tolerance, do these goals argue for extending the arts and the range of objects covered by DBAE?

What is the nature of art in society? Although McFee spent a good deal of time discussing this topic, the group felt that the question remained unresolved in regard to such topics as the relationships between aesthetic, ethical, and legal issues, and whether they play a role in DBAE.

Which arts do we include in DBAE and how do we select them?

At what developmental levels can the various arts be comprehended? Are some of them more comprehensible at different levels? For instance, it was hypothesized by Wolf that although the popular arts may be the most familiar, they may be the least understood, or the most difficult to understand.

What should be the depth and breadth of teaching about the various arts?

What different kinds of inquiry—what different disciplines—do different kinds of art generate? For example, some questions of aesthetics may best be raised with certain kinds of objects, while certain art history issues may be most effectively discussed using other kinds of art.

Does DBAE deal with pedagogy? If so, to what extent?

Should teachers be provided with examples of model discipline-based art education programs?

Summary of Prepared Response: Derrick Woodham, Discipline Representative, Studio

Throughout history, the social role of the artist and the relationship between art and culture has varied dramatically. In the United States today, the range of culture is exceptionally broad, "too broad to teach in terms of exemplars for every special form, context, or application." Effective teaching would best be achieved by using exemplars that represent a community's own ethnic and cultural minorities and that relate the local community to the national and international cultural communities.

The diversity of forms should certainly be addressed in studio practice, said Woodham. But he indicated that he would prefer to see the socio-cultural dimension of art addressed through "practice in its applications" rather than a new component for DBAE.

Woodham was disconcerted by disparaging comments made about "holiday art" during the seminar. While all such popular forms may sometimes avoid creative challenge for the sake of guaranteed results, they do provide important introductory experiences. They generate a sympathy in students that educators ought to nourish. In general, the line between popular and fine art is unstable; insofar as they provide a meaningful representation of the visual experience, both should be included in instructional curricula.

Discussion

The discussion focused on two major areas of concern: curriculum and the socio-cultural functions of art. For each of these, a set of questions arose. Because the questions remained unresolved at the end of the discussion, Hilda Lewis did not present recommendations to the plenary session. Rather, within the context of the two areas of concern, she reviewed the questions—all of which, the participants agreed, are in need of clarification.

On the question of what kinds of art to include in a DBAE curriculum, the group agreed that the examples should not be restricted to museum-quality works from the Western fine art tradition. But there was disagreement about exactly what should be included. Television, video, film, advertising, computer art, product design, craft and folk art, and others—all had advocates and adversaries. Some participants held that there is a widespread perception that proponents of DBAE do not look favorably upon including a variety of art forms. Others called the perception inaccurate. All concurred that if this perception *is* widespread, DBAE's proponents should take the lead in clarifying the issue.

Michael Day observed that one difference between fine art and popular art is that you "need no tuition" for popular art. "You don't need a course to accept Michael Jackson." Fine art must be studied; it needs the schools. But others felt it equally important that students learn how

GROUP LEADER
Hilda Lewis

PARTICIPANTS
Rogena Degge
Michael Day
Stephen Dobbs
Sharon Hill
Michael Parsons
Jean Rush
Derrick Woodham

to analyze and defuse the images bombarding them from the media.

Once a category of art is accepted for the curriculum, specific examples of the art must be chosen. How? One suggestion was that a teacher should feel free to use whatever examples he or she wants if they serve a useful educational purpose. If children can be motivated by the use of something familiar to them, it should be used as a jumping-off point. It was agreed that within whatever categories are accepted, the best works should be used as examples. However, the issue of how to determine the relative quality of a particular object within its kind was not resolved.

Anthropologists and other social scientists work with and study works of art. Should their understandings not be brought to bear on the development and implementation of curriculum? Should DBAE add a fifth discipline related to the social sciences?

Some participants thought that socio-cultural concerns are subsumed under the four established DBAE disciplines. Michael Day, a proponent of this view, also felt it important to note that anthropology and sociology do not *focus* on art, while the disciplines of art do. Others felt that social science should be treated separately; the consideration of cultural, anthropological, and other sociological functions of art, these participants maintained, helps to build mutual understanding among various

peoples. But the counterpoint was raised that within new-immigrant groups there is often a reaction against a group's own traditional art forms. Immigrants who have just arrived from another culture may not be as receptive to the art of their native culture as we would anticipate; they may even be offended by the introduction of these works into classroom discussions. All participants agreed that the subject merits further discussion.

• • •

Questions for Consideration
How should we make decisions about what kinds of art should be included in a DBAE curriculum?

Once a category is accepted, how are specific examples of the art to be chosen?

Should DBAE include a discipline related to the social sciences?

Summary of Prepared Response: Margaret Battin, Discipline Representative, Aesthetics

While normally the philosopher's procedure is to ask for further justification, that appears unnecessary with McFee's paper, Battin said. Most of the claims are "uncontentious": more languages are spoken in the schools today; social populations are changing; things aren't what they used to be. It is hard to disagree with such assertions. But we ought to be very sensitive to one "very dismal" aspect of the picture that McFee draws: She suggests a too-diverse society in which groups don't understand each other, "a society marked by disarray, deterioration, and lack of mutual respect." We are poor at design, she says, and subject to manipulative media. Battin finds the picture extremely gloomy, the prognosis dim.

McFee recommends two ways in which DBAE can deal with all this: include all the arts, and add to the program a fifth discipline of socio-cultural studies. McFee thus raises "a distributive problem" about the scope these new components should be given within the overall program "and to what degree they will replace or supplant something else."

The question for an aesthetician is, what argument provides us with a basis for including or excluding forms of visual expression? To answer, we must ask again a question that "will seem to have been asked remarkably often": What is the overall vision of DBAE? What is it trying to attain? An art-literate society is the usual answer. But in this society, who is and who isn't art-literate? We may be tempted to say, "We are, and they aren't." But that looks self-serving when we view the social picture as a whole.

McFee observes that society has changed, and continues to change, in different ways. The changes themselves are obvious, but her evaluation of them is open to question. To illustrate, Battin addressed the question of what the DBAE program should be. But first she expressed two overriding concerns: Should we capitulate to social changes, try to reverse them, or just hold the line? Should we capitalize on these changes and enhance them, or maintain the status quo? These questions reflect two different ways of seeing the same social phenomena. McFee's is the first way, and Dobbs' is the second. "Which way is DBAE, and the Getty generally, seeing it?" Battin asked.

Is McFee's dismal assessment of cultural changes appropriate, or are these changes "a welcome antidote to what we might call the preciousness of recent, privileged, high-WASP culture?" Seeing that a culture can go off the track at certain points, we must question whether, at *this* point, we are on the right track, "if there is such a thing."

Finally, how can we make such assessments objectively? As members of a particular culture, how can we assess its merits without bias? Although we can

GROUP LEADER
Denis Phillips

PARTICIPANTS
Margaret Battin
Arthur Efland
W. Dwaine Greer
Judy Koroscik
Ronald MacGregor
Jeffrey Seibert
Enid Zimmerman

identify various biases, escaping them altogether is very difficult.

In conclusion, Battin advised that "the current, compelling, direct issue"—art education in a changing society—cannot be adequately addressed without taking these underlying questions into account.

Discussion

If you have people from eighty-two different cultures in your school system, "how the hell do you cope with it?" Whatever artwork you present is going to be cultural imperialism, and children from the other eighty-one cultures are going to be offended because their type of folk art is not introduced.

According to Phillips, this line of thinking, arrived at early on by his group, caused a depression to set in, and it was exacerbated by the realization that it may be offensive, even racist, to suggest that black kids study only black art and Japanese kids study only Japanese art and so on. "Somewhere in here I think we decided that Professor Dobbs was an optimist and that Professor McFee, in her paper anyway, leads to a more dismal prognosis." Everyone agreed that "it's just common sense to start by examining objects or phenomena that are familiar to the kids in a particular classroom." The real issue was what to do after that. Three rival possibilities were delineated and discussed, but the group was unable to

reach a consensus on which strategy to recommend.

The three rival strategies for dealing with cultural diversity in the classroom were:

1 Start with cultural objects from the surroundings and stay with them. Let the familiar objects constitute the entire curriculum.

2 Start with familiar objects, but use them to highlight and underscore aesthetic principles, to develop critical perspectives, and even, perhaps, to develop key historical insights; in other words, use familiar objects to bring out some of the underlying principles.

3 Start with familiar objects but use them not only to lead to principles but eventually to lead to discussions of works of "high culture, the best examples of art from various cultural back grounds." As in textbooks, these examples would not be limited to European paintings of the seventeenth century, for example, but would include works of high standards from other cultural groups.

The first strategy, although it is employed in some classrooms, had no serious supporters in the group. But Battin did note that "staying there" could allow for a more exhaustive exploration of the levels of meaning. The second strategy was thought to be a seriously viable option by one or two participants. But most leaned towards the third alternative, and this was generally held to be the approach

embodied by DBAE. There was "a fair unanimity" that, in fact, there are clear cross-cultural criteria for determining what are fine pieces of art and what are "rubbish." Still, this strategy did not go unchallenged. Some wondered if starting with the familiar and moving on to the older, "great" works might be elitist.

Nor was there consensus on the group's second major discussion topic, McFee's suggestion that a fifth discipline should be added to DBAE. Again, there was agreement that the suggestion attempts to address real problems, but the group was divided over the best way to confront these problems. Some felt that the addition of a fifth discipline—the study of art from a socio-cultural perspective—would make DBAE not really about art but about the social uses of art. Further, "any competent history of art takes socio-political-cultural phenomena into account," and reasonable criticism takes into account "the ethnic, political, social background of the artist" in criticizing a piece of work. Therefore, as the participants holding this view emphasized, if history and criticism are handled competently, these established DBAE disciplines would cover some of the concerns raised by McFee.

On the other hand, although not denying the partial coverage of this aspect of art by current DBAE disciplines, some group members felt that the socio-cultural perspective was so vital that the matter could be handled in the opposite way—by

including the new discipline and throwing out one of the others. For example, rather than socio-cultural concerns being a hand-maiden to history, it might be assumed that any competent socio-cultural instructor would bring a historical dimension; therefore, why not get rid of history as a discipline and let it be a handmaiden to the new discipline? One of the participants who felt strongly that introducing a fifth discipline would necessitate dropping one of the other four was Margaret Battin, the discipline representative for aesthetics, who even suggested that her own discipline—given the difficulty with which people regard it— might be the best area for substitution.

Toward the end of the session, Dwaine Greer posed a question which he felt touched on a larger issue than what had been covered in the group's discussion of social change and its relationship to education. He asked: Should contemporary schooling be responsive to immediate social change? There is always a lag, he said, and he cautioned that content should go through scholarly consideration before inclusion in the curriculum.

ANY COMPETENT HISTORY OF ART TAKES SOCIO-POLITICAL-CULTURAL PHENOMENA INTO ACCOUNT, AND REASONABLE CRITICISM TAKES INTO ACCOUNT THE ETHNIC, POLITICAL, SOCIAL BACKGROUND OF THE ARTIST.

GROUP LEADER
Nancy MacGregor

PARTICIPANTS
Carmen Armstrong
Kerry Freedman
George Geahigan
June King McFee
Kristi Nelson
Lois Petrovich-
 Mwaniki
Robert Russell
Richard Salome
Maurice Sevigny
Jon Sharer
Brent Wilson

**Summary of Prepared Response:
Kristi Nelson,
Discipline Representative, Art History**

In support of McFee, Nelson pointed out that art history considers all types of visual art and expression as "primary data," including "major" and "minor" arts, a wide variety of crafts, and electronic media. In particular, "the problem of design, how to define it, and how to deal with it as part of the history of art" is being addressed by more and more historians. All types of visual expression can be integrated into the art-historical curriculum of DBAE.

McFee maintained that studying the lesser arts need not diminish a student's powers of discrimination when judging fine art. By analyzing the formal qualities of artworks, the potentialities of various materials and techniques, stylistic elements, and artistic themes and purposes, students acquire a "visual literacy" that enhances their understanding of, and increases their ability to distinguish among, various forms and levels of visual expression. They will develop their own standards of quality and will be better equipped to interpret the images with which they are daily bombarded. Citing Kleinbauer on the usefulness of art history in developing these powers of judgment, Nelson added that the study of history "helps to extend and deepen the emotive responses of young persons" to the world, and "vitalizes their lives through exposure to previously unknown artistic values."

Nelson agreed with McFee that art and culture interact, that art expresses cultural values through content and form and at the same time interprets (and thereby shapes) culture. One of DBAE's major aims, Nelson stated, is to help students understand this interactive process. But whereas McFee maintains that this aim would best be served by the addition of a separate socio-cultural discipline, Nelson pointed out that the discipline of art history is already attempting "to transform the chaotic variety of human records into a cosmos of culture." She sees art history programs increasingly adopting Kleinbauer's method of setting an artwork in the context of its time, probing "the artist, the nature of the creative process, and the elements that shape the work." The intention is to integrate the study of foreign cultural traditions into a well-balanced program.

In conclusion, Nelson stressed that whatever art, artwork, or artist is being discussed at a given level within a given ethnic group, art remains a human product, and students should be introduced to "humanistic elements" that are integral to the study of visual arts of all kinds. Students must know that "we study the past because we are interested in reality." In humanistic studies we attempt to understand who we are as humans and how we function in the world. As Marsilio Ficino wrote, "History is necessary not only to make life agreeable, but also to endow it with a moral significance."

Discussion

As a member of Nancy MacGregor's group, June McFee stressed that art is a social action and that cross-cultural understanding is essential. This added clarity to her theory, particularly in contrast to DBAE, and made her position more persuasive. But as the group saw it, the problem with the notion of adding a fifth discipline is one of practicality. Art educators are being asked to do more and more, said Maurice Sevigny. "Where should you put your energies? What should be left to other disciplines?"

"If you add something, it suggests that you have to take something away," said MacGregor, reporting in plenary on her group's discussion. On the other hand, if the four disciplines are left in place, how do you make room for a fifth?

Problems that universities are encountering with adding and taking away from curricula were discussed, and Kristi Nelson pointed out that art history courses are being extended to embrace cultural context and social issues. She suggested that history curricula in the colleges might provide models for adding content to the established DBAE disciplines.

Concerns about the criteria used to select the arts and art objects for inclusion brought out concerns about underlying theory. In order to examine the concept of cross-cultural art understanding, or art as social action, it was felt that what is needed is the development of theoretical founda-

tions for a socially-based art curriculum. The new theories should identify essential goals, so that these could be contrasted with the goals of DBAE. There was some discussion that the theoretical underpinnings for DBAE and for a socially-based art curriculum are different; theoretical study might reveal that the pursuit of cross-cultural art understanding is inappropriate to the DBAE concept.

Various alternatives for beginning to examine the notion of the social issues were examined. For example, experimentally, each of the four disciplines might be focused on the social functions of art, rather than on the art itself, in order to see what would result if this strategy were played out. Another notion that generated interest was the possibility of choosing specific examples—"based, of course, on proper criteria"—that would be appropriate to a specific group of students. However, the selection would be guided by what DBAE wants the art to reveal to the students. Lois Petrovich-Mwaniki expressed a strong preference for this kind of approach over the separate-discipline idea. She was concerned about "compartmentalizing these disciplines." The multi-cultural discipline should be infused, not separate.

Kerry Freedman agreed. "Social context should be part of everything we do," he said. Freedman also brought up another interesting point: Ten to fifteen years ago, the concerns of educators in regard to cultural differences were the exact

IN HUMANISTIC STUDIES WE ATTEMPT TO UNDERSTAND WHO WE ARE AS HUMANS AND HOW WE FUNCTION IN THE WORLD.

opposite of what they are today. Then the goal was to minimize differences and stress commonalities.

Brent Wilson noted that colleagues in other countries read articles in American journals and are impressed. Then they come to this country and find that there is no relation between our rhetoric and our prejudices in the classroom. The problem is how to embody the ideas that educators wish to convey in such a way that they can be understood by little kids. June McFee felt that teacher education is the answer. Teachers need to live in a culture other than their own, she said. Unless people have the experience of questioning their own culture, they won't be able to teach inquiry.

In the classroom, McFee suggested, there is no need to "lose" the fine arts. It's only a matter of "finding kids where they are—cross-culturally. If they are into TV, start there to get them where you're going." Wilson proposed an alternative: Bring something to kids that they *don't* have. Take them anywhere you want. Given enough time, they can focus on any area of art you wish.

· · ·

Recommendations
Research must be conducted to develop the theoretical foundation for a socio-cultural curriculum, so that this can be compared to DBAE as it is presently organized.

The explication of the DBAE disciplines needs to be updated.

Questions for Consideration
What art forms and what exemplars should be used in the classroom? Who develops the criteria?

With limited resources and limited time, how could a fifth discipline be added? Is there even time enough to give the teaching of art within the four disciplines a socio-cultural grounding?

Issue 3: Curriculum Reform

DBAE has features in common with some of the major curriculum reforms of the 1960s. Given the difficulties encountered with those reforms, what can be done to anticipate and deal with potential problems?

• • •

A Summary of
Ronald N. MacGregor's Address

MacGregor introduced his paper as a review of some past proposals for education reform, with notes on their strengths and weaknesses and suggestions for how their lessons might be applied to implementing DBAE. Taking 1960 as his dateline, he observed that the launching of Sputnik in 1957 delivered a jolt to North American pride and resulted in a series of proposals and programs successively "grasped, embraced, and abandoned" in following years.

Jerome Bruner's *The Process of Education*, published in 1960, offered what appeared to be a new direction that could answer current challenges. His approach to education presumed that each field of study had a distinctive structure, that learning takes a spiral form wherein ideas may be reintroduced at increasing levels of complexity, and that learning requires a professional attitude modeled on examples in the work place. Bruner's general thrust was toward scientific inquiry, though he believed that all intellectual activity was essentially the same, whether of the scientist or literary critic.

While Bruner was a proponent of struc-

tured learning, in practice he was led to multiple descriptions of structure rather than the single definition he was looking for. Two of these are cognitive structure (modes of organizing mental operations) and taxonomic structure (forms for information storage and retrieval).

Bruner never discusses art education specifically, but he suggests that curriculum planning should follow the inherent structure of the material, with attention to sequencing, the "psychological pacing of reinforcement," and "the building and maintaining of predispositions to problem-solving."

Bruner assumes that structure, though inherent, is observable by anyone. Taxonomies may differ, but knowledge grows when people pool their intellectual resources in a commonly accepted and more complete model. Art, however, is different. Like science it has its taxonomies, but the structures of art do not point to any one model that can mediate the differences between them. Teaching art, as John Dewey remarked, "is not the approximation of standards, but instead the explication of values."

Over the following decade, Bruner found evidence that learners' different values may confound an approach geared towards "impeccable" scientific ends. As educators (and many minority groups) came to realize during this period, structure-based programs are taught "by persons for persons," and unless students feel that their personal concerns are being

SPEAKER
Ronald N.
 MacGregor
University of
 British Columbia

RESPONDENT
D. Jack Davis
North Texas
 State University

taken into account, they rapidly become alienated from both the content of the program and the institutions that profess it.

Curriculum developers and educators put Bruner's ideas into practice in the early 1960s. Robert Mager's *Preparing Instructional Objectives* reduced the content of programs to a series of explicit steps aimed at focusing instruction on performance, and established a criterion for measuring results. MacGregor characterized this sometimes hilarious effort as proof of the problems educators faced when attempting to implement Bruner's model, leading some to "fractionate" Brunerian concepts into "series of explicit objectives and terminal behaviors."

While some educators focused on elaborating Robert Mager's competency-

Ronald N. MacGregor

based educational model, others wished to show that knowledge was not impartial but a commodity conferring power on those who controlled it. Informed by imported philosophies from Zen Buddhism to Herbert Marcuse, a number of educators challenged the enlightened mainstream pragmatism of Bruner and his followers with a variety of programs. These range along a wide spectrum, from the "conflict theory" of Michael Apple, who saw the educational process as a struggle to suppress the more anarchic individuals who may threaten power groups, to the "gentler reconceptualists," Pinar and Aoki, who advanced a theme of self-discovery and expression as a key to liberation from unauthentic influences. MacGregor noted that for both groups, critical praxis—the idea that theory must be embodied in action rather than remain abstract—was at once the goal and the means of achieving it.

Although admitting that the conflict theory has the virtue of limiting expectations to a realistic level, "meliorists" reject its extreme implications, believing that intervention can bring improvement. MacGregor stated that, like most protest movements, conflict theory focuses more on criticizing existing arrangements than on providing constructive alternatives.

The "reconceptualist" position differs from the others in that it sees the individual as an actor, not a conduit for knowledge. However, given the assumption that knowledge is created by individuals who control it for their own use, it is

difficult to see how increased individual awareness can lead to collective decisions, especially where education is concerned.

Curriculum theorists are used to telling teachers what to do, but they forget that teachers have their own agendas. In the class room, the transmission of ideas almost always involves some "translation." Some educators view the relationship of theory to practice as a dynamic interaction. Teaching is thought of as "knowing-in-action." The teacher "acts his mind," engaging in a process whereby situations are understood in the course of attempts to change them, and changed in the course of attempts to understand them. Teachers complement the theories of curriculum developers with practical knowledge, including knowledge of subject, curriculum, instruction, self, and milieu. While teachers may have knowledge of theory, theorists cannot have knowledge of the classroom without direct experience.

DBAE grew out of a model developed in the 1960s by Barkan, who acknowledged his debt to Bruner for an emphasis on the importance of teaching the fundamental structure of art, for the view that the activity of the artist and that of the beginning student differ in degree rather than in kind, and for the idea that "to learn through art, one must act like an artist." Barkan distinguished, where Bruner did not, between the formal structure of the sciences and "the analogic and metaphorical structures of the arts." The process of artistic work, Barkan thought,

revealed the existence of these intuitive structures. But MacGregor cautioned that well-articulated examples of the process will be difficult to find and introduce into the classroom as models for students; instead, teachers are likely to use local examples "or invite students to work out their own ideas of what artists do."

The use of structure-based models involves problems of structure identification and definition, and problems of preserving the structure through the process of implementation. Structure-dependent positions often lack flexibility; trying to bend them can result in dislocation.

The implicit warning for proponents of DBAE in the "indifferent record of competency-based programs" is that in elaborating the parts of art education, teachers and students may lose sight of the whole. The difference between "curriculum as planned" and "curriculum as lived" is what finally "writes the history of educational innovation."

Unlike both structurist and competency-based programs, conflict-theory models have never been adopted. Chet Bowers, for example, who sees values as expressions of social consensus that are subject to ultimate redefinition, has proposed a program wherein students would learn to take control of their own situations rather than accept given materials as absolute. Despite Bowers' Cassandra-like warning that there can be no change in society until students take an active role in shaping its direction, no school system has shown an interest in

DBAE MUST NOW
BECOME MORE
PARTICIPATORY AND
OPEN-ENDED . . . TO
ACCOMMODATE THE
NEEDS OF BOTH
CURRICULUM
DEVELOPERS AND
TEACHERS AND TO BRING
ABOUT THE BENEFITS
THAT ITS AUTHORS
HOPE TO SEE.

his proposals. At best, the influence of theorists like Bowers limits the tendencies of other planners to exercise too much central control of education.

The content of DBAE, like that of other current programs, is largely predetermined and conservative; it tells teachers what to teach and focuses on the aesthetic, rather than the political, properties of art. It seems unlikely that the program will be recast in political terms, except in the "modest political agendas apparent in local requests to include material of particular cultural, ethnic, or social importance."

What may have significant impact on DBAE is early acceptance of an active role for teachers in addition to that of curriculum developers, who should not be surprised when teachers implement the program with results contrary to expectations. Nor should they oppose the efforts of educators with no formal connection to DBAE to develop their own versions of the program. "Both forms of activity are healthy" and can contribute to the program's evolution. MacGregor cited the Orff method of music education as one example of a diversified program, adopted in variant forms by other groups, that yet retains "an official character."

Concerns about DBAE-sponsored programs that take local forms different from those outlined by leaders of the Getty summer institutes can be addressed by Schubert's notion of "curriculum ecology." Learning occurs in various milieus, within

and outside school, through "an interdependent network of curricula, planned and unplanned." An ecological approach to education recognizes this fact and uses the larger community as "a repository of artifacts for aesthetic contemplation and discourse."

MacGregor's own conceptual model for implementing and appraising programs resembles not the growth of individual organisms imagined by Bruner and Piaget, but the evolution of species as originally proposed by Darwin. Darwin's observation that variations within species are local and random parallels the view that "programs in action" develop according to local needs and opportunities. The claim that species diversify, passing on their essential character to the various subspecies, should reassure those who fear that the original aims of DBAE "may be diluted and lost as the program evolves."

Darwin's principle that "changes are most likely to occur where prevailing patterns have least influence" suggests that the authors of DBAE are in the least favored position to recognize a useful innovation. But meetings and conferences provide an opportunity for different voices to be heard, and MacGregor suggested that, in implementing DBAE, "geographic distance between an instructional centre and the more remote teaching situations may turn out to be a positive asset rather than a cause for concern."

The "clean cut" Tylerian model of

setting goals, devising programs, and evaluating outcomes, with its strict division of labor between those who conceive and those who implement, is misleading. Curriculum building is not static or simple; it is "messy, dynamic, interactive, and evolutionary." As Bruner observed, "each generation must define afresh the nature, direction, and aims of education."

The discipline-based programs of the 1960s have little in common with those of the 1980s, "because curriculum itself has acquired a new definition." Neglect of the interpretative role of teachers and students in handling material blunted the impact of the original programs. The "packaging" of contents and the failure to develop "visible examples of successful structure-based programs" reduced enthusiasm and brought the movement to a standstill. DBAE must now become more participatory and open-ended, MacGregor advised, in order to accommodate the needs of both curriculum developers and teachers and to bring about the benefits that its authors hope to see.

A Summary of D. Jack Davis' Response

Davis focused his remarks according to the stated purposes of MacGregor's paper: to review past reform proposals, to contrast their strengths and weaknesses, and to suggest how lessons learned from these proposals might inform plans for implementing DBAE. MacGregor imposed two parameters, one procedural, one substantive: He took 1960 as his starting date, and he undertook to separate the shortcomings of the materials themselves from those imposed by outside pressures.

MacGregor identified three models of educational change for examination: the Brunerian "spiral," the competency-based, and the conflict-theoretical curriculum models. His selections, descriptions, and discussions were excellent, and his comments linking Bruner to Piaget were "insightful and helpful." But Davis noted that MacGregor's view of the limitations on a possible consensus in art is based on a narrow definition of art itself; MacGregor's conclusion may be true for the making of art, but not necessarily for art history, aesthetics, and criticism.

Davis complimented MacGregor for his "succinct and articulate descriptions" of the spectrum of ideas ranging from the conflict theorists to the reconceptualists. But Davis took issue with MacGregor's description of the competency-based model, which Davis felt did not provide a balanced account of either the model or the literature associated with it. Admitting his

D. Jack Davis

the models' different strengths as inconsistent. Some are identified directly, while others are merely implied. MacGregor is better on the weaknesses, but his overall picture is biased and unbalanced, Davis said. The paper would have been improved by a straightforward assessment of his views on each model.

Another serious shortcoming of the paper is MacGregor's failure to identify curriculum materials for the models he discussed. No examples were presented for either the competency-based or the conflict-theory model. The use of actual examples and a consideration of both the theoretical basis of curriculum projects and their practical implementations—weighing successes against failures—would have enhanced the reader's understanding of MacGregor's conclusions.

MacGregor's thinking "was obviously ahead of his pen." Yet, despite the cloudy nature of his paper, in which assumptions must be made and conclusions drawn that are not evident, MacGregor did achieve his ultimate aim. "Indeed, the cautions he suggests are right on target."

MacGregor outlines five important cautions for DBAE. One is that "in elaborating the parts, teachers and students should not lose sight of the big picture." The gastronomic analogy to a recipe's ingredients is apt; the goal of DBAE programs should be to "prepare students to enjoy an aesthetic experience and not just eat art soup." Second, MacGregor

own interests and biases in this area, Davis held that Robert Mager's book represents only "a small facet of the total picture." Though MacGregor mentions Bloom, Krathwohl, and Harrow, his description would have been more balanced had he "recognized the roots of the model in the behaviorist theories" and the attendant emphasis on identifying and changing human behaviors through education. While behavioral objectives are often seen as the essence and focus of this educational model, they are in fact a means and not an end.

Davis saw MacGregor's presentation of

warned against too much centralized control, a warning which Davis feels cannot be underscored enough. Both students and teachers should be involved in shaping the learning experience, and Davis does not believe that working from a predetermined curriculum prevents this from occurring, if teachers are encouraged to be flexible. He agrees with MacGregor that early involvement of teachers in DBAE would help make this possible. While DBAE has mainly emphasized curricular content, "it has not suggested" that the nature of the learner or of the surrounding social situation should be ignored.

Davis felt strongly that MacGregor's third caution was his most important: "No one can corner the market in knowledge." A number of efforts prior to or contemporary with the Getty program are similar to DBAE—which should not be surprising when one considers the nature of art—and the possessive and protective attitude that many in the field perceive the Getty to have is potentially destructive. Yet it is to the Getty's credit that the DBAE concept is being so widely discussed. In its consideration of outside sources and alternatives, the Getty Center should take to heart MacGregor's concept of "curriculum ecology."

In MacGregor's description of his own model for implementing and appraising educational programs, his biological analogy provides a clear frame of reference for understanding his position,

from which he offers his fourth caution: "The authors of a program are most likely to stick closely to that script, and to be in the least favored position to recognize innovations that would advantageously affect its further development."

MacGregor's fifth warning is that "curriculum implementation must not proceed as though the curriculum were an inert body of material to be delivered like the morning's mail." Davis stated that his own experience confirms this observation and that he understands how easily curriculum developers "can become co-opted by this naive position."

MacGregor's "final message" was that if DBAE is to succeed it must "assume the character of curriculum as a participatory and open-ended activity," and Davis "could not agree more." He concluded, "We must not repeat the adage that history teaches us that history does not teach us."

BOTH STUDENTS AND TEACHERS SHOULD BE INVOLVED IN SHAPING THE LEARNING EXPERIENCE, AND . . . WORKING FROM A PREDETERMINED CURRICULUM DOES [NOT] PREVENT THIS FROM OCCURRING.

Issue 3: Small-Group Discussions

GROUP LEADER
Denis Phillips

PARTICIPANTS
Gilbert Clark
Rogena Degge
Margaret DiBlasio
George Geahigan
Sharon Hill
Anne Lindsey
Howard Risatti
Jean Rush
Jon Sharer
Mary Stokrocki
Dennie Wolf
Bernard Young

As with the first two issues, the presentations by speaker Ron MacGregor and respondent D. Jack Davis at a full plenary session were followed by concurrent small-group discussions, which included the reading of prepared responses by DBAE discipline representatives. At a later plenary session, group leaders reported the recommendations and questions developed by their groups. The discussion summaries below are based in part on these reports.

• • •

Summary of Prepared Response: Howard Risatti, Discipline Representative, Criticism

MacGregor raises important cautions regarding the structural nature of DBAE programs and the pressure to meet standards of assessment. He warns that without a sense that their personal motives and feelings are being considered, students rapidly become alienated; that competency-based programs may reduce or distort content to make assessment easier in the interest of "visible" political accountability; that DBAE content is highly predetermined and may be too inflexible; and that it focuses on aesthetic over social properties of artworks. If DBAE is to succeed, he says, it must be participatory and open-ended.

Risatti found MacGregor's points to be well taken, especially from the view of criticism; MacGregor's reference to the Tylerian sequence of curriculum development and implementation is particularly useful. DBAE should first establish purposes—articulating principles

of critical discourse and investigation. Next it should devise experiences for their attainment, which can be done by offering examples of the kinds of critical questions that can generate genuine critical discourse. Examples of how these questions may be applied will provide models for the development of the critical process.

We must *avoid* dictating answers to critical questions, so that students can learn to concentrate not on memorizing and believing in set meanings for art but on questioning these meanings. Further, "the desire to structure the critical process just to make assessment easier should be resisted at all cost." We should assess student performance by judging not the answers but the quality of questions. By leaving organization and assessment to individual programs or teachers, as Tyler suggests, we will reduce the temptations of total structure and inflexibility.

The advantages of this approach are many. Free questioning will lead teachers and students to relate artworks to their own experiences. Students need not be asked simply to memorize and repeat "data" provided by teachers. If content is *not* predetermined, the directions taken in the development of critical discourse can be shaped to particular needs. By using basic critical principles and models, content need not be limited in any way.

Because basic critical principles apply to all art, non-Western, non-mainstream, and ethnic arts can be accommodated in curricula. "Art criticism is not the same as

the history of Western art," Risatti said. Its teaching, therefore, need not focus solely on the major Western artists. Nor does this mean that the results will be unpredictable; the aim is simply to enable students to discuss a variety of visual images critically.

Furthermore, the proper critical questions need not focus solely on aesthetics at the expense of social and other issues. The artworks selected for study can be related to other curriculum areas—literature, history, environment, government—and some of them can reflect the special social and ethnic issues of that particular school. Far from causing deterioration of the critical process, discussion of local issues, trends, and objects can enhance the process, making it more vital and professional by bringing a student's knowledge of his local environment to bear on objective critical questions.

MacGregor is right to suggest that aesthetic issues do not exhaust the meanings of art, nor, Risatti added, the meanings of visual images in general. The danger of restricting the critical process can be avoided "by not being intimidated by the discipline of art criticism," by recognizing that we are all critics in that we question and judge.

Discussion
"I suppose the discussion was haunted by the ghost of Elvis Presley and the spirit of the sixties," said Denis Phillips. At various points, each participant drew his or her own particular moral from what had

happened to a favorite curriculum reform movement begun in that decade. Everyone was trying to decide what had been learned, if anything, from the eventual fates of other interesting attempts at educational reform.

Phillips saw his group divided. About half the participants held the view that a movement which has a core philosophy has to guard its boundaries. "If the people who are fighting a revolution give up what they are fighting about, then they end up fighting about nothing at all," he said. As Margaret DiBlasio put it, "alternatives *of*" and "alternatives *within*" sometimes drift to become "alternatives *to*," and people in a revolutionary movement have to bear that in mind.

Looking at the sixties, however, one sees numerous curriculum developments—new math, for example—whose proponents tried to hold the line on a tight body of doctrine. Poor teacher preparation and support resulted in pandemonium. The feeling was that, particularly at the beginning of an innovation, teachers need a fairly detailed script because unless they have been centrally involved in planning and design, they won't know what to do. DiBlasio said that in her area teachers are given a curriculum model and asked to commit to it for two years. She finds teachers *eager* for such curriculum guidance. They tend to alter or abandon a curriculum only if they are not properly prepared and supported. In-service training, support groups, mentor teachers,

networking—all were considered very important by the members of the group concerned about "protecting the core."

Proponents of this view also felt that although it was important to defend the boundaries, that does not imply that a single kind of curriculum should be imposed on people. There might be four or five alternative curricula that could embody the principles and virtues of DBAE. George Geahigan expressed the view that this is currently, and always has been, the case with DBAE. There is a centralized decision-making process, and DBAE is held together like a federation of different but related models.

The other position—one that was closer to MacGregor's views, Phillips said—was the evolutionary approach, the idea of DBAE imparting its basic philosophy and principles to teachers and then letting them get together locally and decide how to apply those principles in their own context. Here, the problem is that there may be considerable drift. The end may not look anything like what proponents had in mind at the beginning. But Dennie Wolf brought up an example of a curriculum reform movement in another field that has been very successful in recent years *without* a centrally mandated curriculum: writing. All compostion teachers have is a set of basic principles and assumptions, and the programs operate differently—and successfully—in different parts of the country.

The discussion later shifted to another theme: The reforms of the sixties attempted not only to restructure content but also to revamp pedagogy substantially. For example, the science curricula had to be taught in a completely new way. Some in the group felt that DBAE, if it is to be done well, will involve a number of skills that will be unfamiliar to many teachers. That led to discussion of the need both for documenting what the new skills are and for covering those new skills in the in-service training. The perception was that, to this point, more effort has gone into the content.

Jean Rush said that she was impressed by the enthusiasm that teachers have demonstrated on behalf of discipline-based art education, and she felt that this distinguishes DBAE from many prior reform efforts. Rush wondered *why* teachers are so enthusiastic, and she suggested that it might pay to ask them.

• • •

Recommendations
Careful attention should be given to pedagogy, particularly to teachers' concerns at specific levels of implementation.

There is a need for more direct experience in observing successful model programs in action in classrooms. This need can be partially met by video-taping model programs for distribution to teachers.

Teacher education must include whatever new skills will be needed to teach the innovations.

Summary of Prepared Response: Derrick Woodham, Discipline Representative, Studio

The antecedent curricula mentioned by Ron MacGregor were not familiar to Woodham, he said, and he did not feel that MacGregor had clearly identified the specific difficulties. But he acknowledged that MacGregor made several unique comments regarding the organization of DBAE which could improve its chances of acceptance and success.

Among these were the suggestions that DBAE should be a comprehensively sequenced curriculum; that it should test for observable achievement of objectives; and that it should recognize the variety of applications that could evolve in different communities, without losing sight of the whole.

Woodham felt that the following two points which MacGregor made were deserving of particular attention:

1 DBAE must retain "a permanently open window" on each of the disciplines, preserving a relationship with current practice.

2 Those most likely to remain close to the program—to find it difficult to distance themselves from DBAE in order to evaluate its effectiveness—are the program's authors.

Discussion

One of the group's recommendations for strengthening DBAE was discussed at length in several different contexts, and it became a kind of "thematic thread" throughout the discussion, said Nancy MacGregor. This was the feeling that there is a need to redefine the traditional role of the art specialist in the schools, that to strengthen the DBAE concept the art specialist will need to be placed in a leadership role. This recommendation, introduced by Jack Davis, has curriculum implications at both the pre-service and the in-service level.

There was a lengthy discussion on the notion that there are alternative theories for art education—alternative sets of ideas—and that it might be to DBAE's benefit to advance some of these alternatives instead of trying to embrace them in DBAE itself. This, too, might have curriculum implications—as the ideas are played through in order to trace the parallels and divergences of one set of ideas against another, rather than trying to embrace them all within a single notion of art education. In DBAE, Dwaine Greer observed, the Getty Center has given the field an alternate view of art education that is changing how people think about art. Now proponents of DBAE might benefit from studying other alternatives as well.

Another idea—and it was felt that this will begin to take place as institutes are developed and more district-wide programs are implemented—was the need for more choices *within* DBAE. Decisions should be based on the fundamental principles outlined in the program, but curricula could take different shapes.

GROUP LEADER
Nancy MacGregor

PARTICIPANTS
D. Jack Davis
Jane Maitland-
 Gholson
W. Dwaine Greer
Robert Russell
Jon Sharer
Brent Wilson
Derrick Woodham

Robert Russell noted that Ronald MacGregor used curriculum in more than one sense, and it was Russell's suspicion that most people did not see the shift in meaning. MacGregor used curriculum to mean a program as well as a plan which gets implemented. Russell's view is that curriculum is ''a structured series of intended learning outcomes,'' which leaves instruction and curriculum planning as separate considerations.

Dwaine Greer's concern was that curriculum materials make sense to the teacher. If so, they will be adopted and used consistently. If the curriculum is not consistent, it won't work in implementation, and the teacher will abandon it.

• • •

Recommendations
The traditional role of the art specialist in the schools must be redefined. The art specialist must be given a leadership role.

It might be to DBAE's advantage to advance some of the alternative theories for art education, rather than trying to embrace them *within* DBAE.

Summary of Prepared Response: Kristi Nelson, Discipline Representative, Art History

Nelson concentrated on three of the points raised in the second half of Ron MacGregor's paper: the different interpretations of DBAE, the use of local resources, and the preparation of teachers. Though these areas "may all be interdependent," Nelson discussed them separately, looking for the salient features in each.

Nelson noted that DBAE presumes a written program for each of its four disciplines; thus it is essential that this curriculum be well designed, that it be strong enough to accommodate interpretation by sensitive and intelligent teachers. Different contexts—the children being taught, the characteristics of the local school or community, and the availability of resources—will require some adaptations. To allow for flexibility, the goals of DBAE "must be clearly articulated and meaningful, and the efforts made to achieve them must be satisfying." Art history is rarely taught below the high-school level, though introductory texts now exist. At all levels, then, a major task for DBAE curriculum writers is to develop a program that is worthwhile, meaningful, and flexible so as to be adaptable to a variety of educational contexts.

If teachers are to take advantage of DBAE's flexibility, then teachers must be able to utilize local resources effectively in implementing the curriculum. In some instances, as MacGregor noted, local agendas will require the inclusion of materials of cultural, ethnic, or social importance. Local resources, including museums, galleries, architectural sites and monuments, public sculpture, and locally-produced crafts, as well as artists, historians, and critics in the area, can expand and strengthen the curriculum and should be "tapped" to best advantage. All can be integrated at various levels into a thoughtfully implemented DBAE program.

Curricula are only as good as the teachers who implement them. For DBAE to succeed, teachers need to be capable and their preparation thorough, sound, and appropriate in DBAE's four areas. With respect to art history, teachers need to know more than just what it is. They need to develop a "sense of history itself." They require professional training, experience in the field, and exposure to different practical methodologies. They should be adept at dealing with extrinsic and intrinsic modes of art instruction and inquiry, and be able to understand "integrative art history," through which internal and external modes are applied in combination in order to reconstruct the original context of works of art.

Those in charge of school programs must view the study of art as basic and essential to children's educational development. The study of artworks develops creative, mental, conceptual, and visual skills, helping children to understand their own and other cultures. This is vital to our existence as human

GROUP LEADER
Hilda Lewis

PARTICIPANTS
Michael Day
Kerry Freedman
Judy Koroscik
Ronald MacGregor
Kristi Nelson
Michael Parsons
Maurice Sevigny

beings and to our understanding of ourselves and our culture.

Discussion

What happens when a program developed and tried out in Los Angeles is then "transported" to another community hundreds of miles away? This was one of the major concerns of the group, because teachers who are given a program in which they have no input tend not to make it their own.

Hilda Lewis gave the example of a brand of cake mix that the consumer "made" simply by taking it out of a box, adding water, and baking it. The brand was rejected because the person who baked it could not make it his own. So the recipe was changed—"which they didn't have to do from a chemical point of view"—so that the home baker got to put an egg in the batter. Sales improved immediately. The same thing needs to happen in a curriculum which is developed in one place and then implemented in another. There has to be some allowance for local input, the group felt.

It was observed that the teachers who are already in the field most likely never expected to teach discipline-based art education. Typically, they are well-prepared in studio but not in the other areas. Some adjustment in their training and in the preparation of future teachers will be needed. The group discussed at length how this tends to cause dislocations within institutions of higher learning: it means that certain courses will lose enrollment,

others will gain, and new courses will be requested. Thus, as DBAE's requirements for teachers are adjusted, teacher training institutions will have to respond accordingly.

At the same time, other, major changes are taking place in teacher education. More states are expected to follow the lead established in California, where teacher education takes place largely in the fifth year, after the bachelors degree is earned. This means that the content which students have been getting in their undergraduate work will have to be moved into a fifth-year program. The positive side of this is that the students are more mature; but they will have difficulty fitting in the range of courses that would prepare them adequately for a DBAE approach.

Another issue discussed by the group was the question of how flexible DBAE can afford to be. How far can people in local communities be allowed to go, in accordance with their particular needs and desires, before what they are doing is no longer DBAE? Are the boundaries of

DBAE fixed and impermeable, or are they flexible? Everyone agrees that if change goes beyond a certain point, the result is no longer DBAE, but where is that point? Maurice Sevigny asserted that there is a strong need for overall flexibility. The issue of ownership (of the definition of DBAE) is a serious problem, he said, making us "uptight about changing the concept."

The point was made that we need to have a clearer understanding of what DBAE is. What classroom materials fit in with the concept of discipline-based art education? "Essentially what we were saying," Lewis said, "is that proponents of DBAE need to give the field a clearer idea as to what kind of flexibility is permissible, so that we'll have a greater sense of security, knowing that we are on the proper track."

Another issue raised was the question of integrating art with other curricular areas in the schools "and whether this can take place under the umbrella of DBAE." The most logical place for integration, it was suggested, is social studies, where a great deal of art-historical material can easily be introduced. "Students are going to be doing social studies anyway, and teachers are hard-pressed for time to work in the arts. Why not merge these two areas and use the social studies as an additional opportunity to learn something about art history?"

Aesthetic scanning was discussed in terms of means and ends. The point was made that aesthetic scanning is a means by which teachers can engage children in looking at works of art. It keeps them engaged long enough to notice certain qualities of significance about it. But it does not deal with everything. There is much more to be seen in a work than can be taken in through the scanning technique. It should be used as the beginning point but should not constitute the entire process of working with children in the visual arts.

• • •

Recommendations
A clearer understanding of what DBAE is, and is not, is needed.

DBAE must make some allowance for local input.

• • •

Questions for Consideration
How far can people in local communities be allowed to go, in accordance with their particular needs and desires, before what they are doing is no longer DBAE? Are the boundaries of DBAE fixed or are they flexible?

Can art be integrated with other curricular areas? Can this take place under the umbrella of DBAE?

GROUP LEADER
Mary Erickson

PARTICIPANTS
Carmen Armstrong
Margaret Battin
Stephen Dobbs
Arthur Efland
Louis Lankford
Lois Petrovich-
 Mwaniki
June King McFee
Richard Salome
Jeffrey Seibert
Marilyn Stewart
Karen Thomas
Enid Zimmerman

Summary of Prepared Response: Margaret Battin, Discipline Representative, Aesthetics

During his discussion of several previous attempts at curriculum reform, Ron MacGregor alluded to two "bad-case scenarios" for DBAE. Although he doesn't address them in a direct way, Battin said, they are "something that I smell smoking at the bottom of this paper."

First, MacGregor fears that DBAE may be "a kind of Cassandra," doomed to be tolerated without being taken seriously. As with any Cassandra, although there might be a cautionary influence on planners, the advice would not be acted on.

Second is his fear that DBAE, however well-intentioned and well-conceived at the beginning, may become so inflexible "that it undermines that set of intuitions and sensitivities which it was designed to enhance," with the authors of the program sticking too closely to their script and failing to recognize beneficial innovations. In other words, "it may be the architect of its own downfall."

The downfall of any program paves the way for its opposite. What follows is generally a response to what are seen as the first program's inadequacies. Thus a poorly conceived or poorly executed program may invite the opposite of what it was intended to produce.

DBAE may of course be welcomed enthusiastically and taken up by everyone, flourishing without serious criticism far into the future. This is *a* best-case scenario.

But what is *the* best-case scenario? To answer that question, we have to pose a prior one about what a curriculum is for in the first place.

MacGregor's paper identifies nine features of previous curricula and alludes to their purposes. A curriculum is: 1) an aid or convenience to teachers; 2) an agent of social change; 3) a strategy for international competition; 4) a basis for expectations about what students know that is of value to society; 5) a facilitator of social interaction; 6) a device for maximizing potential in children; 7) a compensator for social inequalities and prejudices; 8) a promoter of self-discovery; and 9) a protector or promoter of the given subject matter.

Contrast the last of these with what you find in business school, said Battin. There, you don't find anything resembling reverence for subject matter. A business school curriculum seeks to enhance the aggressive, financial, and strategic capacities of students.

The question here, given the variety of views about curricula, is what exactly is DBAE's background rationale? In other words, "For whose benefit is DBAE supposed to be?" Battin identified four principal candidates: the child, the teacher or school system, society, and the subject matter itself. These four, she said, are not necessarily mutually exclusive. But any curriculum closely examined will betray a fundamental allegiance to one of them. Which one is DBAE serving?

DBAE is "advertised" as a benefit to children. Teachers are its allies, but the program is not designed primarily with their interests in mind. DBAE concerns itself with social benefits as well. But "my real hunch," said Battin, is that it was developed "out of a reverence for the subject matter itself." Art and its transmission are taken by the Getty Center to be of primary importance.

This conclusion leads to further questions of what art is today and what will count as art in the future. Why is it important? Why does it deserve this kind of respect? What would happen if we didn't have it? What is its role in society? DBAE in essence views the individual (the child, the student, the adult) as "a carrier of tradition." This is the underlying rationale, and it leads us to think in a slightly different way about the needs of its curriculum.

Battin acknowledged that DBAE may be perceived differently by others, but the question of whose interests a curriculum promotes must still be asked.

In closing, Battin commented on the relationship of these issues to aesthetics. Aesthetics concerns itself with what we say and do in respect to art. Being more theoretical than practical, it is not a discipline that gives much thought to teaching art. But it can pose important questions: What is it about art as a subject matter that deserves transmission in a specially-designed curriculum? What is its value to begin with? Is it good because it gives us pleasure, or for the sake of some

other intrinsic value it possesses, independent of whether we enjoy or profit from it? "These are quite different views of the value of art," said Battin, "and attention to these questions is part of the necessary background for DBAE."

Discussion

Mary Erickson's group focused primarily on several historical questions—"lessons we can learn from the history of reform in curriculum."

A question was raised by Arthur Efland with regard to MacGregor's account of the sixties and seventies. Efland felt that MacGregor had confused "the accountability movement—which seemed to follow in the wake of that discipline-centered movement—with the discipline-centered movement itself." In Efland's view, the discipline movement of the sixties should be seen more separately from the behaviorism movement of the seventies.

The Ohio State University summer institutes were suggested as a historical precedent for institutes and their effects on staff development and curriculum reform. Stephen Dobbs pointed out that different institutes, including the Utah seminar coming up, attack the problem of teacher education from a completely different perspective than do the Getty Center's summer institutes.

There was talk about whether or not there has been effective dissemination of the concept of DBAE through the educational system and other networks—

ALTHOUGH MANY TEACHERS KNOW ABOUT THE SIMPLE NOTION OF DBAE, THEY DO NOT NECESSARILY KNOW WHAT TO DO ABOUT IT.

for instance, the state departments of education. On the other hand, Marilyn Stewart observed that DBAE "notions" are making it into the popular press. Brent Wilson cautioned, however, that although many teachers know about the "simple notion" of DBAE, they do not necessarily know what to do about it.

Another concern was the fact that teachers are out of date, according to June McFee, after five years. Curriculum changes more slowly than society itself. Anticipating the momentum of social change and building an accommodation for change into the DBAE structure is difficult but essential.

The group also talked about, in Erickson's words, "the ebb and flow of enthusiasm in curriculum change." This was in line with Battin's inference of worst-case/best-case scenarios in MacGregor's paper. The question was: Where is DBAE in the ebb and flow of history, and where will it be by 2010? If DBAE arose as a reaction to "the creativity, self-expression stuff," what will be the ultimate reaction to DBAE? Is there anything we can do to control that?

• • •

Recommendations
Develop means to get more information out to the field about improving art education. There are people who, even without funding, would listen in order to improve.

The input to teachers should be nonjudgmental, noncontrolling.

DBAE should not be so reactive to the "creativity movement" that it discourages creativity.

• • •

Questions for Consideration
If we really are "a pendulum society that goes pro and con and pro and con," is there any way that we can predict, and have some control over, what will follow DBAE?

Can we maintain a core— even an evolving core—for DBAE and, at the same time, *plan* its evolution?

Responses to Group Summaries and Recommendations

In subsequent plenary, the groups leaders' discussion summaries and recommendations were followed by a brief open forum. Leaders and group participants elaborated on the summaries, and members of the various groups responded to each other's discussions as reported. The session began with comments from the seminar director.

• • •

Hermine Feinstein said that one of her major concerns was the "very difficult and thorny" topic of exemplars of good design. "If you're going to have art education students making choices, if you're going to have elementary-school teachers making choices, then it seems to me that they had better *know* the principles and elements of visual organization." She said that in teaching industrial design students, she has discovered that they do *not* know how to argue for good design. "What are the exemplars? What are the criteria for choosing them? And who is going to assign the use of a particular piece?"

Her other concern was a fear that "somewhere along the line we're going to lose the fact that we're dealing with art forms." With regard to the art-social context issue, she asked, "Are we dealing with, say, two-thirds art object and one-third social context, or is it the other way around?" Her fear is that there we may "slip" toward overemphasizing the socio-cultural perspective.

Brent Wilson observed that the discussions seemed to focus on such specific concerns as whether to add a fifth discipline or to incorporate social content into the four established DBAE disciplines. "We're looking at the means to something rather than the end, and we really do need to spend some time talking about what in the world is it for." The only justification for having students work in the disciplines is if it leads them somewhere. "If we simply determine where we want them to go, then a lot of the arguments would begin to take their place in the background."

Mary Erickson, concurring with Wilson, said, "The goals of DBAE apparently are not very clear." Her group talked about numerous practical and pedagogical issues, and from this arose the questions, "Does DBAE have a pedagogy?" and, "Is there to be a 'national curriculum' or many curricula?" Although admitting that she was dealing with several different issues, she felt that "the goals tie them together."

Feinstein's response was that "when we talk about rationale and goals, the overarching rationale is for students to be able to make literal and metaphoric meaning in visual forms. That's the whole reason for teaching the visual arts."

But *Erickson* saw this as a question of whether "the goals come out of the content—the discipline—which I'm not at all sure they do." In her group, the first debate was prompted by Michael Parsons' contention that an overarching goal for discipline-based art education was to choose what is taught within the disciplines on the grounds of enhancing

aesthetic understanding. Yet it was felt that McFee was proposing goals other than aesthetic understanding.

Kerry Freedman reported that she had learned from the small-group discussion that all four DBAE disciplines are apparently becoming more social. She had also learned that there seemed to be a distinction between understanding the social and cultural aspects of art and understanding art as a way of becoming more humanistic. "I see those two areas as talking at cross-purposes sometimes."

June McFee stated that, in her view, what is important is to realize that "both kinds of things are going on." We need to be clear that art has social meaning "and that it also has a social end, in terms of groups of people." Regarding Feinstein's concept of design, McFee pointed out that "design *is* culturally based, and that maybe there are some aspects of design that are universal." In any case, the question has not been addressed, McFee feels, and needs to be.

Maurice Sevigny's concern was that "always trying to accommodate more and more is only going to water down the orientation."

Hilda Lewis said she felt that the willingness "to agree to disagree" was all to the good. "I think the purpose of this meeting was to identify and discuss issues, not to reach conclusions," she said.

Director's Comment: Hermine Feinstein
After the open forum, Seminar Director Hermine Feinstein commented on "the positivist approach versus the phenomenologist approach," which she described as "basically very, very different positions." Positivists, she said, would hold that the subject matter—content and sequence and scope—is more important than the student, the society, and so on. The phenomenologist would hold that the students' *experience* of the subject matter is more important. She admitted that she was making the dichotomy more "black-and-white" than it might actually be; she and most of her colleagues, she said, are probably somewhere in the middle, leaning toward subject matter. "But I think it's important as educators that we think about where we are. Do we in fact think we *have* a subject matter, and is it worth teaching? Then let's teach it."

Issue 4: Boundaries of DBAE

Given that the dissemination of knowledge in schools is governed by pedagogical, regional, and political considerations, to what extent can those considerations be distinguished from the conceptual core of DBAE?

• • •

A Summary of Brent Wilson's Address

Wilson distinguished three varieties of discipline-based art education programs: "name brand," "generic," and "populist." He said that the future of art education will be profoundly affected by our grasp of similarities and differences among them, especially the differences in their origins, and by our ability, in practice, to balance their strengths and weaknesses.

"Name brand" DBAE, represented by the Getty Center program—with its emphasis on the four disciplines of studio art, art history, art criticism, and aesthetics—is a "direct descendant of the 1960s curriculum reform movements in art education." It involves a written, sequentially organized curriculum centered on works of art that is implemented jointly by administrators and teachers and adhered to by all who teach art in an entire school system. In practice, however, DBAE "carries a heavy load of traditional art educational baggage," which is why it needs to be examined in light of both the older "generic" forms of disciplined art education and the always-present popular varieties.

The roots of the generic form of disciplined-art-education are not so easily traceable as those of DBAE. A theoretical grounding was outlined by Barkan, Chapman, and Kern in their aesthetic education *Guidelines* (1970), prior to which similar ideas had been discussed by a variety of educators. But where did these ideas come from? Wilson quoted Roland Barthes' metaphor of the mythical ship *Argo*, whose parts were gradually replaced during the long quest for the Golden Fleece until "by dint of combinations made within one and the same name, nothing is left of the origin." Art education, like Jason's ship, is "a vessel without a creator." Its goals and contents form a structure "made by no one or by everyone." New statements and theories of purpose and practice seem original but really represent "recombinations and extensions" in a preexisting structure of ideas.

The basic formulation of today's instructional art history and critical disciplines may be found in the "Picture Study" movement of eighty years ago. Wilson (1904) and Casey (1915) did "a marvelous job" of relating works of art to literature, and to historical and social contexts. The studio practices relating to drawing, painting, and design that are now part of DBAE also have early precursors. Indeed, "the creative expression movement that some proponents of DBAE view as the enemy was firmly entrenched long before Lowenfeld arrived." A combination of circumstances helped this brand to obscure these others, whose virtues are now being asserted by new proponents.

SPEAKER

Brent Wilson
Pennsylvania State
 University

RESPONDENT

Rogena Degge
University of Oregon

Brent Wilson

Much less disciplined than these, but ignored at our peril, is the enormous core of "populist" practice. Art educational practices relating to various school-art traditions (folk-handicrafts, holiday art, popular-arts, design, decoration, etc.) passed down through generations of teachers often bear only a slight relationship to the goals that have been proposed for nearly a century by the leaders of art education. This populist-based school art is not unresponsive to change, but theoretical trickle-down is minimal because frontline practitioners do not have access to the professional literature. New ideas are nibbled at by "this amorphously shaped, essentially non-ideological behemoth of folk practice" and thereby lose distinct identity. But once they become part of popular practice they have a very long life indeed.

"Theories seldom specify the intricacies of practice," Wilson cautioned. In the absence of specification, populist practices

may be incorporated into reform programs despite their basic incongruence. DBAE is probably threatened in this way. Vigilance is needed to protect against "a new package design" containing "a timeworn, ineffectual product."

Both the generic and the name-brand versions of DBAE emerged under occasional stress. Wilson again invoked the Barthes metaphor in comparing educational innovators to the crew of the *Argo,* who were "drawn to the parts of the *Argo* that needed renewing. While some parts were replaced, others were ignored." The generic disciplined art education movement of the 1960s grew out of the general educational reforms inspired by the success of the Soviet Sputnik program. Name-brand DBAE is partly an outgrowth of that failed reform movement and partly a response to the "current conservative call for attention to the basics."

Moving to specific analysis, Wilson noted that name-brand DBAE's prospects for success depend on how well its advocates work cooperatively with those of the generic model, and on how both deal with "the behemoth of populist art educational practice."

He addressed three problem areas in educational reform: pedagogy, politics and ideology, and regional factors.

Pedagogical Issues and Problems
In theory, Wilson said, name-brand DBAE holds the promise of genuine and pervasive reform in art education. Many

populist recreational and decorative practices might be replaced by more directed art activities. Further, because DBAE is based on ideas largely accepted in the field, it enjoys considerable advance support. Its initiatives are based upon "comprehensive insightful inquiry," and it recognizes that reform requires assistance from administrators and advocacy groups, as well as written, sequential curricula and teacher education.

But the transition from theory to practice has been difficult, partly due to opposition from two groups of educators. Populists and other proponents of studio-based creative expression fear that art practice, which they believe to be the essence of art education, will be diminished. They also sense that they will be expected to teach art criticism, art history, and aesthetics—disciplines for which they may be poorly prepared. A more subtle but equally serious problem is the disappointed reaction of some former advocates of the generic disciplined approach to the working model of DBAE in Los Angeles County. While acknowledging its many promising advances, they nonetheless perceive it to have serious flaws.

Indeed, there are grounds for criticism; one in particular "symbolizes the theory-into-practice difficulties" faced by those who favor DBAE. High expectations have been raised, but despite summer training institutes and other development programs, DBAE teachers remain ungrounded in basic art disciplines. Reliance

on aesthetic scanning as a method of instruction for both teachers and students raises doubts about the level of appreciation being inculcated. Advocates claim that scanning opens students to potentially deep dimensions of experience, but it can also be merely a seductive and trivializing activity. Some features of art cannot be reduced to a scanning procedure.

Are there any worthwhile shortcuts to a pedagogically sound disciplined art education program? Is there a longer route that could adequately prepare teachers in the disciplines? If not, if DBAE offers more than it can deliver, perhaps the theory should be modified to conform to the realities of practice.

Politics, Ideologies, and Conflicts of Interest
The political aspect of art education involves the attempts of individuals to get their ideas situated advantageously in relationship to the ideas of others. Proponents of DBAE have carefully distinguished their brand from the others, while advocates of generic disciplined art education think that DBAE should incorporate the best aspects of child art and creative expression. Opinions vary as to the ultimate goal of art education in general: acquisition of skills, increased social consciousness, broadened world view, or heightened aesthetic experiences. The best means to education's ends are debated as well.

But these issues can be seen in the light of a larger and more profound issue: the

INSTRUCTION IN ALL FOUR DISCIPLINES IS NOT REALLY THE GOAL BUT THE MEANS THROUGH WHICH AN EDUCATIONAL IDEAL MAY BE ACHIEVED.

"paradigm shift" in the philosophy of art, from modernism to postmodernism. Originality, for instance, is now being philosophically discounted as an artistic imperative. Out of this is coming a realignment of assumptions about the importance of artistic style and whether apprehension of aesthetic qualities is the essential ingredient of art experience, along with debate about the philosophical foundations of art history and criticism. The emergence of a fresh intellectual paradigm in art and art education adds a new ideological ingredient to the debate about DBAE, whose intellectual ideals are post- and pre-modernist, while its aesthetic theories and practices are essentially modernist.

Given these conflicting ideologies, how should DBAE advocates respond? These conflicting ideologies may mean that pressing for ideological purity will limit the appeal of DBAE—which hopes for wide acceptance—to a small group associated with the Getty Trust. If it is to be more broadly accepted, it will have to incorporate a variety of views about the nature and purpose of art education, despite occasional contradictions and the dangers of programmatic incoherence or weaknesses resulting from intrusions by other brands of art education. DBAE will be stronger, more valuable, and more widely accepted if it is allowed either to include the best features of its generic predecessors or to develop into "a variety of acceptable name-brand forms."

Regionalism and the Special Teacher of Art

The various states and regions in the U.S. have developed very different educational practices, and programs designed for one part of the country may not function well elsewhere. In the East and Midwest, art instruction is generally the province of special art teachers. DBAE's working model in Los Angeles County has to date involved only classroom teachers, and teachers in other regions see the program as having little or no application to their school systems. They further fear that DBAE may actually reduce the number of special art teachers in their schools.

Through regional institutes and pilot programs around the country, DBAE could be adapted to a variety of delivery systems, including one that would include joint instruction by art specialists and classroom teachers. Such a program would combine the best aspects of disciplined art instruction with DBAE's broader educational concerns. But rather than giving even the hint that art can be taught without art specialists, Wilson strongly urged DBAE and disciplined-art advocates to work toward the appointment of an art specialist in every school of the nation.

It will be difficult to instigate change in a field in which the majority of practitioners belong to no professional association, in which few school systems have a discipline-based leader, and in which new information travels slowly. In addition, some proponents may be too intent on maintaining the balance between DBAE's

four discipline areas without sufficiently defining the central core of DBAE: the goals of art education. Instruction in all four disciplines is not really the *goal* but the *means* through which an educational ideal may be achieved. Aesthetics is still a weak area for many art teachers, for example, and it may be presently unreasonable to insist that aesthetics be on equal footing with the other DBAE disciplines.

Further, though art teachers have much to learn from specialists in all the art disciplines, "when it comes to pedagogy, *we* are the experts." We ought not relinquish our responsibility as mediators between students and art specialists.

It is also true that no amount of persuasion and advocacy will bring about a general reform of art educational practice. Only a concerted top-down effort on the part of all the agencies that regulate and monitor education on the federal, state, and local levels can accomplish such a goal. Most school administrators will not establish broadened art education programs unless a mandate comes from above.

Wilson stated that he is a strong proponent of disciplined-art education, an outspoken critic of the populist variety, and a cautious supporter of DBAE. He described DBAE as a "product" that could have a profound positive effect on art education if its ingredients are tested for validity and marketed with the needs of its consumers in mind. For better or for worse, he concluded, we will all have a hand in the building and rebuilding of the *Argo*.

A Summary of
Rogena Degge's Response

Beyond the useful distinctions which Wilson made between name-brand, generic, and popular art education, Degge noted one point on which he did not elaborate: "Having instruction through the four disciplines is not a *goal* for art education, it is only a *means*." The means/goal distinction illuminates Wilson's pedagogical concerns regarding the trivializing of art, for which he gives aesthetic scanning as one example.

Aesthetic scanning is a system, not a goal. It is a means intended to help students apply skills which can enable them to discuss design and other expressive properties of art. We certainly do not want children to learn about only the "easy" or "trivial" aspects of art; nor do we want to imply that "design-based

Rogena Degge

MANY MORE MODELS ARE NECESSARY IF ALL DISTRICTS ARE TO DEVELOP APPROPRIATE AND ACCEPTABLE VERSIONS OF DISCIPLINE-BASED ART INSTRUCTION.

concepts" are the most important aspects of art education. But unless the goals are clear, misunderstandings are inevitable.

Like the *Argo,* DBAE is "a vessel of means" or content. But unlike the *Argo,* with its clear destination, art education does not sufficiently clarify the distinction between vessel and destination and tends to be seen as the sum of its discipline-based parts. DBAE is not a Golden Fleece, but it *is* "a seaworthy vessel," and it can carry us to many worthwhile ports, though these may differ according to pedagogical, political, regional, and cultural priorities.

Recognizing DBAE as a *means* permits elaboration on a variety of model curricula reflecting not only regional and political differences but also those we call "essentialist, socio-cultural, and perceptual," among others. Each model can be developed and extended with the appropriate content. Development of such models has already begun, although they should be viewed as highly experimental and should be critically examined from a range of perspectives.

Those who would reform art education must confront three related challenges. One is to help local curriculum developers clarify their goals; even if the goal is mainly to develop students' appreciation of art, something more must guide the shaping of content, whether socio-cultural, essentialist, or some other special thrust. A second challenge is to ensure that program content reflects local cultural values. Third, when unfamiliar curricula are introduced

into a community, school system, or classroom, trivializing or misleading instruction must be avoided.

Until teachers and "citizens" receive a better education than the current institutes are providing, and until there are diverse model curricula and guidelines based in research that can promise greater flexibility in terms of regional relevance, reception of DBAE will be difficult and slow, Degge said.

Changes of the nature proposed by name-brand DBAE must be, finally, a local matter. But if discipline-based art curricula are to be more than the repackaged popular brand, we must develop meaningful frameworks for structuring viable art education goals. Many more models are necessary if all districts are to develop appropriate and acceptable versions of discipline-based art instruction.

Through carefully focused research under various models, we may learn how to effect the desired changes. But from the outset we must see the disciplines as a means, and hold out for the larger goal of art education as a method of advancing our own humanity and that of our civilization as a whole.

Questions to Speakers from Participants and Guests

Ronald MacGregor

To generate dialogue, I would like to make four points.

First, it seems to me that we're at a very interesting point in the development of DBAE, in that we've almost reached a point where there will be a significant shift from what I might call a "proximal" model, with a rather local, Los Angeles-based program, to what I might call a "distal" model, with people in other parts of the country getting involved. And in order for that transition to occur, a whole different set of strategies is going to have to be adopted to monitor the progress of the program and to insure that there's continuity.

Second, in thinking about alternatives, I do not see that this necessarily should affect the direction that has been taken by the originators and developers of the DBAE program to date. Denis Phillips yesterday used the word "permeability," which I think is a superb word to describe what I anticipate for the next stage of the process. The model as developed goes ahead, and ideas that come from outside the framework of the model become assimilated through that permeable wall that surrounds the model. Obviously, if a model is going to have any authenticity, it does have a structure and it does have boundaries; but it need not be inflexible. If one accepts the notion of permeability, then I think one has the best of both worlds.

Third, in developing programs in centers other than Los Angeles, the opportunity exists for participation by members of the art education community in a way that I think will give quite thrilling results, in that each of those settings can serve as a laboratory wherein graduate students in our universities can make ongoing studies of the program as it develops. It's a wonderful opportunity. A number of years ago Sandra Packard wrote an editorial in which she said that, for some reason, art education research never gets itself together in such a way that findings are shared and pooled and really big projects happen. This program, it seems to me, has the potential to encourage that sort of thing to happen.

Finally, for the promoters of discipline-based art education, as for classroom teachers, it's always Monday morning. The thing about classroom teachers is that they don't wait for the perfect thing to come along, because it's Monday morning and they have to get up there and teach. And for program developers as well, there comes a point when one has to go with what one has. Instead of going back and making the thing more nearly perfect, I would prefer to go out with the thing, warts and all, and work out changes as the program evolves.

Brent Wilson

Regarding the development of models, I think we have to ask the question, "Is a regional institute—or any institute— the best place to develop curriculum." Curriculum development is a different kind of activity from running an institute. I

think we may need another important component, and that is to encourage the best minds to go off and take the enormous amount of time necessary to develop and test new curricula.

This is now one of the weak links in art education in this country. Our theorizing and our research is brilliant, but when our colleagues from other countries come over here after reading and quoting us for years, and they go to our schools, they ask, "What is wrong?" Well, what is wrong is that there is no connection between our theory, our research, and our practice in a broad and general way. We must develop the models, and we must work them into state departments of education. We must build a link between the vision of a state department of education and what is going on in local school districts. Perhaps we can even get some examination teeth into the process. In fact, I think that's probably the only way to bring about meaningful and lasting educational change; we must tie curriculum to the evaluation process.

Ronald Sylva

When it comes to putting theory into practice, it seems to me that the bottom line really has to do with who we are teaching. What we are engaged in is not trying to force four types of content on students rather than one. What we are attempting to do, I think, is to think about dimensions of engagement with art. I think where the good heads need to be is in thinking about the relationships among

these four dimensions of engagement with art. Where are the relationships and how can they be put clearly to classroom teachers and to children so that they're not simply carrying four pieces around? This may be a fundamental problem with calling it discipline-based art education, which refers to four different types of people who sometimes talk to each other about art.

June King McFee

I'm not sure I comprehend what you're asking for, but I think there is a big gap here, and it occurred to me only this morning as I listened to Brent Wilson. All of a sudden I realized that as a person concerned with the social and cultural aspects of art, I've never given any thought to the reasons for the populist art movement. Why has this consistent movement of a pseudo-decorative arts gone on for years and years, no matter what we do? Maybe they have some real cultural meanings that we don't understand. If we understood the reasons for their power and consistency and pervasiveness, perhaps we would have a chance to change that. In other words, we have negated the enemy but we have not tried to deal with it.

Margaret DiBlasio

I have a question for Brent Wilson regarding an analogy in his paper. You make the distinction between name-brand and generic brand DBAE. And as I listened to you, I had another analogy, because if we talk about name-brand aspirin and generic-

brand aspirin, we're still talking about the same thing. They're only packaged and priced differently. Maybe the analogy you might have used was to a broader category of pain relievers—Advil, Tylenol, and aspirin—because in fact you were talking about three different things. This is something that keeps recurring in the discussion here: Are we all talking about the same thing or are we really talking about three different theories about curriculum in art education?

Brent Wilson
Your analogy is a nice extension. Actually there are some minor differences. All of these products seem to relieve pain, and each manufacturer is out there advertising something a little bit different about his product in order to get a bigger share of the market. They *try* to make the products different. But in effect, the bottom line is pain relief, and they all sort of do it. So, yes, it's essentially one thing that we're talking about, but we keep putting different names on it. My effort to label them more specifically was simply to draw the distinctions a little more clearly, so that we might begin to determine whether there are differences or not.

Foster Wygant
Having missed the earlier talks, I was reminded of the piece that Foshay wrote in 1971 reflecting on the decade of the sixties. Having introduced discipline-based education at a 1971 educators' meeting, he

was looking back. He said that, with respect to the problems of the idea and its future, he saw two challenges to discipline-based education that he thought had yet to be met adequately. The first of these, timely enough then, was the issue of relevance when the focus remains as it is, on the fine arts. The second was the issue of the relationship of discipline-based art education to the rest of the curriculum.

Dennie Wolf
One of the dangers might be to assimilate discipline-based art education into a kind of general movement in critical thinking. What the whole discussion of arts education brings to the fore is the notion that it's a particular kind of knowledge and that in fact it brings something very special to a curriculum. What it may have in common with other forms of education is interest in rigor, interest in excellence. But that does not mean that it should be subsumed by something else in the curriculum.

Margaret Battin
I have a question, but first you have to hear a little diatribe about aesthetics. This question will eventually be directed to Brent Wilson, who said along the way that it wasn't clear whether we could handle aesthetics without much trouble.

I think it's a real misunderstanding of what the discipline of aesthetics is if we assume that it is so complex and arcane and jargon-filled and sublime that it is

inaccessible at lower levels, or to ordinary teachers. Aesthetics consists of just the kinds of background questions that we ask all the time and that school-age kids will be asking as well. For instance, if you take a group of kids on a museum tour, one of them will ask at some point, "Why do we have to do this? What are we doing inside this museum on this nice day? Why do I have to look at this dumb stuff in here?" If you try to answer that question, you are smack in the middle of the main issues in aesthetics.

That's the diatribe. Here comes the question.

Very early in your paper, Brent, you said that some proponents of DBAE regard creative expression as the enemy. Does this mean that you belive that some pro-ponents of DBAE think the enemy is misidentified, that it's something other than creative expression? Or do you think that some proponents think there isn't really an enemy? Is there an enemy or isn't there one?

Brent Wilson

I think an enemy *was* designated. I'm going all the way back to the first position paper prepared for the Getty Trust. I don't even know who the author was, but in the paper, the Creative Expression Movement associated with Lowenfeld and his followers was indicated as something that needed to be overcome. Many people are saying that it is not the enemy, that part of the essence of a discipline-based art

education would be many of the creative and expressive practices that are encompassed by that movement. But what is being pointed out as problematic in that movement is its purpose—which was to promote some sort creative growth, good mental health, or general social and psychological development. I think it's essentially a paper tiger. We have to have something to mark ourselves off from, to make ourselves different from what had gone on before.

I want also to respond to your comments about aesthetics. I don't think the philosophy of art—which is what I would prefer to call it—is any more complex than art-making or art history or art criticism. What I was trying to point out is that it's a good deal more remote for most art educators at this point—which is why I am looking forward to your book. I hope it will bring some of this material closer to us. We don't have the same kind of history and tradition of teaching aesthetics as we do in teaching the other three areas.

Dennie Wolf

It was suggested that developmental psychology has nothing to tell us, or that we currently don't know anything on the basis of it. But I think cne thing it tells us is that if you look at people making complex responses to objects which they see as aesthetic, what you see is that an individual moves very rapidly and very productively across a number of points of view about the object. There is a kind of empathy with the

maker. There's a kind of observer stance—"What is it that I behold here?" There is a critical stance, and it may involve, "How is this image like other images I've seen?"—which is somewhat like an art historian. Then there are the questions that Peggy Battin is talking about: "Is this different from a table? Is this different from a chair? Is this different than a dictionary illustration?"

The point I want to make here is that psychology does tell us something. Those three stances are not the rare and strange inventions of people who need professional identities different from one another. They are fundamental ways of orienting to otherness. When we talk about the problems of giving instruction in four sets of disciplines, I would suggest that the concept of psychological processes traveling back and forth across those stances suggests one way of instruction.

Mary Erickson
With regard to Peggy's notion about enemies, we do have to mark off some distinctions. I think that was the topic we were addressing this morning. My question is: Can the boundaries of DBAE ever be *too* permeable?

Ronald MacGregor
From permeable to porous, I suppose, is not too big a step.

Let me use Brent Wilson's analogy of the *Argo.* In every wooden boat, there is a certain amount of "working" that has to

happen in order for the wood—which is a relatively rigid material—to operate properly in the inherently unstable element of water. A good shipwright builds a certain amount of "working" into the hull. As a result, a little water will get in. But also as a result, paradoxically, the boat stays afloat.

Mary Erickson
Yes, and some boats sink. We don't want *this* particular boat to sink.

Ronald Sylva
At our university we're involved with the Holmes group, which supposedly is reconceiving the purposes of education. I have a sense that if the group moves in the direction that it's planning, it may well move away from the notion of disciplines as central to curriculum content. What happens if education takes off once again in a new direction and here we are sweeping up and polishing and varnishing and sandpapering something that's irrelevant? Is anybody thinking about the boundaries of DBAE with respect to other initiatives, or are we just talking within the family?

Brent Wilson
My impression is that one of the things reformers of teacher preparation are concerned with is moving the teachers further *into* the disciplines. In the visual arts, this may actually work against us. We ground our people pretty well—at least in the studio discipline and to an extent in history and aesthetics—and it may well be

that in the future we will actually have less time to make the connections between the discipline and how to teach it.

June King McFee

We've done a lot of talking about how much change we could make in DBAE without losing the concept. I would have to reinforce a point I made earlier: With all the social change that's going on, we're going to have to be as aware of what's happening *outside* the field as within it.

Arthur Efland

Having heard the four papers now and having sat through many very interesting discussions about the complexities of our problems, it occurs to me that when we first began to talk about the four disciplines we were going to teach, the essential idea was really a simple one. Then we got involved in all of the complexities. Now we talk about the difficulty of implementation. Are we becoming too elitist? Are we inattentive to the social dimensions? Are we doing this, are we doing that? Sure, we're going to make mistakes. What reform movement hasn't? But it seems to me that if we belabor the complexities, rather than the elegance of a good idea, we might lose something. Maybe we should forget some of the complexities and get to the business of doing it.

Ronald MacGregor

Somebody once said, "Excitement is the moment after you've thought of an idea,

but before you realize it won't work." It's perfectly natural to get into something and then think, "My God, what have I done!" Authorship, I think, plays a big part in this. It is not as if the program were being launched and then all stood back and watched to see what happened. A number of people have a kind of proprietary interest—and I think that preserves the authenticity of the program. Perhaps it is one of the best forms of insurance that we have that the program will eventually succeed.

Marilynn Price

The question comes to mind, why did the Getty Center decide to have this seminar in the first place? The reason was that once the collection of papers in *The Journal of Aesthetic Education* was completed and published, we believed that they belonged to the field, and we wanted to offer to the field an opportunity to grasp the ideas and do something with them. These ideas don't belong to the Getty Center. They are a common starting place for many people, and they're yours. The recommendations that you have developed and the ideas that you have clarified are for you and me, as art educators. We are responsible for our own actions and our own ideas, and that's the excitement of a seminar like this. We come up with ideas for ourselves that *we* can act on, independent of anyone else.

Selected Written Recommendations Collected at the Final Plenary Session

Hold a national conference showcasing other versions of DBAE that are considered viable possibilities. These might be called "Generic Models of DBAE." An example is the Ohio Department of Education's BCAC guidelines.

Constantly and consistently ally a philosophic consideration of values with research addressing the *effectiveness* of instruction and the appropriateness of evaluation. For example, while one might disagree with the conclusions of Lowenfeld's work, he does present an admirable model of research and content and pedagogy, which incorporates at once the *aptitudes* of learners with assertions about what is *important* to learn and how teaching should proceed when grounded in a knowledge of human development and humanitarian concerns.

- The goals and purposes of DBAE should be clearly articulated in language understandable to the lay person, and school systems should be aided in developing DBAE curricula that reflect the needs and character of their communities. The development and implementation processes should be documented, and research should be conducted in these schools to answer some of the questions raised at this conference.
- Teacher education needs emphasis. Preservice courses should help teachers use the disciplines in an integrated way. In-service courses might be focus on how art specialists and classroom

teachers can work together for their mutual benefit.

Further discussion is needed of the means-ends relationship, along with further clarification of the "ultimate" goals of DBAE and the rationales behind them. The relationship of the Los Angeles model to the aims of art education and general education must be examined. All the different DBAE models that are being implemented need to be identified, to reassure educators that there are alternatives to the Los Angeles model.

- Continue clarifying the goals of DBAE in order to give options to teachers who are expanding of art programs, and provide suggested guidelines for those who are revising their programs.
- Continue clarifying DBAE theory, and identify the parameters within which a theoretically sound model can be developed and implemented.
- Demonstrate how the four disciplines can be interrelated conceptually, and disseminate examples and suggestions for resource materials to both practicing art teachers and those in pre-service training programs.
- Publish material from the five-year institute that demonstrates the teaching-learning effectiveness of DBAE.
- In developing DBAE curricula, maintain the dominance of art educators but emphasize the involvement of resource persons from the other disciplines.
- Build into the eight new institutes some pre- and post-test strategies that include

students from traditional programs, to provide comparisons between DBAE and other approaches.

Additional meetings are needed in order to develop:
• exemplars of curriculum that clarify the different views of DBAE's boundaries
• separate curriculum models for classroom and art instructors
• pedagogical models
• graduate student participation
• alternate approaches to implementation
• research data bases
• theoretical frames of reference for each discipline
• relationships among the disciplines

Develop units and lessons based on the interrelationships among the four disciplines that could be adapted to various regions, socio-economic classes, and ethnic groups. Conduct ongoing research that evaluates:
• the appropriateness of DBAE goals to the social values of students
• the interpretation of goals into practice
• implementation of activities

Research needs to be conducted cooperatively by the district and regional planning and implementation projects. A future seminar might focus on identifying research priorities.

Curriculum materials for the four components of the DBAE program are needed immediately by art education professors and art teachers. Providing these materials will help the Getty Center to capitalize on the enthusiasm of many in the field who wish to implement the DBAE curriculum right away.

Continue building a theoretical framework for DBAE and, through the collaborative efforts of university programs, establish a body of research that explains why and how DBAE programs foster learning.

More models of effective DBAE teaching are needed. So, too, are team approaches to designing and evaluating curricula, materials on teaching aesthetics, and more clearly defined goals.

Encourage, support, and demand the development of a variety of alternative discipline-curriculum models — models that are theoretically grounded, philosophically sound, and very specific.

Time, money, effort, and personnel need to be harnessed in order to develop conceptually sound, empirically tested lessons, and curricula that adequately reflect the DBAE focus.

Clarify for art teachers the difference between the "aesthetic experience" and aesthetics as a content area of art education. Teachers may be equating the two when they say that they "already do DBAE."

Recap of Recommendations from Each Small-Group Discussion

In order to strengthen DBAE, well-thought-out theoretical discussions—or theoretical concepts—should be devised for each of the disciplines, with regard to both the discipline activities and the inquiry modes.

The designers and supporters of DBAE are obligated to determine what youngsters can and cannot do at the various ages within each of the disciplines. Because child development and art education are two separate realms, DBAE is responsible for its own inquiry and its own research.

Financial support is needed both for research—which inquiry requires—and to foster information gathering and exchange.

• • •

DBAE concepts need a stronger research base, and research areas need to be studied and prioritized.

Whatever developmental research is prescribed, and whatever theories are developed, should be informed by an awareness of the interrelationships of the learner, the teacher, the disciplines, and the culture.

In contrast to Feldman's view of development as particular, Wolf's view was more general. In DBAE, we need to make more particular our concerns for the individual, for educational intervention, for the disciplines, and for the culture.

The DBAE literature needs more clarity regarding the distinction between verbal understanding and such terms as "visual intelligence," "visual concepts," and "visual understanding."

• • •

Hold a planning conference to establish research priorities.

Consider very carefully the psychological and cultural content of teacher-training courses, in order to ease the special burdens borne by teachers in introducing innovations into the classroom.

• • •

Despite DBAE's focus on the content to be taught, communication regarding the program should strongly and directly acknowledge the importance of the learner's and society's needs.

Art instructors should not be casual about the *concept* they are presenting to students when they introduce an artwork. Teachers have a responsibility to confront the question "Is this art?" and to teach this to students.

The Getty Center needs to address strongly and directly questions of what DBAE is going to include and what it is going to exclude, rather than leave this to chance. Examples include pedagogical issues and the pop-versus-fine arts controversy.

The Getty Center needs to make it clear that even though DBAE focuses on content, it does not overlook the needs of the learner in society.

• • •

Research must be conducted to develop the theoretical foundation for a socio-cultural curriculum, so that this can be compared to DBAE as it is presently organized.

The explication of the DBAE disciplines needs to be updated.

• • •

Careful attention should be given to pedagogy, particularly to teachers' concerns at specific levels of implementation.

There is a need for more direct experience in observing successful model programs in action in classrooms. This need can be partially met by videotaping model programs for distribution to teachers.

Teacher education must include whatever new skills will be needed to teach the innovations.

• • •

The traditional role of the art specialist in the schools must be redefined. The art specialist must be given a leadership role.

It might be to DBAE's advantage to advance some of the alternative theories for art education, rather than trying to embrace them *within* DBAE.

• • •

A clearer understanding of what DBAE is, and is not, is needed.

DBAE must make some allowance for local input.

• • •

Develop means to get more information out to the field about improving art education. There are people who, even without funding, would listen in order to improve.

The input to teachers should be nonjudgmental, noncontrolling.

DBAE should not be so reactive to the "creativity movement" that it discourages creativity.

Participants List

SEMINAR DIRECTOR
Dr. Hermine Feinstein
Department of Art Education
University of Cincinnati
Cincinnati, OH 45221

SEMINAR COMMITTEE
Dr. Mary Erickson
104 Graduate Center
Kutztown University
Kutztown, Pennsylvania 19530

Dr. Hilda Lewis
Department of Elementary Education
San Francisco State University
San Francisco, California 94132

Dr. Nancy MacGregor
Department of Art
The Ohio State University
Columbus, Ohio 43210

Dr. Denis Phillips
School of Education
Stanford University
Stanford, California 94305

PARTICIPANTS
Dr. Carmen Armstrong
Department of Art Education
Northern Illinois University
Dekalb, Illinois 60155

Dr. Margaret Battin
Department of Philosophy
University of Utah
Salt Lake City, Utah 84112

Dr. Gilbert Clark
School of Education
Indiana University
Bloomington, Indiana 47405

Dr. D. Jack Davis
North Texas State University
P.O. Box 13707
Denton, Texas 76203-3707

Dr. Michael Day
Department of Art
Brigham Young University
Provo, Utah 84602

Dr. Rogena Degge
Department of Art Education
University of Oregon
Eugene, Oregon 97403

Dr. Margaret DiBlasio
Department of Art Education
University of Minnesota
Minneapolis, Minnesota 55455

Dr. Stephen Mark Dobbs
School of Creative Arts
San Francisco State University
San Francisco, California 94132

Dr. Arthur Efland
Department of Art Education
The Ohio State University
Columbus, Ohio 43210

Dr. Kerry Freedman
Department of Art Education
University of Minnesota
Minneapolis, Minnesota 55455

Dr. George Geahigan
Department of Art and Design
Purdue University
West Lafayette, Indiana 47907

Dr. W. Dwaine Greer
Department of Fine Arts
University of Arizona
Tucson, Arizona 85721

Ms. Sharon Hill
Graduate Student
School of Art
Arizona State University
Tempe, Arizona 85287

Dr. W. Eugene Kleinbauer
School of Fine Arts
Indiana University
Bloomington, Indiana 47405

Dr. Judy Koroscik
Department of Art Education
The Ohio State University
Columbus, Ohio 43210

Dr. Louis Lankford
Department of Art Education
The Ohio State University
Columbus, Ohio 43210

Dr. Anne Lindsey
Department of Art
University of Tennessee
Chattanooga, Tennessee 37403

Dr. Ronald MacGregor
Department of Art Education
University of British Columbia
Vancouver, B.C., Canada V6T 1Z5

Dr. Jane Maitland-Gholson
Department of Art Education
University of Oregon
Eugene, Oregon 97403

Dr. June King McFee, Emeritus
Department of Art Education
University of Oregon
Eugene, Oregon 97403

Dr. Kristi Nelson
Department of Art History
University of Cincinnati
Cincinnati, Ohio 45221

Dr. Michael Parsons
Department of Educational Studies
University of Utah
Salt Lake City, Utah 84112

Ms. Lois Petrovitch-Mwaniki
Graduate Student
Department of Art and Design
Purdue University
West Lafayette, Indiana 47907

Dr. Howard Risatti
Department of Art History
Virginia Commonwealth University
Richmond, Virginia 23284

Dr. Jean Rush
Department of Fine Arts
University of Arizona
Tucson, Arizona 85721

Dr. Robert Russell
Department of Art Education
University of Cincinnati
Cincinnati, Ohio 45221

Dr. Richard Salome
Department of Art
Illinois State University
Normal, Illinois 61761

Mr. Jeffrey Seibert
Graduate Student
Department of Art Education
University of Cincinnati
Cincinnati, Ohio 45221

Dr. Maurice Sevigny
Dept. of Fine and Performing Arts
University of Texas at Austin
Austin, Texas 78712

Dr. Jon Sharer
School of Art
Arizona State University
Tempe, Arizona 84287

Dr. Marilyn Stewart
Department of Art Education
Kutztown University
Kutztown, Pennsylvania 19530

Dr. Mary Stokrocki
Department of Art
Cleveland State University
Cleveland, Ohio 44115

Dr. Brent Wilson
School of Visual Arts
Penn State University
University Park, PA 16802

Dr. Dennie Wolf
Project Zero
Harvard Graduate
School of Education
Cambridge, Massachusetts 02138

Professor of Derrick Woodham
School of Art
University of Cincinnati
Cincinnati, Ohio 45221

Dr. Bernard Young
Department of Art Education
University of Kentucky
Lexington, Kentucky 40506-0022

Dr. Enid Zimmerman
School of Education
Indiana University
Bloomington, Indiana 47405

PERSONNEL

THE GETTY CENTER FOR EDUCATION IN
THE ARTS
Dr. Marilynn J. Price, Consultant
Ms. Vicki Rosenberg, Program Officer
Ms. Gwendolyn Walden, Intern

PHOTOGRAPHER
Ms. Helen Adams, Cincinnati, Ohio

RECORDERS KEENS COMPANY, NEW YORK
Mr. William Keens
Ms. Jenny Dunnegan
Mr. David Hertzeg
Mr. Paul Kennedy

LUNCHEON GUESTS, SUNDAY MAY 24TH

Dr. Terry Barrett
Department of Art Education
The Ohio State University
Columbus, Ohio 43210

Dr. Laura Chapman
Art Education Consultant
343 Probasco Street
Cincinnati, Ohio 45220

Dr. Georgia Collins
Department of Art
University of Kentucky
Lexington, Kentucky 40506-0022

Dean Jay Chatterjee
College of Design, Arch.,
 Art & Planning
University of Cincinnati
Cincinnati, Ohio 45221

Dr. Sharon Kesterson-Bollen
College of Mount St. Joseph
Mount St. Joseph, Ohio 45051

Dr. Meryl Fletcher DeJong
Department of Art
Clermont College
University of Cincinnati
Batavia, Ohio 45103

Dr. Kathy Desmond
Department of Art Education
The Ohio State University
Columbus, Ohio 43210

Dr. Henry Glover
School for Creative
 and Performing Arts
1310 Sycamore Street
Cincinnati, Ohio 45210

Dr. James Hutchens
Department of Art Education
The Ohio State University
Columbus, Ohio 43210

Mr. John Labadie, Student
Department of Art Education
University of Cincinnati
Cincinnati, Ohio 45221

Dr. Kenneth Marantz
Department of Art Education
The Ohio State University
Columbus, Ohio 43210

Dr. Ralph Raunft
Education Department of Art
Miami University
Oxford, Ohio 45056

Dr. Ronald Sylva
Department of Art Education
University of Cincinnati
Cincinnati, Ohio 45221

Mr. Jerry Tollifson
Ohio Department of Education
Columbus, Ohio 43215

Dr. Harold Truax
Department of Art
Miami University
Oxford, Ohio 45056

Mrs. Mary Anne Wehrend
Department of Art Education
University of Cincinnati
Cincinnati, Ohio 45221

Dr. Helen Wessel
Department of Art Education
University of Cincinnati
Cincinnati, Ohio 45221

Dr. Foster Wygant
Department of Art Education
University of Cincinnati
Cincinnati, Ohio 45221

Ms. Joyce Young, Art Supervisor
Cincinnati Public Schools
230 East 9th Street
Cincinnati, Ohio 45202

Complete Texts of Presentations by Speakers and Respondents

THE GROWTH OF THREE AESTHETIC STANCES: WHAT DEVELOPMENTAL PSYCHOLOGY SUGGESTS ABOUT DISCIPLINE-BASED ART EDUCATION

Dennie Wolf
Harvard University

I have been asked to summarize what developmental psychology has to say about children's capacity, at different ages, to acquire basic concepts in the four components of discipline-based art education: art production, history, criticism, and aesthetics. To answer that charge honestly and fully is the work of a lifetime and I have only the compass of a short paper. Consequently, let me share with you the particular approach that I have taken.

To begin, I want to examine the notion of discipline-based art education from a broad developmental perspective. Central to my examination are three notions: 1) that the acquisition of concepts from the various disciplines has as its foundation the formation and mutual development of three *stances* or ways of interacting with a work—that of a maker, an observer, and an inquirer; 2) that across time, each of these ways of interacting with a work undergoes a series of major changes which deeply affect the individual's current understanding of what is involved in the making and reading of, as well as the reflection on, visual works. I will describe three such shifts: the advent of picture making, visual systems, and the understanding of artistic choice; and 3) that the characteristics of these shifts provide a framework for, but not firm limits to, the kinds of aesthetic learning students of different ages might engage in. Finally, in closing, I want to raise some cautions about too wholly a sequential view of aesthetic learning or a curriculum based too wholly on what we currently know.

Several Stances in Artistic Experience
A discipline is a highly organized body of specialized knowledge, a characteristic epistemology and certain focal questions, as well as a canon or a body of works to which these ways of knowing are applied. Thus, in her sleep an aesthetician can talk about how the Greeks or the English romantics conceived of art or beauty; she knows about defining and relating terms, constructing an argument, and citing evidence. On her shelf are works by Plato, Beardsley, Goodman, and Dickie. When she looks at Degas' painting of the cotton exchange she might remark, "In the late nineteenth century this was not seen as beautiful. Now it is. What does that imply about the nature of aesthetic judgment?" Different questions arise and different answers are given from the vantage point of other disciplines. An artist might use the painting itself as the text, and acute observation as a method to learn about color, studying the canvas almost as an instruction manual. A critic might refer to the whole oeuvre of Degas, using cross-painting comparisons to highlight how this mercantile world is treated as if viewed from a theatre box—a deep space framed by the proscenium—and draw comparisons to Degas' renditions of ballet and stage worlds. An art historian could use what we know of the pattern of friendships, conversations, exchanges of works to

TABLE 1: A COMPARISON OF DISCIPLINES AND STANCES

Disciplines	Stances
Art production	Making/Production
Art history	Observing/Perception
Art criticism	Inquiring/Reflection
Aesthetics	
—Formal bodies of explicit knowledge	—Informal, implicit knowledge—"attitudes"
—End states	—Development
—Distinctiveness	—Integration

point out Degas' unique contributions to the Impressionist movement.

But, long prior to and outside of these disciplines, children, and even uninitiated adults, engage with visual experience; they create it, they note it, they wonder about it. It is these basic activities, or *stances*, which may provide the basis for working towards knowledge in or across particular disciplines. Each of these stances leads to certain actions and inquiries.

1 The Maker: From this stance an individual thinks about or engages in questions like "How do I translate this experience into powerful visual terms?" "Which materials will convey my meaning?" "How will I use the elements of visual experience—line, shape, color, texture—to create just the personality, mood, effect I am after?"

2 The Observer: From this stance an individual concentrates on noticing and comparing, asking "What do I see?" "What in the work conveys that experience?" "What other kinds of visual experience does this bring to mind?"

3 The Inquirer: From this stance an individual stands back from a work and poses questions like, "How does this painting or drawing do its work?" "How is it different from a sign or a dictionary illustration?" "Does everyone read and respond to it in the same way?"

If these stances are similar to formal disciplines, why introduce the concept? To begin, there are some procedural reasons. While few people have discipline knowledge, everyone can take up these stances. Just as native speakers rely on a set of informal intuitions about language quite

different from those of linguists, literary scholars, or authors, these stances structure many of our interactions with visual works, without in any sense being conscious or explicit. They are more nearly attitudes than bodies of knowledge. In addition, while we are only beginning to have research on children's learning of formal disciplines (with the possible exception of studio art), we do have research which is at least relevant to the stances.

More importantly, there are conceptual reasons. By examining the development and interactions between stances, we may make observations which inform how we want to think about more formal kinds of aesthetic learning, such as that called for in what has come to be known as "discipline-based art education" (Eisner 1987). Two points will serve as illustrations. First, a discipline is, almost definitionally, an endpoint. If we assess what children know about visual art, using the structures and questions of disciplines too wholly, we risk missing earlier forms of aesthetic knowledge which may take important, but "un-disciplined" forms. Again, the case of language is helpful. Until linguists gave up the expectation of finding adult grammar in children, they were blind to the powerful, but qualitatively different, rule systems children generated. When a five-year-old asks if a Vermeer was made with a camera, it may be hard to recognize any relationship to the refined questions of art critics. However, if we think less in terms of formal endpoints, it is possible to recognize

that the five-year-old is testing his fundamental conceptions of what the human hand can accomplish, and beginning to form ideas about what is amazing in a painting.

Second, a discipline is, by definition, a distinct form of knowing. Yet if we look closely at moments of naturally occurring aesthetic experience, we find individuals spontaneously move among the several stances. Thus, when a fifteen-year-old tries to make sense of Munch's woodblock *The Kiss*, she puts herself in the shoes of the maker in order to observe the print more fully:

> [When I look at the print] I notice right away how unevenly the figures divide the space. In my mind I imagine how different, how still it would have been, if he had placed the figures in dead center. The figures have an extraordinary simplicity. Their features aren't defined. So in a way, more than the figures, you absorb the softness and roundness of the shapes. It's that that says, "This is a kiss."
>
> When I look at the one shape for two people, I think about the way he cut the block, getting those long lines . . . hard as that is in wood. But I know that if I imagine the figures with elbows and lips, the power drains out.

What these examples indicate is that in naturally occurring, informal interactions with aesthetic objects, viewers (and makers) use all of the stances to make sense of their experience. The stances

offer multiple entry points into aesthetic experience. In addition, when these stances function *together*, in an integrated way, they greatly expand visual experience. They are, when well taught and fully exercised, like Braque's several versions of tables of violins—versions which enhance and confirm the integrity and the multiplicity of visual experience.

The Development of Several Stances: Understanding Pictures and Choices

How do these informal stances develop over time? And what kind of basis might they provide for the eventual acquisition of discipline-like knowledge? In the following section, I suggest that we can detect at least three very broad phases in the development of these stances, each with a characteristic way of approaching making, observing, and inquiring into visual experience. One note: In working out this sequence, I I have used developmental research pertaining chiefly to visual experience. I have not, for instance, frequently appealed to Piaget as suggesting the limits for what can and cannot be understood in a painting. This is out of a conviction that human knowledge is more local than it is general and that the kinds of principles that govern logical thinking may offer some, but hardly a satisfying, explanation for why visual skills develop as they do. This is essentially a position that suggests we would lose much of what is specific, even unique, to visual knowledge, if we were to submerge it with other forms of knowing (Gardner 1983).

From Four to Seven: The Understanding of Pictures

In infancy children build up a storehouse of sensations, routines, and expectations. From this experience they make practical sense out of the physical and social worlds. Based on this experience, between two and five, normal children take the tremendous leap from being exploratory animals to becoming symbol-using human beings. They acquire the fundamental grammar of their native language (Brown 1973), the rudiments of a number system; the conventions that govern the music they hear and sing (Davidson 1983). The consequence of this burst of symbolic development is that children who have only been picture readers (Deloache, Strauss, Maynard 1979; Hochberg, Brooks 1962; Jahoda et al. 1977) join the community of picture makers (Golomb 1974; Kellogg 1969; Smith 1972, 1982; Wolf, Gardner 1980). This means, quite simply, that they begin to understand the demands and power representation—for instance that you can make an image of something you have never seen or are not now looking at. More specifically, children grasp the peculiar demands of visual symbolization. At three, a child drawing Mickey Mouse inscribes his power belt by drawing a line which encircles the paper front to back. At five, he understands that in a picture he can draw only what shows in the picture plane (Wolf n.d.).

With the appearance of these picture making skills, children's ability to observe images gains a second dimension. From the

onset of graphic representation, they can, at least in simple ways, look at a work from the stance of a maker, being impressed by how large a canvas is, how many marks there are, what a clear and vivid picture it presents of a cow, a house, or a scene. However, the remarkable alertness to what a painting pictures cuts in two directions. One the one hand, young viewers tend to look through, rather than at, the visual rendition. Hence, they rarely notice style, composition, or the multiple meanings that visual forms can carry (Machotka 1966; Parsons 1987; Parsons, Johnston, Durham 1978; Walk 1967; Winner 1982). Moreover, their perceptions of visual displays are often limited to a single interpretation. Under the age of seven, if shown a figure made with an apple for a head, bananas for legs, young children cannot see the contours as part of both the man and the fruit (Elkind 1970).

But that same alertness to "what is there" can, under some circumstances, permit children to go beyond mere decoding of pictures. First of all, children this age have the ability to scan complex visual displays thoroughly enough to recognize a particular scene built up out of local detail. Recognizing the larger situation from myriad bits of information is a first, and not a trivial step, towards interpre- tation. When children are encouraged to use their ability to scan and take in whole scenes in conjunction with what may be their richest form of knowledge—their feel for situation, characters, narrative, and

scene (Nelson 1986)—they may show themselves to be skilled at drawing what must be recognized as pictorial inferences. Thus, in looking at Seurat's *La Grande-Jatte*, a six-year-old can imagine what the little girl in the red dress might find if she ran right straight out of the picture frame. She can also predict what the sensations of that river bank on a Sunday afternoon might be:

If I was in that park, it would be noisy. The people would be talking. Maybe one of the mothers is yelling to a kid not to go too close to the water. And the dog might bark at the monkey. And there's wind blowing for the boats.

Typically, we think of being able to read a painting in much more purely visual and formal terms. But children's responses remind us that part of understanding and interpreting a work like *La Grande-Jatte* does involve being drawn deeply into a particular time, space, and light.

We know perhaps the least about young children's capacities to take on the role of the reflective inquirer, that stance which may be most nearly allied with the later work of the aesthetician. Moreover, what we do know presents a curiously checkered portrait. On the one hand, research by investigators like Tizard and Hughes (1984) shows that children as young as four can pursue long arcs of questions about visual phenomena that puzzle them (such as why you only see half a cow at the edge of a book illustration). But other recent work

TABLE 2: ACQUISITIONS OF VISUAL SKILLS: YEARS FOUR-SEVEN
PHASE: THE UNDERSTANDING OF PICTURES

Making/Production
—understanding of the differences between representations and things
—understanding of pictures as a special form of representation

Observing/Perception
—strong picture reading skills (integrating detail into scene)
—initial pictorial inferences (interpretations based on event and scene knowledge)

Inquiring/Reflection
—pursuit of an arc of questions about visual phenomena
—decisions about "what I like"

indicates how these inquiries take place within important limits. Children at these ages make few distinctions between the world of pictures and the world of objects pictures represent. Young children gravitate to pictures of things they like and reject as ugly pictures of violence, frightening items, or objects they personally dislike (Parsons, Johnston, Durham 1978). Consequently, the criteria for aesthetic judgment appear to be simple: "If I like what it pictures, it's good." Children this young make little distinction between what they like and what others might like.

Still other research suggests what may underlie the apparent limits on the way young children question and reflect on their visual experience. In interviewing children about the differences between appearance and reality, Flavell, Green, Flavell (1986) found that they have difficulty grasping that distinction. For instance, they struggle with the idea that the color red lent by a piece of cellophane does not inhere in the object covered by that cellophane. Similarly, the way young children understand the workings and products of the mind is still incomplete (Wellman 1987). They have difficulty understanding how a person might say or show one thing and mean either several things or something quite different. Thus, at the moment when they have a grasp of the image-making process, young children

lack the skills to "second-guess" that image. They cannot imagine it other than it is; hence, they are unable to consider it as one of a number of alternatives. The absence of this hypothetical frame suggests why young children's inquiries about paintings and drawings are often limited to the images as they are, rather than how they might be.

Finally, young children appear to lack well-defined concepts of different types of visual activity. For instance, they make few distinctions between (potentially) aesthetic and nonaesthetic objects, such as maps and drawings (Liben, Downs 1987). Even though they may be able to identify maps vs. drawings, they will still argue that the upper portions in a map represent the sky, while the lower regions show where the buildings and ground are. Hence, a limit on young children's inquiries about drawings and paintings may be that they do not yet think in terms of special classes of visual images or experiences, each distinguished by particular qualities. Quite possibly, even though young children certainly enjoy making and looking at visual images, they may not spontaneously pose specifically aesthetic questions

From Eight to Twelve: The Understanding of Visual Systems
Across cultures, by the age of seven, children begin the formal training in adultlike tasks of their particular culture— whether that is herding, hunting, or reading and writing (Whiting, Edwards

1973; White 1970). In any culture this is the period in which we require children to adopt explicit versions of the thinking skills and codes they will need to survive in their particular society, such as the formal codes of counting, reading, writing as well as the major categories for understanding human action: right and wrong, play and work, possibly even mundane and aesthetic (Erikson 1963). It has often been argued that this welter of rules contributes to what is often called a literal, or highly conventional, phase in children's productive development (Winner 1982). However, this is not necessarily a "flat" or uncomplicated period in aesthetic development. During these years, children acquire the ground-level knowledge of the social and psychological world which is essential to any artistic work which refers to the human aspect of experience. It is crucial to know what the signs of being a villain are, how princesses usually dress, what's in a jungle or a desert scene. As children in the back of the bus or classroom practice them, these recipes may be commonplace and flat, but they do provide the bare-bones anatomy of art works, which must be learned before it can be adapted or changed.

It is not surprising that in this context children's understanding of visual images grows more systematic in two ways. First of all, as makers, children become absorbed with learning the "tricks of the trade" that make things "right"—how to draw Charlie Brown, how to make a deceptively three-

dimensional cube out of just lines. In this way, school-age children often avidly acquire symbolic recipes—the conventions of everyday illustration (e.g., the thought bubbles, zoom lines, tricks for making noses and muscles) (Gardner 1973; Lowenfeld 1957; Willats 1977; Wilson, Wilson 1977). However, this kind of attention to the making of things can be harnessed. Preadolescents can become alert to the craft, not just the depictive obligations, of rendering visual experiences. For instance, they can become careful, even expressive, observational draftsmen (Smith 1982).

At the same time, these same forms of attention mean that children become keenly aware of the different systems or genres of image making that flourish in their culture. For example, it is at this time that children begin to distinguish between maps and drawings (Liben, Downs 1987) or between different types of drawings. When ten- or twelve-year-olds are asked to finish drawings with and without aesthetic properties like expression, they accurately match their own drawing styles to that of the original drawing (Carothers, Gardner 1979). Similarly, when asked to make birds that would appear in a science report, zoo sign, and art gallery, preadolescents produce distinct forms. The blue jay for the science paper is drawn in careful, but not interpretive, detail; the zoo sign is a spare, generic contour drawing; the art gallery bird is richly colored and fantastically detailed (Wolf, 1984).

This awareness of the systematic nature of visual images has interesting ramifications for the ways in which preadolescents take on the stance of both observers and reflective inquirers. On the one hand, their keen awareness of rules means that they are often troubled by, or intolerant of, works in which the expected rules are broken, finding them puzzling, weird, or ugly (Parsons 1987). They have fixed expectations: just like all poems should rhyme, all paintings should be recognizable pictures of handsome, valuable, or interesting items. The same things that make a machine, building, or tool seem "neat" are valued in paintings or poems: size, complexity, a high price tag, power, strength (Child and Iwao 1977; Machotka 1966; Parsons, Johnston, Durham 1978). Limiting as the point of view may seem, implicit in it is the ability to go to a work, rather than just personal preference, for evidence. For example, when asked what his favorite object was in an exhibition of Chinese artifacts, one eight-year-old replied:

I liked the jade sword that was right by the door. It was longer than six feet. The guy who used it had to be real strong. I think they used it to chop off people's heads. Because Dan and I looked at it up real close and we could see some rusty brown stuff that maybe was old blood.

In a more positive light, preadolescents'

TABLE 3: ACQUISITIONS OF VISUAL SKILLS: YEARS EIGHT-TWELVE

PHASE: THE UNDERSTANDING OF VISUAL SYSTEMS

Making/Production
—fluency with visual conventions
—understanding of different systems of visual representation (cartoons,
 careful observations, drawings, maps)
—understanding of craft and skill

Observing/Perception
—understanding of concepts of rendition and version (style, genre)
—a pictorial attitude (ability to look at how the picture is made, not simply what it represents)

Inquiring/Reflection
—a category of aesthetic works
—ability to "second-guess" an image (to consider it against how
 else it might have been accomplished)
—explicit criteria for judgment (albeit often limited to realism and craft)
—ability to point to evidence in the work to substantiate preferences

sensitivity to system can, if tapped in thoughtful ways, be used to alert them to the particular ways in which aesthetic images work. In particular, they can extend their earlier understanding of depictions (pictures) to a conception of rendition. For example, with teaching, children can learn to see "through" an image, looking instead for the style or mood of a work (Deporter, Kavanaugh 1978; Gardner 1970; Gardner 1973; Walk 1967). For the first time as viewers, children can begin to recognize that images function in a number of ways as denotations and as particular versions (Elkind 1970; Silverman et al. 1975). With the advent of this kind of visual thinking, school-age children, if encouraged, can begin to understand why and how an image might portray something other than literally the way "things look." They have the beginnings of what might be called a pictorial attitude (Winner 1982).

Still other veins of research suggest that between the ages of eight and twelve children begin to think much more flexibly and richly about their experience. Work concerning their conceptions of mind suggest that after seven, they can think about the motives which underlie behavior (Wellman 1987). Quite possibly this opens up to them questions of what an artist might have been trying to effect in a viewer. Preadolescents can look at a Paul Strand photograph and ask why the photographer might have chosen to picture a machine at such close range and what the effect might have been if he had shot it from an enormous distance. As their hold on the reality-appearance distinction firms, they can think about things other than as they literally are (Flavell, Green, Flavell 1986). This means they can look at a painting or drawing and consider how else the work might have been made. They can be engaged in looking at *The Bathers* by Picasso and talk about how it is different from a *National Geographic* photograph of swimmers on the beach at Cannes.

At the brink of adolescence, students are alert to the realistic texture of experience. In their "middle years" children build up an impressive network of practical facts concerning how the world works. This raw data about "the ways things are" is a rich repertoire of both formal and informal techniques for getting things done— whether the task is long division, dividing words into syllables, or drawing chair rungs "right." This "know-how" also

contains conventions, stereotypes, and "shoulds": what girls should do, what a "good" drawing should look like. On the one hand, preadolescents want to equip themselves with the tools and techniques for clearly encoding important facets of what they perceive. This makes them aware of craft. At the same time, children in middle school years begin to understand pictures not merely as depictions but as renditions. They understand that the same visual information might be rendered sparely in a map, richly in a landscape drawing. With opportunities and instruction, they can grasp the notion of style—a kind of system of viewing or making that spans still lifes, landscapes, and figure paintings. Thus, they have the raw materials for beginning to appreciate some of the complex and demanding aspects of specifically aesthetic experience.

From Thirteen to Eighteen:
The Understanding of Artistic Choices
Adolescence (the years between thirteen and eighteen) brings two major changes to the apparently systematic world of the school-age child. In some ways, each of these changes has to do with under-standing choice. Perhaps the "most famous" of these changes is the turbulence that is associated with sudden bodily changes, independence, and a search for personal identity (Csikszentmihalyi, Larson 1984; Erikson 1968). The second, quieter—but just as profound—shift

derives from the adolescent's ability to think abstractly, to reason about ideas and principles, and perhaps most significantly for aesthetic thinking, to imagine detailed and novel alternatives to "what is" and the customary version of "what should be." Put differently, adolescents are capable of entertaining for themselves and recognizing in other people the making of choices.

One quite striking addition to aesthetic production at this age is an interest in selecting a powerful means to convey an experience or idea. When making a series of studies of sea shells, an adolescent artist commented:

> *Last term I started drawing shells. I wanted to learn how to draw things from life, so I decided to draw the same object over and over and over. While I was working on them, I started to see a lot about different kinds of lines. Shells force that. As you move around drawing one of them, you have sharp edges, folds, flaps, round shoulders. I went from pencil to charcoal because I couldn't get the pencil line to do all that, but with the charcoal you can get a hard edge and blurry, soft forms. The more I worked, the more I saw each one of the lines as a "story." It would start at the front edge all clear and hard and then travel up towards one of the shoulders and I would have to change it, make it thicker and softer, as it went.*

As second major change concerns choosing, not so much the medium, as the message for a work. Whereas younger children focus on picturing families, buildings, scenes, adolescents begin to use those familiar forms not merely to denote, but to communicate attitudes and messages. Adolescents experiment with making up symbols for abstractions like peace, freedom, envy, and evil. This understanding that works can send complex messages or evoke impressions is yet another way in which adolescents become involved in careful reexaminations of the tools he or she has available—design elements like color, form, compositional patterns, texture, and conventional icons (Burton 1980; Wolf 1987).

Building on the formulae picked up in middle school, and mixing in the high-speed, widely reduplicated images of *Miami Vice* and album covers, adolescents know a number of the stock "moves": muted colors convey melancholy; jagged shapes are for angst; palm trees signal "tough cool." But for the student who is going to be an artist or a performer, a major developmental hurdle lies in getting past these "moves" to a point of producing new structures or messages. As a part of this process, young artists have to work out authentic, rather than simply imitated, personal styles (Specter 1987).

As adolescents become capable of considering how to alter their own works in order to convey moods and messages, or to create specific effects, they may become more sharply sensitive to similar efforts on the part of others. In this way, adolescents

can approach the work of adult artists from a novel perspective. Not only can they read the surface of a painting to notice particular forms, materials, or techniques, they can explore how these are matched to meanings. Remember back to the adolescent comments about just this match in Munch's block print, *The Kiss*. Thus, adolescents begin to see the importance of knowing not just "what" a work is about but understanding "how" the print, film, or sculpture manages to achieve its effect (Hausen, 1979; Machotka 1966; Parsons, Johnston, Durham 1978). What this signals is that the way in which adolescents observe works is characterized by their ability to bring to bear a number of dimensions.

Although this makes adolescents sound aesthetically sophisticated, three further points are in order. First, it is *critical* to realize that only those students with a history of consistent, thoughtful instruction in the arts reach these understandings during their high-school years. Second, adolescents do have more to learn. Though they may appreciate works from quite different traditions, they are often bound by their personal likes and dislikes. It turns out to be a largely adult development to recognize or look for standards of excellence larger than personal preference (Gardner 1970; Parsons, Johnston, Durham 1978). Moreover, high-school age students still are very much in the throes of understanding the issues of invention and authenticity.

Research on problem solving suggests that adolescents have the capacity (whether or not it is realized) to consider all the logical possibilities in a problem (Inhelder and Piaget 1964). Similar clues from looking at adolescents' thinking through moral dilemmas indicate these same qualities: the ability to think about statements, comparing and contrasting two or more statements, finding the similarities, conflicts, and gaps in information, all in the name of searching for broader principles (Gilligan 1984; Kohlberg 1969). Across domains, then, adolescents can engage in speculation, they can make inferences and comparisons, they can examine a range of possibilities. This speculative turn of thought has marked consequences for what adolescents produce artistically, what they are able to perceive in the works of others, the kinds of questions they can consider raising about paintings, drawings, and sculpture.

It is during these years that adolescents can begin to think of the work of other makers in terms of artistic choices. In other words, they can make the distinction between technical and expressive skills, realizing that artists could *choose*, for reasons of expression or innovation, to make deliberately simple, jarring, or blurred forms. Not surprisingly, it is during adolescence that criteria such as meaning and effectiveness replace earlier dimensions of realism, size, and value as the basis for judging a work. In this way adolescents can recognize that there may

be a range of handsome or effective compositions: the highly recognizable landscapes of Corot, the planes of Mont St. Victoire, even the psychological landscapes of abstract expressionism. It is also during this period that students begin to think about the complicated differences between what they like and what is good (Child 1965). Between seventeen and eighteen, students' judgments come closest to that of experts (Child, 1964).

During adolescence the challenge for art education lies in making the potential developments in aesthetic development *occur*. A central problem is designing art experiences that offer high-school students not just more techniques or facts about art history but genuinely different ways of thinking about the arts. As compared with school-age children, adolescents can be engaged by what goes on "behind the scenes" in works of art—by issues of symbolism, deeper messages, double meanings. While many secondary-level art appreciation curricula teach students the fundamentals of art history, in terms of techniques and styles, the process of reading world views contained in works is often neglected. Just as with logical reasoning, they may be able to engage in the process of reasoning about works of art, arguing for their meaning or value in terms of the content and structure of the works.

TABLE 4: ACQUISITIONS OF VISUAL SKILLS: YEARS THIRTEEN-EIGHTEEN

PHASE: UNDERSTANDING ARTISTIC CHOICE

Making/Production
—concern for the match between rendition and message (attention to composition, personal style, and a range of other artistic choices)
—concern for distinctiveness, individuality, authenticity

Observing/Perception
—the ability to see many aspects of a work (its composition, style, narrative, message, etc.)
—ability to observe the figurative aspects of a work (the tone, attitude, etc., implied)

Inquiring/Reflection
—ability to conduct inquiry from a number of vantage points
—intention and message replace realism as criteria

Conclusion

Even this brief look at the develop-
mental changes in the stances of maker,
observer, and inquirer suggests
that just as in the fields of reading
or science, students at different ages
have qualitatively different skills in
producing, perceiving, and reflecting
upon works. Several illustrations will
help to capture the qualities of these
different periods. These illustrations
came from a six-, a nine-, and a fifteen-
year-old being asked to complete an
already started drawing (in fact, a head
and shoulders taken from the collec-
tion of Persian miniatures, *The Book of
Kings*). What the six-year-old's drawing
shows is a sensitivity to finishing a
picture: the bottom of a body is
supplied, the lines of the head and
shoulders are carefully matched and
continued. Missing, however, is any
awareness of the particular kind of
person depicted, or the set of artistic
choices implied. By comparison, the
nine-year-old sees clues that his
drawing must work within—he
recognizes what he calls "a fancy
bad guy" and works within those
implications, providing a costume, black
moustache, medals, sword, and boots, as
well as the finer detail. On a more
formal plane, taking a cue from the
head, the student systematically turns
the torso and limbs as well. Finally, the
adolescent appears to have an inkling
that completing the figure calls for

attention not only to what the figure is
but to a set of artistic choices about how
it is drawn. She completes it in a way
that continues not just the content or
trappings but the style—curving forms,
fine lines, and decorative detail. In this
drawing there is attention to the par-
ticular sinewous qualities of line, the
composition of an overall pattern, and
the expression of fierceness through the
asymmetry of the total composition.

Before we tune arts education strictly to
these phases, it is important to reflect on
how information about the development of
these stances can turn out to be a useful
rather than a limiting heuristic. It seems to
me that several caveats are in order. The
first of these concerns the limits of the
developmental description I've offered.
Such descriptions are based on average
patterns of performance for just that
segment of this culture's population who
turn up in studies of child development.
Until we have more diverse samples and
considerable attention is paid to individual
patterns of growth, it will remain unclear
whether we are looking at anything like
universal or even widely disbursed
patterns of aesthetic development.

The second caveat concerns teaching.
The efforts to teach children aesthetic skills
have often in the past been short-term,
underfunded, with varying support from
schools and communities. Under these
circumstances, we cannot tell whether a
seven-year-old's inability to see the ex-
pressive or stylistic qualities of paintings

comes from some fundamental cognitive immaturity or from a failure to understand what kinds of questions are relevant to paintings—a failure that comes from living in a world where interactions with works of visual art are few and sparse. Until we have children who have consistently had the chance to make, observe, and inquire about visual art, we will not know whether the phases I have described are all that is possible or only the beginning of what is potential.

Bibliography

Broudy, H. 1977. "How basic is aesthetic education?: Or is art the fourth R?" *Educational Leadership* 35:2.

Brown, R. 1973. *A First Language.* Cambridge: Harvard University Press.

Burton, J.M. 1980. "Line, Space and the Origins of Meaning in Human Figure Drawings Made by Children 8-15 Years." Doctoral thesis, Harvard University.

Carothers, T., Gardner, H. 1979. "When Children's Drawings Become Art: The Emergence of Aesthetic Production and Perception." *Developmental Psychology* 15(5):570-80.

Child, I. 1964. "Development of Sensitivity to Aesthetic Values." Cooperative Research Project No. 1748, Yale University.

Child, I. 1965. "Personality Correlates of Esthetic Judgment in College Students." *Journal of Personality,* 33:476-511.

Child, I., Iwao, S. 1977. "Young Children's Preferential Responses to Visual Art." *Scientific Aesthetics* 1(14):291-307.

Csikszentmihalyi, M., Larson, R. 1984. *Being Adolescent.* New York: Basic.

Davidson, L. 1983. "Early Tonal Structures in Children's Songs." Paper presented at International Conference on Psychology and the Arts, Cardiff, Wales.

Deloache, J.; Strauss, M.; Maynard, J. 1979. "Picture Perception in Infancy." *Infant Behavior and Development* 2:77-89.

Deporter, D., Kavanaugh 1978. "Parameters of Children's Sensitivity to Painting Styles." *Studies in Art Education* 20(1):43-48.

Elkind, D. 1970. "Developmental Studies of Figuration Perception." In *Advances in Child Development and Behavior* 4, L. Lipsitt and H. Rees, ed. New York: Academic.

Eisner, E. 1987. *The Role of Discipline-Based Art Education in America's Schools.* Los Angeles: The Getty Center for Education in the Arts.

Erikson, E. 1963. *Childhood and Society.* New York: Norton.

_____ 1968. *Youth, Identity and Crisis.* New York: Norton.

Flavell, J., Greene, R., Flavell, E. 1986. *Development of Knowledge about the Appearance-Reality Distinction.* Monograph for the Society for Research in Child Development. Chicago: University of Chicago Press.

Gardner, H. 1970. "Children's Sensitivity to Painting Styles." *Child Development* 41:813-21.

_____ 1973. *The Arts and Human Development.* New York: Wiley.

_____ 1983. *Frames of Mind.* New York: Basic.

Gilligan, C. 1984. *In a Different Voice.* Cambridge: Harvard University Press.

Golomb, C. 1974. *Children's Painting and Sculpture.* Cambridge: Harvard University Press.

Greene, M. 1980. Notes on aesthetic education at the Lincoln Center Institute.

Hochberg, J., Brooks, V. 1962. "Pictorial Recognition as an Unlearned Ability: A Study of One Child's Performance." *American Journal of Psychology* 75:624-28.

Inhelder, B., Piaget, J. 1964. *The Early Growth of Logic in the Child*. New York: Norton.

Hausen, A. 1979. Special qualifying paper, Harvard University.

Jahoda, G., Deregowski, J., Ampene, E., Williams, N. 1977. "Pictorial Recognition as an Unlearned Ability: A Replication with Children from Pictorially Deprived Environments." In *The Child's Representation of the World*, G. Butterworth., ed. New York: Plenum.

Kellogg, R. 1969. *Analyzing Children's Art*. Palo Alto, Calif.: National Press.

Kohlberg, L. 1969. "Stage and Sequence: The Cognitive-Developmental Approach to Socialization." In *Handbook of Socialization Theory and Research*, D. Goslin, ed. New York: Rand McNally.

Liben, L., Downs, R. 1987. "Children's Conceptions of Maps as Objects and Representations." Paper presented at the biennial meeting of the Society for Research in Child Development, Baltimore, Md.

Lowenfeld, V. 1957. *Creative and Mental Growth*. New York: Macmillan.

Machotka, P. 1966. "Aesthetic Criteria in Childhood: Justifications of Preference." *Child Development* 37:877-85.

Nelson, K. 1986. *Event Knowledge*. Hillsdale, N.J.: Erlbaum Associates.

Parsons, M. 1987. *The Way We Understand Paintings*. Cambridge: Cambridge University Press.

Parsons, M.; Johnston, M.; Durham, R. 1978. "Developmental Stages in Children's Aesthetic Responses." *Journal of Aesthetic Education* 12(1)83-104.

Silverman, J.; Winner, E.; Rosenstiel, A.; and Gardner, H. 1975. "On Training Sensitivity to Painting Styles." *Perception* 4:373-84.

Smith, N.R. 1972. *The Origins of Graphic Symbolization in Children 3-5*. Ph.D. diss., Harvard University.

_____ 1982. *Painting and Experience*. New York: Teachers College Press.

Specter, B. 1987. Comments presented at panel discussion, Discipline-Based Arts Education in the 80's, at Carl Sandburg High School, Chicago, IL.

Tizard, B., Hughes, M. 1984. *Young Children Learning*. Cambridge: Cambridge University Press.

Walk, R.D. 1967. "Concept Formation and Art: Basic Equipment and Controls." *Psychometric Science* 9:237-38.

Wellman, H. 1987. Paper presented at symposium, Children's Conceptions of Mind. Biennial meeting of the Society for Research in Child Development, Baltimore, Md.

White, S.H. 1970. "Some General Outlines of the Matrix of Developmental Changes between Five and Seven Years." *Bulletin of the Orton Society* 20:41-57.

Whiting, B., and Edwards, C. 1973. "A Cross-Cultural Analysis of Sex Differences in the Behavior of Children Aged 3-11." *Journal of Social Psychology* 91:171-88.

Willats, J. 1977. "How Children Learn to Represent Three-Dimensional Space in Drawings." In *The Child's Representations of the World*, G. Butterworth, ed. New York: Plenum Press.

Wilson, B. and Wilson, M. 1977. "An Iconoclastic View of the Imagery Sources in the Drawings of Young People." *Art Education* 30:33-42.

Winner, E. 1982. *Invented Worlds: The Psychology of the Arts*. Cambridge: Harvard University Press.

Winner, E., McCarthy, M., Kleinman, S. and Gardner, H. 1979. "First metaphors," In *Early Symbolization, New Directions for Child Development*, D. Wolf, ed. 3:29-41.

Winner, E., Rosenstiel, A., and Gardner, H. 1976. "The Development of Metaphor Understanding." *Developmental Psychology* 12:289-97.

Wolf, D. 1984. "Drawing Conclusions about Children's Art." Paper presented at "Vom Kritzeln zur Kunst," Ichenhausen, Germany.

_____ 1987. "Realizing It in the Block: Portfolio-Based Study of Artistic Development." *Journal of Aesthetic Education*. Forthcoming.

_____ (n.d.). "Drawing the Boundary." In *The Development of Spatial Representation*, J. Stiles-Davis and U. Bellugi, Eds. Hillsdale, N.J.: Erlbaum Associates. Forthcoming.

Wolf, D. & Gardner, H. 1980. "Beyond Playing or Polishing." In *Arts and the Schools*, J. Hausman, ed. New York: McGraw-Hill.

A RESPONSE TO DENNIE WOLF'S PAPER, "THE GROWTH OF THREE AESTHETIC STANCES: WHAT DEVELOPMENTAL PSYCHOLOGY SUGGESTS ABOUT DISCIPLINE-BASED ART EDUCATION"

Enid Zimmerman
Indiana University

The task assigned to Dennie Wolf was formidable. She was to explain, in forty minutes, how current research in child development and different cognitive styles relates to discipline-based art education requirements that children in grades kindergarten through twelve learn concepts and skills associated with the four disciplines of studio art, art history, aesthetics, and criticism. It is apparent that such a task becomes one of exclusion rather than inclusion as evidenced by Wolf's narrowing the topic to developmental psychology and its relation to discipline-based art education (vs. more research on cognitive style).

The summary of children's developmental stages as understanding pictures, understanding visual systems, and understanding artistic choices, as just presented, is a very good contribution to the literature about the development of children's aesthetic responses to a variety of visual stimuli. Basic perspectives or approaches, termed *stances* by Wolf, to aesthetic experiences and their interactions are posited as organizers for relating children's aesthetic development and discipline-based art education. The stances of maker, observer, and inquirer are explained as stances that students may take in relation to understanding works of art and creating art work. The making stance is manifest in studio production; being a spectator involves comparing and analyzing works of art as is the mode in art history and art criticism; the inquirer reflects upon the nature of making and evaluating art as

does the aesthetician. It would appear to me, however, that observation and inquiry, as commonly defined, would play vital roles in all four disciplines of studio art, art history, art criticism, and aesthetics. A student could also participate in art, not only as a maker, but as a researcher of art history and in aesthetics as a critic of art as well. Making, observing, and inquiring are critical to all four disciplines and define different modes in relation to advanced study in each discipline.

The three stances are presented as being easily integrated, informal, less structured, and offering multiple entry points into aesthetic experiences as compared to the four disciplines outlined in discipline-based art education. The content of what should constitute discipline-based art education is based in part on Broudy's (1972) theory of aesthetic education in which the teacher directs both student perception experiences with selected works of art through the scanning method and student expression with art media. At this beginning level, all learning is informal and integrated and there is no separation of the disciplines. Once students have learned through such perception experiences, they then can develop knowledge and skills specifically related to art making and making aesthetic judgments about works of art by using art history techniques, art criticism techniques, and aesthetic theory appropriate to their levels of cognitive development. Students are not expected to perceive as artists, art historians, art critics, or aestheticians until

they are mature and have mastered all previous levels of learning.

The three stances of maker, observer, and inquirer are viewed as basic perspectives for aesthetic experience. Wolf's preference toward what may be termed "art appreciation," rather than "art education," is evident in her emphasis on aesthetic response to art making and works of art rather than developing knowledge about art and art making skills. Wolf's emphasis is toward *grasping qualities* presented by a work of art (Dewey 1934; Ingarden 1973) rather than *theorizing* about art as associated with the work of the artist, art historian, and art critic (E.B. Feldman 1972; Smith 1968). It is true that if discipline-based art education were *only* based upon art techniques, historical information, technical criticism of works of art, and concepts related to art theory, then aesthetic experience would be bypassed. An aim of discipline-based art education should be to develop knowledge, skills, and valuing related to making and studying works of art as well as to develop students' sensory capacities to have aesthetic experiences with works of art.

Wolf does emphasize that it is *"critical to realize that only those students with a history of consistent, thoughtful instruction in the arts"* are able to reach aesthetically sophisticated understandings in their high-school years. It would be interesting to speculate how the developmental stages described by Wolf might be accelerated and altered through early intervention in terms

of directed teaching of discipline-based art education curricula.

The majority of references to studies in Wolf's paper are those done in connection with research conducted at Project Zero where she is a research associate. All research she surveyed is, as she admits, based "on average patterns of performance for just that segment of this culture's population"; in translation, that means mainly white, middle-class, Caucasian students from the core culture. Individual and cultural differences, Wolf admits, may play a role in how universal patterns of development are described in her paper. Fisher and Silvern (1985) take the position that developmental stages and individual differences should not be dichotomized. Although cognitive development evidences universal, stagelike changes and consistency across domains, at the same time differences among individuals and cultures are common. In fact, only under certain environmental conditions do people behave in a stagelike manner. D.H. Feldman (1980) views development in art as occurring in universal stages as well as nonuniversal regions where culture, *including educational intervention*, impinges on the child.

Berry, Dasen, and Witkin (1982) argue for avoiding an ethnocentric interpretation of developmental theories and stress the importance of cultural context in understanding child development. Theories such as Witkin's cognitive style and Piaget's genetic epistemology lend themselves to ethnocentricism unless individual dif-

ferences and cultural context are taken into account. Bond and Bond (1983) caution against creating another's world in our own image.

Discipline-based art education should be predicated upon both developmental stages inherent for *all* students and yet be flexible enough to make accommodations to *some* students from differing cultural contexts and *each* individual student according to his or her cognitive style. This is a very difficult task, but it does provide a challenge for those who will design discipline-based art education curricula and those who will teach it.

Bibliography

Berry, J.W., Dasen, P.R., Witkin, H.A. 1982. "Developmental Theories in Cross Cultural Perspective." In *Cross Cultural Research at Issue*, ed. L.L. Adler. New York: Academic Press.

Bond, L., Bond, M.H. 1983. "A Proposal for Cross Cultural Studies in Attribution." In *Attribution Theory: Social and Functional Extensions*, ed. M. Hewstone. Oxford: Blackwell.

Broudy, H. 1972. *Enlightened Cherishing: An Essay in Aesthetic Education*. Urbana: University of Illinois Press.

Dewey, J. 1934. *Art as Experience*. New York: Minton and Balch.

Feldman, D.H. 1980. *Beyond Universals in Cognitive Development*. Norwood, N.J.: Ablex.

Feldman, E.B. 1972. *Varieties of Visual Experience*. Englewood Cliffs, N.J.: Prentice-Hall.

Fisher, K.W., Silvern, L. 1985. "Stages and Individual Differences in Cognitive Development." *Annual Review of Psychology* 36:613-48.

Ingarden, R. 1973. "The Structure of Appreciation." In *Contemporary Aesthetics*, ed. M. Lipman. Boston: Allyn and Bacon.

Smith, R.A. 1968. "Aesthetic Criticism: The Method of Aesthetic Evaluation." *Studies in Art Education* 9(3).

ART AND SOCIETY

June King McFee
Emeritus, University
of Oregon

The question of how to impact the lives of American children through education in art engrosses us all. The history of this effort is long. Each plan that has been tried has merit. Some people have focused more on content and curriculum, some more on the nature of children, others on the needs of society or on the nature of schooling. It is most commendable that this seminar, sponsored by the Getty Center for Education in the Arts, is exploring all these issues as it plans for the future of its program of discipline-based art education (DBAE). It is further important to note that psychological and socio-cultural foundations of education as well as curriculum and the nature of schooling are included.

I have been asked to identify what arts should be included in DBAE from an art and society perspective. My purpose is to clarify the larger social and cultural content in which DBAE is operating in order to answer the questions given me. Rather than use a research paper design I will use the point-counterpoint and position format suggested for these sessions. My remarks are based on my own assimilation of study in anthropology and cross-cultural psychology as related to art, art education, and teaching and producing art.

To sharpen this dialogue I will make three points. First, I posit that the study of fine art or studio art is not inclusive enough to serve the needs for art study for students in a multicultural democracy. Second, while I support the use of art history, art criticism, and aesthetics, I posit that these

disciplines need to be recognized as bounded within Western culture. They have not addressed all the art within Western culture nor are they adequate for studying the art of other cultures. And third, I posit that a fifth discipline, a socio-cultural study of art, needs to be added.

The counterpoint of these points is that we are not a multicultural democracy, that the melting pot ideal has worked and is still working, and that the traditional hierarchy of art with studio-fine arts at the top still meets the needs of art learning for all students in our society.

Now I will examine some of the interactions between art and society to help identify student needs for art learning in a complex cultural and technological age. I am assuming that all art, that which we call fine art as well as the other visual, human-made manifestations of art, comes from the interaction of individuals and groups within socio-cultural systems. Thus, comprehending the dynamics of culture and society in relation to art is necessary to understand art.

A few definitions as I am using them are needed:

Art means the human use of visual elements in designed or composed forms to express ideas, feelings, attitudes, conditions, qualities, and to enhance experience with objects and environments.

Culture means the shared values, attitudes, belief systems, and cognitive styles (the

ways of knowing, seeing, thinking) that affect the behavior of a group of people, including the making of and responding to art. Art is also one of the main communication systems for transmitting, maintaining, learning, and analyzing culture.

Society means the reasonably stable organization of groups of people that differentiates them from other groups and gives structure to their internal and external interaction. A large society may have a distinguishing overall culture. It may also have subcultures as well as smaller societies. Subcultures are formed in living groups but also in work groups, or activity groups, such as schools of art. Society and culture are mutually effective, and sometimes are hyphenated into "socio-culture" to express this interrelated meaning.

The following seven generalizations about the nature of art in relation to culture and society support the points I make and the final position I take:

1 *Art is universal in the sense that it is found to some degree in all cultures, but the variations of art are related to the different socio-cultural contexts in which they develop.* Each art is affected by its time in a given cultural history, the amount of innovation tolerated, and by its social, physical, and technical environment, as well as by the values and belief systems of the culture. Because we are a multicultural society we have many visual arts.

2 *A socio-cultural system motivates, molds, modifies, and rewards the production and use of art.* People who share cultures not only have similar value systems and concepts of reality, but also share ways of coping with others and the natural environment, and develop somewhat similar cognitive styles for thinking, sorting, and reacting. All these affect the kinds of art they create and the ways they value and attend to it.

3 *Their art is a mirror for the members of a cultural group.* It gives them a basis for seeing their culture as more real. It objectifies, enhances, differentiates, organizes, communicates, and provides continuity for values, attitudes, and belief systems. Art also identifies cultural change. Innovation in art can change the way the cultural reality is viewed and this can modify cultural beliefs or values. Art is one means for each new generation to learn its culture: past art as the culture was, and new art as the culture is becoming. As cultures converge their art may modify each other's.

4 *Most art is made for some social purpose.* It is used to influence others, to affect and inspire others, to interpret history, to amplify cultural events, to celebrate culturally defined life transitions, to enhance significant roles, and in some cases to express the essential abstract qualities of a culture's ambience. Most cultures provide roles for artists to carry out these social purposes. When we limit the kinds of art taught in a multicultural

society we limit the transmission of some of the subcultures.

5 *The different visual arts have subcultures of their own. They include the artists and the social networks of individuals who share their values and support their work.* Each of the arts develops a value system which differentiates it in some degree from the others in terms of purposes, aesthetic values, and criteria for criticism. Each has a distinguishing cultural history. For example, potters, weavers, quilters, jewelers, and fine, folk, and ethnic artists all belong to different subcultures within the broad category of art.

Fine art as identified in Western civilization has changed over time as the subcultures which support it and background cultures have changed. The values about what is good and acceptable fine art have gone through continuous modification as individual artists have broken the bounds of the acceptable and support groups have formed to promote it. Social change itself has affected the context in which fine art is accepted, sometimes after an artist's lifetime.

Sometimes an art emerges that meets many of the artistic criteria for inclusion as fine art, but is neglected because of social status reasons, as is the case with Black art and women's art. In the crafts, hierarchies have evolved that sometimes relate to quality, but more often to the status of the object. Fine crafts are taking their place in art museums and in the concerns of art critics, thus changing the concept of what fine art includes.

Our society also has distinct indigenous and old immigrant art cultures with their own sets of values. These include such diverse cultures as American Indian, Eskimo, Mexican Indian, Polynesian, Spanish, and Russian. Ethnic art cultures and their social systems have both long and short histories here. While for a long time these had European, African, Asian, and Middle Eastern art backgrounds, we now have ethnic art by persons from most parts of the world.

Among all these groups architectural form has been part of their cultural communication system. It has varied according to the cultural values of the group. As art, it communicates values and beliefs.

Folk art, which overlaps with ethnic art, has been part of our history from our earliest beginnings. It moved west with us and stayed strong in the lives of people everywhere whose values about art were to enhance the quality of their daily lives, and give pattern and meaning to it.

The overall culture of the crafts is divided into multiple groups with support systems for each different craft. A fine crafts network is growing stronger. Hierarchies of each craft are developing according to group criteria.

The networks of individuals and groups that support a type of art influence how an art develops. They are a strong motivating force for the creation of a kind of art or a type of political or social message. Among them they identify, evaluate, collect, disseminate, analyze, and defend the values of art. For example, without groups of collectors,

benefactors, curators, historians, theorists, critics, educators, and a supportive public, fine art as a body of art would be too elusive to study. Fine, crafted, folk, ethnic, popular, commercial, video, computer-assisted, and environmental arts all have social support groups that motivate, educate, critique, and distribute and maintain them.

Street art, protest art, and some forms of graffiti are social statements and represent groups of people trying to be recognized through their art.

All these arts play vital roles in our society. They all have histories, forms of aesthetic judgment, and criticism. They are all part of the art environment in which students need to critique, comprehend the historical and cultural meaning, and make aesthetic as well as social judgments.

6 *The new video and computer technologies are such pervasive communication art forms that we need to consider them as social factors of their own.* They are changing society as well as the cultures of art. Their use of design in time-space dimensions has more impact on more people than any other art. Children are being enculturated into the values of television and computer graphics, their speed, their fast transitions, their highlighting and abstracting of events. Growing up without other strong en-culturating forces, they may be learning this as a cognitive style for interpreting their experience in the other aspects of their lives. We can also assume they are more exposed to television and computer-based design and composition than any

others. This is further reinforced by reproductions in toys, games, and comics. Also, the changing styles that flow through these media affect costume, product, and graphic design as well. A growing body of research on television aesthetics and criticism, as well as television's effect on children, is available for us to use.

7 *Finally, American society today continues in a churning state of flux.* I have been observing and studying art, art learning, and education in their socio-cultural context for the last thirty or more years. Our ideological pendulum keeps swinging while our population and cultural diversity have increased. The social reforms of the sixties and seventies continue though less visible. Though some Black and white women have more options, more of them and their children live in poverty than before. For the first time in this country children generally can't expect to live as well as their parents. An average-income family cannot afford an average-price home. Social stratification is increasing. Density and deterioration in much housing is accelerating.

Our overall society is being further changed by the upswing in concern for ethnic, racial, and gender identity, the reaffirmation of cultural heritage, and the immigration of many more cultural groups. For example, there are eighty-two different languages spoken by school children in the Los Angeles public schools. Further, the core of American society is going through changes in mores and patterns of family

structure, child rearing practices, sex roles, life goals, and life styles. We can't talk about art in the schools without recognizing what changes society is having on those children in the schools. Further, the diminishing size of our middle class, around which the melting pot ideal and our educational system was developed, is also losing ground in the search for the good life.

All these points affect learners and the schools and increase the diversity found in single classrooms, whether they appear to be homogeneous or not.
Based on all the above I take the following positions:

First, I would include in DBAE study of fine arts, the art of our own ethnic and social subcultures, fine and applied crafts, folk art, costume, television, computer graphics, advertising and product design, architecture and environmental design, graphic design, art from other countries, and, where appropriate, street art and comics. How much of each and what sequence would depend on the particular students.

There are two reasons for including all these arts. One is that a majority of our students are very involved with a variety of these arts with which their art study can most effectively begin.

Children usually succeed in learning when the art they are analyzing, or the art they are creating, is culturally familiar and they can use already acquired cognitive skills. For a large majority of children in this country learning about fine or studio arts is a cross-cultural study. (This may be the most important statement I'll make here.) What we may see to attend to, to analyze, to critique, may be foreign to their way of seeing, knowing, and feeling.

Television may be the source of greatest exposure to art forms for children. Some teachers are successful in leading children from critiquing television to critiquing art. Others move from popular products to fine crafts. Students can learn to transfer their acquired skills in analyzing to subject matter they are less familiar with, as from folk art, to ethnic art, and then to cross-cultural art. We have to be willing to learn about their art in order to help them build bridges to other arts.

The other reason for including all these arts is that they are expressions of our complex of cultures. We need to comprehend this diversity to continue our society and build bridges of respect. When we thought of ourselves as a melting pot acknowledging diversity was not considered necessary. Now that we are recognizing that we indeed are multicultural, the arts can play an important part in building cross-cultural cohesion.

But it is a paradox in this country that commercial entertainment television operates as if we were still a melting pot and reinforces the common denominator of stereotypical values and attitudes. Our regional and cultural diversity is largely ignored.

The capacity for critical, independent responses to the arts, including television, is necessary for democratic survival. A

visually critical audience cannot easily be persuaded with visual innuendo or satisfied with the inept. Since the greatest consumers of television are children, education into the ways their art forms influence thought, feeling, taste, and behavior are critical.

The second position I take is that design needs to be upgraded and reintroduced as a studio art as well as a factor in critical, historical, and aesthetic areas of study.

Children need discriminating and judgmental skills in design to respond to the visual imagery they experience. Design varies among cultures. Teaching multiple design systems is required to reach diverse students. Exploring how people in different cultures design, make variations in order to express qualities and ideas, and make things work can lead students to become more aware of how design affects them in their own culture.

They also need to comprehend the ways they use design in their own art and environment for expressing self and group identity and in reacting to the identity of the rest of the people in society. They need to explore how visual qualities and design are used to influence how they think, how they feel, how they organize their reality, and how they make aesthetic judgments. Then they can learn to be independent critical judges and selectors among all the images projected to them. They can make their own expressions more effective through use of an appropriate design system. A majority will need design skills

to create viable living areas in less space at less cost.

The quality of most design in this country is not competitive in the world. This is affecting our well-being. Design has not been stressed in higher education for some time. We have not considered that education in design was necessary in general education, yet we are a product oriented society. Now we are paying a price for this. Public taste is more influenced by throwaway transitional values, while long-range design qualities have been less important. Now we need not only design reintroduced but multicultural studies of design for our present art education curriculum. These can be foundational to comprehending all the other arts including the fine arts.

The third position I take is that learning the other arts need not deprive students' ability to discriminate quality in fine arts. We can teach fine arts and fine crafts openly so that students can transfer their skills of criticism, historical awareness, and design to enjoy the different arts and evaluate the arts cross-culturally within and without our country. They can learn to enjoy and evaluate with aesthetic awareness the great traditions of the different folk and ethnic arts that nourish the lives of so many people without losing their ability to enjoy and discriminate in the fine arts.

Students can move more freely from fine arts or folk arts to analyzing the built environment between and within historical periods, and between folk, pop, and fine

architecture if we teach each type of architecture as it has developed in its own cultural history. If we teach art in terms of the values, attitudes, and belief systems that motivate artists or craftspersons it can be critiqued in its own context. Each period in fine arts history can be analyzed in terms of that period's costume.

Students' study of design, of artistry, of expressive qualities can be applied to all the arts in terms of each art's context. Some quality criteria may be found in many art cultures, but others may not. It requires a degree of cross-cultural relativism, but we can maintain aesthetic qualities within an art subculture in the degree that a culture's values about art remain stable over time. And when cultures are changing, we must keep track of those changes in order to understand what is happening.

In my fourth and final position I recommend that a fifth discipline be added—that of *socio-cultural art*, which addresses both its teaching and content.

The disciplines already being used by DBAE have mainly been developed around the studio arts. Though some art critics, some art historians, and some aestheticians are considering cultural factors, they have yet to recognize how much these disciplines are culturally embedded in Western modes of thought.

To get at the aesthetics, the history, and the systems of criticism of the other arts and in arts of other cultures, the relation of the art, the artists, and the people to each other must be studied in terms of their specific cultural value system. Aesthetic responses are learned by experience in a culture—what is or isn't considered to have artistic value, or what those values are. Such values emerge and are maintained as a cultural group evolves.

Some of the components of a fifth discipline would explore:

1 How a given art expresses cultural concepts of reality, values and belief systems, and patterns of behavior

2 How design and artistry are developed in different cultures

3 How artists are motivated, conditioned, inspired, and rewarded by cultural mores

4 How art is used to transmit and maintain culture, and how a single artist can change a culture

5 How the values of the different subcultures of the fine arts, crafts, electronic media, folk arts, popular arts, etc., direct the development of these arts and affect artists

6 How aesthetic responses can be compared between the art subcultures of fine, folk and ethnic arts, and crafts, and the popular arts and electronic media

7 How art can be compared cross-culturally within and without the country

8 How culture affects one's own art values

9 How teachers can recognize and find information on the cultural patterns of students in their classrooms in order to adapt curriculum to their cultural as well as psychological aptitude

10 How all these arts can be used to help us comprehend and apprehend the nature of the society in which we are living

This field has a history of several decades in art and education and has an established literature. The International Society for Education through Art and its worldwide regional sections, particularly Canadian, American, and European, and a section of the National Art Education Association are devoted to social issues. All produce journals and reports in this area.

The just-published U.S. Society for Education in Art (USSEA) issue of the *Journal of Multicultural and Cross-Cultural Art Education* reports on the international conference on this subject in Vancouver last summer. An anthology on *Art and Democracy*, edited by Blandy and Congdon and to be published next fall by Teachers College Press, will be a major and challenging addition to this field. It addresses a wide range of visual arts as viewed in the context of a multicultural democratic society.

Some of our textbook writers and researchers include in varying degrees the

affect of culture on art. But much remains to be done as in even the most established disciplines.

How could this be done given time and curricular restraints in public education, and be incorporated in the content of teacher education? The socio-cultural aspects of art should be included as a foundation for art education curriculum development and teacher education. Teachers should then be prepared to select those arts most appropriate from the complex of students' cultures represented in their classrooms. Learning to critique their own arts in depth—whether graffiti, television, or whatever—and exploring how these skills can be used in critiquing others' arts would prepare students to be more aesthetically, visually, and culturally literate in the rich stew of the diverse American society. It would prepare more of them to respond to the fine arts and crafts, respect the folk and ethnic arts of their own and other cultures, be more active critics of mass media, and more caring of our shared environment.

We can be expansive in our teaching of art, not putting one art down at the expense of another, but helping students see each art in its socio-cultural context and then making judgments about its value in its context. Thus, more students could learn to respond to the culture of the fine arts with enriched awareness of its place among all arts, in history, and between cultures.

Bibliography

Blandy, D., and Congdon, K.G., eds. n.d. *Art in a Democracy*. New York: Teachers College Press. Forthcoming.

Boyer, B. n.d. "Cross-Cultural Studies in Aesthetic Behavior with Implications for Art Education." *Visual Arts Research*. Forthcoming.

Brislin, R.W. 1983. "Cross-Cultural Research in Psychology." *Annual Review of Psychology* 34:363-400.

Chalmers, G.F. 1973. "The Study of Art in a Cultural Context." *Journal of Aesthetics and Art Criticism* 32:249-56.

_____. 1980. "The Art of Contemporary 'Tribes': Using the Methods of Cultural Anthropology to Study the Out-of-School Arts of Our Students." In *Arts in Cultural Diversity: INSEA 23rd World Congress*, ed. J. Condors, J. Howlett, and J.Skull. Sydney and New York: Holt, Rinehart & Winston.

Congdon, K.G. 1984. "A Folkloric Approach for Teaching Folk Art: Benefit for Cultural Awareness." *Journal of Multi- Cultural and Cross Cultural Research in Art Education* 2(1):5-13.

Degge, R.M. 1985. "Models for Visual Aesthetic Inquiry in Television." *Journal of Aesthetic Education* 19(4):85-102.

Geertz, C. 1973. "Thick Description: Toward an Interpretative Theory of Culture." In *The Interpretation of Cultures*, ed. C. Geertz. New York: Basic.

_____. 1983. *Local Knowledge*. New York: Basic Books.

Hamblen, K. 1986. "Three Areas of Concern for Art Criticism Instruction: Theoretical and Research Foundations, Sociological Relationships and Teaching Methodologies." *Studies in Art Education* 27(4):163-72.

Handler, R. 1984. "On Socio-Cultural Discontinuity: National and Cultural Objectification in Quebec." *Current Anthropology* 25:56.

Herskovits, M.J. 1959. "Art and Value." In *Aspects of Primitive Art*, ed. R. Redfield, M.J. Herskovits, and G.F. Ekholm. New York: Museum of Primitive Art.

Hofstede, G. 1984. *Culture's Consequences: International Differences in Work-Related Values*. Cross-Cultural Research and Methodology Series, vol. 5. Beverly Hills: Sage.

Jones, B.J., and McFee, J.K. 1986. "Research in Teaching Arts and Aesthetics." In *Handbook of Research on Teaching*. 3d ed. A Project of the American Educational Research Association. New York: Macmillan.

Kluckhorn, C. 1951. "The Study of Culture." In *The Policy Science*, ed. D. Lerner and H.D. Lasswell. Stanford, Calif.: Stanford University Press.

McFee, J.K. 1980. *Art, Culture and Environment*. Dubuque, Iowa: Kendall Hunt.

_____. 1980. "Cultural Influences on Aesthetic Experiences." In *Arts in Cultural Diversity: INSEA 23rd World Congress*, ed. J. Conders, J. Howlett, and J. Skull. Sydney and New York: Holt, Rinehart & Winston

_____. 1984. "Analysis of the Goal Structure and Social Content of the 1965 Penn State Seminar and the 1983 Getty Institute for Education on the Visual Arts

Report." *Studies in Art Education* 25(4):276-81.

_____. 1986. "Cross-Cultural Inquiry into the Social Meaning of Art: Implications for Art Education." *Journal of Multicultural and Cross-Cultural Research in Art Education* 4(1):6–16.

_____. 1986. "Describing the Network Called Art Education." *Annual Journal, Canadian Society for Education Through Art* 17:7-12.

_____. n.d. "Cultural Dimensions in the Teachings of Art." In *The Foundations of Aesthetics, Art and Art Education*, ed. F.H. Farley and R.W. Nepurud. New York: Praeger. Forthcoming.

Paige, R.M., and Martin, J.M. 1983. "Ethical Issues and Ethics in Cross-Cultural Training." In *Handbook of Intercultural Training*, ed. D. Landis and R.W. Brislin, vol. 1.

Triandis, H.C. 1983. "Essentials of Studying Cultures." In *Handbook of Intercultural Training*, ed. D. Landis and R.W. Brislin, vol. 1.

A RESPONSE TO JUNE KING MCFEE'S "ART AND SOCIETY"

The initial premise which gave rise to this seminar issue on art and society is that "discipline-based art education is focused upon the fine arts." I think this is the way things are, but not necessarily the way things ought to be. We do generally assume that the paradigms and exemplars of art selected for discipline-based art education DBAE derive from traditional art categories such as painting, sculpture, and architecture. Why this is so turns largely upon historical circumstance. The community of scholars, including historians, critics, and aestheticians, whose studies provide inspiration and models, have focused upon their subject areas *as if they were* restricted to the traditional fine arts. There is the occasional historian who casts the net further, into such areas as folk art or computer art. But generally, as Oscar Wilde put it, art consists in drawing the line somewhere, and such scholars usually draw the line at media and electronic imagery. In the universities, for example, film and video are not, as a rule, taught in the art department, but in film, broadcasting, or communication departments.

It is possible to conceive of scholarly inquiry that offers convergent interests to art historians and, say, colleagues in a cinema department. For example, a study of Salvador Dali's surrealism might range from *Persistence of Memory* to *Un Chien Andalou*. Such correspondences seem to offer natural opportunities to emphasize in discipline-based art education the relationships which may exist among different forms of visual expression. But despite such possibilities the subject area boundaries remain strong, and DBAE is perceived to articulate art history, not film history, as a source of content. June King McFee's arguments, and mine, are intended to nurture visions of an expansive concept of the fine arts. But it is, to a degree, an uphill battle.

There is, unmistakably in the academic community, an elitist notion which distinguishes the high road (i.e., fine arts) from the low road (i.e., popular culture). Film, television, advertising, and product design are all consigned to the latter, a kind of visual purgatory. Some have suggested that because such visual forms are "popular" they need not be taught in schools, but I think that misses the point: if they offer qualities for visual perception that help a student to notice and appreciate visual form, it seems to me they are entitled to a place in art education. The fact that some art historians may regard electronic imagery, for example, as a questionable subject for scholarly study and status ought not to dissuade us from considering its utility for discipline-based art education. In fact, in recent years the inquiry about the nature of visual form has been broadened by historians, critics, aestheticians, and artists. The implications for "art" are profound, and suggest a widening rather than a narrowing of definitions. Professors of film, preoccupied with the latest wrinkles in semiotic theory,

Stephen Mark Dobbs
San Francisco State
University

for example, can now compete for esoteric posturings with any art historian.

Nevertheless, say the traditionalists, this doesn't mean our art museums ought to begin giving equal time to exhibits of television arts. The fact that some museums have allowed a modicum of video (i.e., Nam June Paik's work in the Whitney's Biennial) and computer art into their galleries, and that film programs are much in evidence, suggests that the pressures and trends of the contemporary art scene may have brought some curators to their knees. Anyway, the venerable Museum of Modern Art in New York enshrined photography and product design in their galleries decades ago.

But why accept an antediluvian and narrow concept of art in the first place? There is nothing in the Clark, Day, and Greer monograph on discipline-based art education that precludes the uses of non-fine art objects for illustrating ideas about visual form. Furthermore, some critics and aestheticians, such as Morris Weitz, have long concluded that an all-inclusive statement defining the essence of art is impossible, and the mutability of art appears to bear this out. Historically, yesterday's experiment may be tomorrow's old master, as once daring styles are transformed from boundary breakers into establishment darlings.

Nevertheless, the historian and critic of modern art studies Jackson Pollock, not Michael Jackson. Traditionalists would say

that *Thriller* is not art, even if it's artistic. We are a society anyway which is confused about what and who is an artist. Julia Child is an ''artist'' in the kitchen, Vidal Sassoon in the hair salon, called, incidentally, the ''beauty shop.'' The Oscar ceremonies are sponsored by the Academy of Motion Picture *Arts* and Sciences. Certainly there is considerable artistry in Raymond Lowey's Coca-Cola bottle design. The issue is: does it deserve the same attention in art education as Brancusi's birds? Is it arbitrary or culturally elitist to exclude one interesting and stimulating visual form but include another because of the uses to which they are put? Andy Warhol's Coca-Cola images symbiotically bridge the fine art and popular art worlds and blur the distinction.

Returning to our questions, it might be rephrased: what conceivable grounds are there for *excluding* such art categories, from discipline-based art education, as television, video, film, advertising, computer art, product design, crafts, and folk art? After all, artists themselves have been working in these formats for decades and have been themselves responsible for pushing back the boundaries of art. Shall we say that what art museums exhibit, or what scholars study for its aesthetic power, may be labeled art and included in our curricula? Then objects from all of the above forms could be included. From Marcel Duchamp's bicycle wheel on a stool to Nam June Paik's video screens our criteria for treating certain imagery and

objects as art have been in constant flux. Today's artists, with their core training in painting, sculpture, and other fine arts, often blend their works with elements drawn from film, dance, theatre, and popular culture. The very production of works of art has also become the subject of aesthetic attention, from action painting to contemporary performance art.

Thus, the ground is set for searching widely for appropriate art content for discipline-based art education. This is not only sound artistically, it is sound educationally. We have learned from Rudolf Arnheim that perception begins with gross and general differentiation, and proceeds gradually to what is complex and subtle. We must grasp the large and more obvious differences before we can notice and articulate more subtle distinctions. The selection from a wide array of visual forms provides more opportunity for arranging such configurations of form for perception, with the consequence of better educating our artistic vision, as Elliot Eisner has put it. The selection ought not to depend upon the designation of one object as fine art and another as popular culture, but upon which object presents for perception and aesthetic attending the qualities which it is our purpose to help students notice.

In addition to the considerations thus far mentioned, one of the most compelling reasons for broadening the scope of art content for DBAE has been eloquently stated by June King McFee in her paper,

which exhibits that humanity and compassion which runs consistently through her writings, as an art/social consciousness, over the years. There is care and concern in her words for the social context and real world in which students are to learn about art, and for the messages that art carries. McFee has reminded us of the aspirations for an egalitarian educational system which respects and inquires about cultural differences. She insists on acknowledging the rich spectrum of expression which exists in a multicultural democracy.

The alternative visual formats or modes at issue here—film, television, product design, folk art, and others—are often the major vehicles through which the values and ideas of subcultures in American society have their opportunities to be expressed or made visible. They may even prefer such formats to the traditional fine arts; can we exclude them from discipline-based art education? On this basis alone they are entitled to our attention in art education and as sources of content for the art curriculum. Through them we can learn, as McFee puts it, to "be expansive in our teaching of art, not putting one art down at the expense of another." In fact, such "enriched awareness," as she calls it, will only increase students' appreciation of what a more specialized spectrum of cultural choices in the fine arts can provide. The ultimate arbiter of selection in both instances—sources in "fine art" and sources in "popular culture"—must be

quality. We are not endorsing "anything goes." Curriculum developers and teachers must select to high standards, whether they choose to use a painting, a ceramic, a household object, or a media advertisement.

I want to end on a pragmatic note. Discipline-based art education needs legitimation from all of the various constituencies and communities in which its concepts may be assimilated and deployed. We should not ignore, as June McFee asserts, the multicultural equivalents of fine arts for the millions of minority and ethnically diverse youngsters now in American schools. We cannot ignore the ever-changing face of art which may invest the fine-popular distinction with more conceptual and practical baggage than it is worth carrying. Teachers of art are more likely to succeed if they utilize the existing social context, at least as a point of departure for helping students see the rich and interesting visual forms created by other cultures in other times and places. There are so many aesthetically and intellectually intriguing visual categories awaiting our attention. In some art museums and scholarly journals these have been awarded sanction as art, and in others they have not. Discipline-based art education ought to render its own verdicts, especially when such alternatives are so accessible and attractive to students and teachers alike. Folk art and crafts, media, and computer imagery are important sources of information, feeling, and power to young people all over the world. The

impact of form in a quality industrial product affects the aesthetic senses of people across national boundaries, both physical and linguistic. They provide bonds which are as important to understand and appreciate aesthetically as are the motivations of Monet.

That such alternative visual forms are a part of students' lives is unavoidable. That they often possess visual qualities worthy of our aesthetic attention is inevitable. We should not fail to recognize their appropriateness and utility for the purposes of discipline-based art education.

CURRICULUM REFORM:
SOME PAST PRACTICES AND CURRENT IMPLICATIONS

The task given to me is to review a number of past proposals for educational change, identify some of their strengths and shortcomings, and suggest how the lessons to be learned from these might provide cautionary material for implementing discipline-based art education (DBAE) programs. Two immediate problems with this present themselves, one procedural, the other substantive. Procedurally, the problem is to determine a dateline beyond which it is unproductive to venture in identifying and describing educational movements. Substantively, the problem is to separate shortcomings of the curriculum materials themselves from those intro- duced or superimposed upon the material by market pressures and political agendas.

I have responded to the problem of datelines by choosing not to retrieve material from a period prior to 1960, even if its influence has been profound and persistent. While I am sensitive to the appearance of William T. Harris' 1895 listing of subjects for school study under what must be one of the more picturesque labels in the history of curriculum, the "five windows of the soul" (Schubert 1986); while I note that John Dewey had, in 1902, introduced the idea that education involved continuous interaction between learner, society, and subject; while I perceive George Counts' 1932 admonition that the schools should build a new social order to be linked in spirit to the writings of contemporary critical theorists, yet to forestall curricular indigestion a cutoff

must be made. The launching of the Russian satellite *Sputnik* in 1957 delivered a jolt to North American pride in educational achievement that resulted in a succession of programs grasped, embraced, and abandoned by governmental bodies for whom the intimation to "move up, or move over" took on unpleasant stridency. Jerome Bruner's *The Process of Education* was published in 1960 and provided what appeared to be at once a new direction, an answer to the immediate problem of finding a tough-minded alternative to allegedly soft-centered programs, and a vehicle for the drive to catch up with the Russians. From that point this paper begins.

Bruner's approach to education was built upon three premises: first, that each field of study, or discipline, had a distinctive structure; second, that the learning process assumed a spiral form wherein concepts could be reintroduced at increasing levels of complexity; and third, that learning required a professional attitude modeled upon successful examples in the work place. At least some of Bruner's ideas were developed out of a conference sponsored by the Education Committee of the National Academy of Sciences, held at Woods Hole, Massachusetts, in 1959. It is therefore not surprising, especially when set against the *Sputnik* launch, that the thrust of *The Process of Education* was towards scientific inquiry.

Neither is it surprising that Bruner, whose notions of development had

Ronald N. MacGregor
University of British
Columbia

much in common with those of genetic epistemologists like Jean Piaget, should favor a learning model in which people are recognized for their similarities rather than their differences; hence, he writes that

> *intellectual activity anywhere is the same, whether at the frontier of knowledge or in a third grade classroom. What a scientist does at his desk or in his laboratory, what a critic does in reading a poem, are of the same order as what anybody else does when he is engaged in like activities—if he is to achieve understanding. The difference is in degree, not in kind (Bruner 1960).*

The irony of these words, with their connotations of a single scientific attitude which, once grasped, leads one to fortune, should be apparent to anyone who has read *The Double Helix* (Watson 1968), the account of Watson and Crick's discovery of the structure of DNA. Francis Crick was, indeed, a structuralist; Watson, by contrast, loved to puddle around with information. Together, they were a formidable research team; separately, they typified two quite different scientific styles, one of them not amenable to a classically structured approach. Scientists, like literary critics, come in different types and flavors, partly shaped by their area of specialization, and partly by their individual interpretation of the cosmos and their relationship to it.

While Bruner was clearly a proponent of structure in learning, its translation into practice led him to multiple descriptions of structure rather than to a single definition. Efland (1984) has noted two of these: structure in the cognitive sense, as a mode of organizing mental operations, and structure in the taxonomic sense, as forms for storage and retrieval of information.

Bruner quotes Piaget's collaborator Barbet Inhelder at length on the subject of presenting structurable material in concrete terms so that children at pre-formal levels can understand what is going on. Inhelder notes that it might be instructive "to devote the first two years of school to a series of exercises in manipulating, classifying, and ordering objects in ways that highlight basic operations of logical addition, multiplication, inclusion, serial ordering, and the like" (Bruner 1960). Bruner, however, at that time begged the question of the usefulness of these kinds of operations in subjects like literature. He did not mention art specifically, either in *The Process of Education* or in *Toward a Theory of Instruction* (1968), a collection of essays that were essentially reflections of the role of cognition in educational goal setting and goal attainment. He suggests, though, that in curriculum planning in general, what matters is "the inherent structure of the material, its sequencing, the psychological pacing of reinforcement, and the building and maintaining of predispositions to problem-solving."

There is an assumption of consensus in this that seems not to hold up in the practice of art. In the sense that Bruner

means it, structure, though inherent, is potentially discernible to any researcher. Though my taxonomy may initially be different from yours, it is more than likely that we will eventually pool our resources in a commonly accepted, more complete model. Hence, in medical practice new diseases may initially be given different names because different groups of symptoms are noted, but these are finally recategorized within a more comprehensive disease profile, usually to everyone's satisfaction.

The inherent structure of art is different. It has its taxonomies, but whatever structure these form part of seems not to act as the exemplar or focus or desired model for all who make art. The process owes more to back room tinkering than to up-front science. It manifests itself in different teaching exemplars, as Thelen pointed out. He described three types—shapers, enablers, and strategists. With the possible exception of the shapers, the quest for most of these teaching types was, as John Dewey succinctly remarked, not the approximation of standards, but instead the explication of values (Dewey 1932).

Within a decade of writing *The Process of Education*, Bruner was presented with evidence of the confounding effect that the values of the learners may have on material structured towards impeccable scientific ends. *Man: A Course of Study* was an anthropology-based program partly formulated and developed by Bruner. It was structured around three questions:

What is human about human beings? How did they get that way? How can they be made more so? Several episodes were filmed of incidents in the lives of the Netsilik Eskimo, and in one of these a young boy was shown attacking a sea gull. However logical and necessary it may have been to the Netsilik mother to stand by while her proto-hunter son stoned a sea gull to death; however reasonable it may be to the anthropologist to classify the incident as one of a repertoire of hunter-gatherer skills, many North American children were outraged and bewildered by what they perceived as beating up on a poor bird.

Man: A Course of Study brought into the open what the reader of *The Process of Education* might have suspected, and what minority groups during that period came to realize in their examination of educational opportunities: that structure-based programs are taught by persons for persons, and that without a sense that one's personal motives and feelings are being considered, individuals rapidly become alienated from the content of the program and ultimately from the institutions that profess it.

Curriculum developers in the early 1960s seized upon Bruner's ideas and set about packaging them in texts and kits, aided by taxonomies such as those developed by Bloom, Krathwohl, and Harrow. This form of academic merchandising provided an appropriate modus operandi for a group of educators, including Robert Mager, who reduced the content of programs to a series

of steps encompassing the selection of an instructional objective in terms focusing on performance, and establishment of a criterion for measuring the specific behavior demonstrated by the subject as a result of undergoing the process. Mager's book, *Preparing Instructional Objectives*, attempted to resolve some of the problems teachers had in breaking down those concepts that were part of Brunerian thinking by fractionating them as series of explicit objectives and terminal behaviors.

Preparing Instructional Objectives at least had the redeeming quality of being amusingly written. Most of the hilarious moments in a process that lasted for over a decade and generated enough objectives to keep educators supplied well into the next century came from detractors of the competency-based movement, rather than from its protagonists. These critics delighted in taking a simple operation, such as sharpening a pencil, and so hedging it about with qualifiers and details that it assumed the kind of complex character normally associated with moving a division of infantry. The analogy is not totally accidental; military minds were early converts to breaking complex operations into even more complex suboperations by attempting to expunge the possibility of human interpretation or initiative. More seriously, Ryle (1979) and Eisner (1973) attempted to show how competency-based instructional models met only a small part of educational imperatives when viewed across the curriculum. Areas for which

competency-based programs did seem appropriate included computer familiarization, and it is perhaps a reflection of the North American preoccupation with this form of technology, along with administrative desires to be visibly accountable to political bodies for improved performance on the part of students and teachers, that kept this movement alive under various labels throughout the seventies and into the eighties.

While competency-based programs were being assembled by one sector of the educational community, another was attempting to show that knowledge, far from being impartial, was a commodity conferring power on those who controlled it, to the exclusion or detriment of those who did not. At first evident in the counterculture of the 1960s in the form of imported philosophies ranging from Zen Buddhism to the skeptical sociology of Herbert Marcuse, all in the end attempted to reveal the limitations of mainstream enlightened pragmatism. By the mid 1970s, a continuum could be identified. At one end stood conflict theorists like Michael Apple, who categorized the education process according to political power groups engaged in an ongoing struggle with those individuals, more anarchic than the norm, who worked to subvert it. At the other were gentler reconceptualists, such as Pinar and Aoki, whose emphasis was on self-discovery and self-assertion as means to achieve liberation from unauthentic influences. For both groups critical praxis,

the embodiment of theory in action rather than consignment of ideas to redefined categories, was at once the goal and the means of achieving it.

Huberman (1987) has provided a personal account of coming face to face with conflict theory when, as a graduate of an American educational psychology program, he went to Europe to conduct research. While admitting that, as an educational platform, conflict theory has the virtue of preventing over-inflation of expectations on the part of the researcher, Huberman concludes that his meliorist stance, that sense that intervention brings improvement, is one with which he can more happily live. The problem with protest movements (which are essentially what Michael Apple and other conflict theorists are leading) is that they tend not to give the attention to providing alternatives that they give to diagnosing problems. Education, for practical purposes, needs both.

The reconceptualist end of the continuum suffers from a similar shortcoming, given the phenomenological nature of much of its research. If, as some reconceptualists claim, knowledge is created by individuals who then control it for their own use, it is difficult to see how growth in individual self-awareness can be translated into decisions taken on behalf of others on what is to be covered in school programs, or how those others may be persuaded to adopt those decisions.

The reconceptualist position is different from the others summarized in this paper in that it centers attention upon the individual as a contributing actor, rather than regarding the individual as a channel through which knowledge is brought to light. Curriculum theorists have to rely on classroom teachers to transmit ideas, and sometimes they neglect to note that transmission is bound to be accompanied by translation. Nils Bohr once admonished Albert Einstein to stop telling God what to do; his admonition was probably unnecessary, since God no doubt had other matters to occupy him at the time. Curriculum theorists continually tell teachers what to do, but sometimes forget that teachers, too, have their own agendas to occupy their attention.

The nature of the relationship between theory and practice is marked by particularity, practicality, and the eclectic usage of viewpoints selected in turn because of their appropriateness for different aspects of the phenomenon under study. This sounds something like Levi-Strauss' (1966) notion of *bricolage* (that is, making do with whatever is handy); an impression reinforced by Schon's (1983) description of teaching as knowing-in-action, a state and a process in which the professional "acts his mind." The professional stance, says Schon, selectively manages material, spinning out lines in the course of attempts to change them, and changed in the course of attempts to understand them.

The teacher contributes practical knowledge to complement the theoretical

knowledge supplied by the curriculum developer. Elbaz (1981) identified the content of practical knowledge as knowledge of subject, curriculum, instruction, self, and milieu. While the curriculum theorist might be expected to have a similar, even better knowledge of the subject than the classroom teacher, the teacher's knowledge of self and milieu cannot be approximated by the theorist. Connelly and Clandinin (1985) claim that those essentially teacher-generated components provide material for narratives-in-action, expressions of personal history and biography called forth by particular situations that give life to the material being presented.

Discipline-based art education grew out of a model developed by Barkan in the 1960s. Barkan's debt to Bruner is explicitly mentioned in regard to the significance of teaching fundamental structure in art, in the differences of degree rather than kind that may be predicated between the activity of the artist and the activity of the third-grade student, and in the notion that to learn through art, one must act like an artist (Barkan 1962). Barkan, uneasy with the science-based version of structure that Bruner had described, distinguished between the formal structure of the sciences and the analogical and metaphorical structures of the arts. These latter, he argued, might be observed in the control exercised by artists at work. In exercising control artists "engage in structured inquiry which is disciplined" (Barkan 1966).

Barkan is evidently in this instance using discipline in a sense different from that used by Bruner. For Barkan it is adjectival, a recognition of something occurring that is person- and situation-specific, while for Bruner it is both a logical grouping of elements and relationships and a general cognitive process. Just as Bruner neglects to provide paradigm cases of scientists and literary critics, so Barkan makes no specific mention of artists who best exercise the control by which discipline is recognized.

Even if one could fix upon a handful of exemplars representative of the entire art producing community, it is unlikely, if Schwab is correct, that these exemplars will find their way into the classroom and out again as important models for students. Instead, teachers are likely to point to local examples or invite students to work out their own ideas of what artists do, or ought to do.

The problems created by fixing on structure-based methods of program development are, therefore, problems of structure identification and definition, and problems of ensuring that structure is not bent out of shape during implementation. Positions that are structure-dependent often lack built-in slippage, and attempts at bending them run the risk of totally dislocating them.

The warning provided to developers of discipline-based art education by the indifferent record of competency-based programs is that in elaborating the parts, teachers and students are all too likely to

lose sight of the big picture. Any recipe book will provide instructions on how to make lentil soup: precisely measured quantities of lentils, celery, onion, and even a careful description of the ham bone included for stock. What it cannot do is cover the fact of its being cooked in a fifteen-year-old pot, or being left to simmer near the back of the stove for anything from a few hours to a day or two, or being served on a blustery February day, any combination of which can make the difference between eating lentil soup and enjoying a gastronomic experience. The difference between recipe and experience is the difference between curriculum as planned and curriculum as lived. It is reaction to curriculum as lived, by teachers, students, and the community at large, that finally writes the history of educational innovation.

In contrast to structuralist and competency-based approaches, both of which have been adopted with some enthusiasm by various school districts and states, conflict-theoretical models have never, for obvious reasons, had much chance of being operationalized in school programs. Chet Bowers, for instance, has since the early 1970s been advocating a program wherein students would be encouraged to perceive values and explanations as expressions of social consensus at a given time, to be redefined as they become obsolete. Students would learn to take control of their own situations rather than handle material presented as

objectified and absolute (Bowers 1974). No system has expressed interest in following through on Bowers' proposals, despite his warnings that there can be no change in society until participants in the learning experience become actively involved in shaping its direction. Political Cassandras in North America are doomed to suffer the fate of Cassandras everywhere of being listened to with varying degrees of tolerance and, at best, serving to exercise a little cautionary influence on planners who would otherwise run to excesses in centrally controlling education.

In this respect, discipline-based art education is not different from most programs now taught in schools. Its content is to a large extent pre-determined and conservative, carrying clear signals to the teacher about what should be taught, and focusing on the aesthetic rather than social properties of art works. It could be recast in political terms, though Marxists have so far been the only political group willing to analyze art systematically in this way, and it seems unlikely that one could find enough of them in any one spot in North America to undertake the task. It seems more likely that modest political agendas will be apparent in local requests to include in the program material of particular cultural, ethnic, or social importance.

What may have particular consequences for discipline-based art education, particularly in light of the increasing involvement of school districts in translating DBAE

ideas into classroom activities, is early acceptance of the active parts taken by teachers as well as curriculum developers in the enterprise. Developers should not be taken aback if, despite attendance at summer institutes and implementation seminars, teachers will present information and handle classroom dialogue in ways that produce outcomes unintended by the designers of the course.

Nor should DBAE planners be dismayed to note that educators who have no formal connection with the program are developing their own versions, based on whatever knowledge they have, or impressions that they have formed about the nature of the program. Both forms of activity are healthy and can have positive effects on the program's evolution. Certainly, the last thing DBAE personnel ought to do is play the role of dog with a bone, snapping and growling at anyone who attaches a discipline-based label to a privately generated program.

Music education provides an example of how a program may become diversified yet retain an official character. The Orff method of music education is formally handled by the Orff Association which awards credentials to those who complete its courses. At the same time, Orff courses that carry no Orff Association credit are available at several universities to education students who will, it is argued, benefit from exposure to the precepts of the Orff method without having to make the time commitment required by the Orff

Association. The Orff Association does not necessarily like it, but enough graduates of what might be termed "pirate" Orff courses later take Association courses because of the interest generated by that initial exposure and keep the Association's reaction from reaching an actively hostile level.

Simply put, no one can corner the market in knowledge. Instead, one can promote a position and draw attention to the shortcomings of evident alternatives if need be.

As for DBAE-sponsored programs that take local forms different from those offered by leaders of summer institutes, one might reconsider these apparent aberrations in light of what Schubert (1986) has called "curriculum ecology." He describes it as "the interdependent network of curricula, planned and unplanned, that forge the outlooks and ideals learned in a culture, society, or world." An ecological approach recognizes that learning occurs in several milieus, within and outside school, something that is compatible with DBAE's commitment to using agencies such as museums, agents such as practicing artists, historians, and critics operating within their own working environments, and the larger community as a repository of artifacts for aesthetic contemplation and discourse.

My own suggestion for a model for the implementation and appraisal of educational programs is borrowed from biology, not the growth of individual

organisms, as employed by Bruner and Piaget, but the evolution of species as originally proposed by Charles Darwin. Bruner's sole reference to Darwin occurs in a negative context, for he contrasts Darwin's ideas about the irreversibility of genetics with the reversibility, the ups and downs, of cultural history (Bruner 1968). But Darwin has a number of things to say that carry positive and appropriate educational messages. First, his observation that variations within species are local and random has much in common with the observations of Connelly and Clandinin (1985) that the nature of programs in action is determined by the character of a situation, or its locale, as it affects and is interpreted by teachers with specific career histories. Second, the claim that species vary, and that each species endows its family of subspecies with something of its own character, should reassure those who fear that the aims of discipline-based art education, as originally articulated, may be diluted and lost as the program evolves. At the same time, planners should regard this principle as an endorsement for creating enough flexibility within categories to guard against the monotony of invariance.

A third evolutionary principle is that changes are most likely to occur where prevailing patterns exert least influence. The inference for discipline-based art education is that, having established a frame within which a program may be conducted, the authors of that program are most likely to stick closely to that script

and to be in the least favored position to recognize innovations that would advantageously affect its further development. The 1985 Scottsdale seminar on discipline-based art education, and meetings like this present one, create occasions where different voices are heard. I would suggest that in the implementation phase of discipline-based programs, geographic distance between an instructional center and the more remote teaching situations may turn out to be a positive asset rather than a cause for concern, in that lacking a readily available source of feedback, teachers may have to work out solutions for themselves and take responsibility for them.

Traditionally, the Tylerian sequence of establishing purposes, devising experiences for their attainment, organizing those experiences, and evaluating the results has been divided so that curriculum developers take care of the first two steps and class room teachers take care of the last two. Furthermore, curriculum implementation has traditionally proceeded as though the curriculum were an inert body of material, to be delivered like the morning's mail to students, with some allowance made for aptitudes and situations. This kind of model's initial impressions of clean cut simplicity is misleading. Curriculum building, as described by contemporary writers, is messy, dynamic, interactive, and evolutionary.

Bruner commented that "each generation must define afresh the nature, directions, and aims of education to assure

such freedom and rationality as can be attained for a future generation. For there are changes both in circumstances and in knowledge that impose constraints on and give opportunities to the teacher in each succeeding generation. It is in this sense that education is in constant process of invention" (Bruner 1968).

The message for discipline-based art education as a movement is clear. The discipline-based programs of the 1960s have little in common with discipline-based programs in the 1980s, because curriculum itself has acquired a new definition. Neglecting to consider how teacher and students might together interpret materials, or that the situations in which learning occurred might affect what was valued and what was rejected, blunted the impact of 1960s programs. Packaging their contents bled off the excitement that people like Bruner had felt when they first presented their ideas to the public. Failure to develop visible examples of successful structure-based programs resulted in the movement trickling to a standstill.

Discipline-based art education must, if it is to be successfully implemented, be translated as a curriculum that is to some extent participatory and open-ended. Only by doing so will it accommodate the objectives of curriculum developer and classroom teacher alike, and bring about the benefits that its authors desire.

Bibliography

Barkan, M. 1962. "Transition in Art Education: Changing Conceptions of Curriculum Content and Teaching." *Art Education* 15(7):12-18, 27.

_____. 1966. "Curriculum Problems in Art Education." In *A Seminar in Art Education for Research and Curriculum Development* ed. E.L. Mattil. USDE Cooperative Research Project No. V-002. University Park: Pennsylvania State University.

Bowers, C.A. 1974. *Cultural Literacy for Freedom*. Eugene, Oregon: Elan.

Bruner, J. 1960. *The Process of Education*. Cambridge: Harvard University Press.

_____. 1968. *Towards a Theory of Instruction*. New York: Norton.

Connelly, M., and Clandinin, D.J. 1985. "Personal Practical Knowledge and the Modes of Knowing: Relevance for Teaching and Learning." In *Learning and Teaching the Ways of Knowing*. 87th Yearbook of the National Society for the Study of Education, ed. E. Eisner. Chicago: University of Chicago Press.

Counts, G. 1932. *Dare the School Build a New Social Order?* New York: John Day.

Dewey, J. 1902. *The Child and the Curriculum*. Chicago: University of Chicago Press.

_____. [1932] 1958. *Art as Experience*. New York: Capricorn.

Efland, A.D. 1984. "Curriculum Concepts of Penn State Seminar: An Evaluation in Retrospect." *Studies in Art Education* 25(4):205-211.

Eisner, E. 1973. "Do Behavioral Objectives and Accountability Have a Place in Art Education?" *Art Education* 26(5):2-5.

Elbaz, F. 1981. "The Teacher's 'Practical Knowledge': Report of a Case Study." *Curriculum Inquiry* 11(1):43-71.

Huberman, M. 1987. "How Well Does Educational Research Really Travel?" *Educational Researcher*, 15-16 (January–February):5-13.

Levi-Strauss, C. 1966. *The Savage Mind*. London: Weidenfeld & Nicholson.

Mager, R.F. 1962. *Preparing Instructional Objectives*. Palo Alto, California: Fearon.

Ryle, G. 1979. *On Thinking*. Oxford: Blackwell.

Schon, D.A. 1983. *The Reflective Practitioner*. New York: Basic Books.

Schubert, W.H. 1986. *Curriculum: Perspective, Paradigm, and Possibility*. New York: Macmillan.

Schwab, J. 1971. "The Practical: Arts of Eclectic." *School Review* 79(4):493-542.

Watson, J.D. [1968] 1980. *The Double Helix*. New York: Atheneum.

A RESPONSE TO RONALD MACGREGOR'S "CURRICULUM REFORM: SOME PAST PRACTICES AND CURRENT IMPLICATIONS"

In responding to Dr. MacGregor's paper, I will attempt to focus my observations and remarks in relation to the stated purposes of the paper as he outlined them. They were: 1) to review some past proposals of educational change; 2) to identify some of the strengths and shortcomings of these proposals; and 3) to suggest how lessons learned from these proposals for educational change might provide cautionary material for implementing discipline-based art education (DBAE) programs. In approaching these three stated purposes, Dr. MacGregor established two parameters for his work, one procedural and one substantive. The procedural parameter dealt with establishing a dateline for reviewing proposed changes. Nineteen sixty was established and justified as an appropriate start date. While justifiable, we should never overlook, as Dr. MacGregor points out, that valuable lessons can be learned from history. Unfortunately, we too often substantiate the adage that history teaches us that history does not teach us. The substantive parameter set by Dr. MacGregor has to do with separating "shortcomings of the curriculum materials themselves from those introduced or superimposed upon the material by market pressures and political agendas." Based upon his stated purposes and the two imposed parameters, I would like to comment upon Dr. MacGregor's paper by first examining his process and then his conclusions. He identified three models of

educational change for examination: Bruner's spiral curriculum, the competency-based curriculum, and conflict-theoretical models of curriculum. His choices are excellent and representative of the major trends in curriculum thinking during the past twenty-five years. He provided a very good description and discussion of Bruner's model, noting its roots and evolution and pointed out some refinements made in translation to the visual arts, as noted by Efland. His comments regarding the linkage of Bruner's thinking to that of Piaget were very insightful and helpful. In his discussion of the assumption of consensus and its lack of applicability to art, I must question the fact that he defined art very narrowly, addressing only the making of art. He states, "The inherent structure of art is different. It has its taxonomies, but whatever structure these form part of seems not to act as the exemplar or focus or desired model for all who make art." This may be true of the making of art, but what about art history, aesthetics, and criticism?

His description of the conflict-theoretical models of curriculum is very succinct and comprehensive, and points out the broad spectrum of thinking ranging from the conflict theorists to the reconceptualists. Dr. MacGregor is to be complimented for his succinct and articulate descriptions of these two proposals for educational change.

However, I must take issue with his

D. Jack Davis
North Texas State
University

description of the competency-based curriculum model. Admitting my bias, background, and writing in this area, Dr. MacGregor did not provide a balanced description of this particular curriculum model and the thinking associated with it. To deal only with Robert Mager's *Preparing Instructional Objectives* is to deal with only a small facet of the total picture of competency-based education. While he does mention the work of Bloom, Krathwohl, and Harrow, a more balanced description would have resulted had he recognized the roots of the model in the behaviorist theories and the importance attached to identifying the relevant human behaviors which are the focus of change through the process of education. While the development of behavioral objectives is often believed to be the essence and focus of competency-based curriculum, it is only a means to the end, not the end itself.

The identification of strengths and shortcomings of the models described by Dr. MacGregor is inconsistent. While some strengths were implied, he did not straightforwardly and consistently identify strengths for each of the models. He was more consistent in pointing out the shortcomings of each; however, this tends to give a biased and unbalanced picture. Each has strengths and weaknesses and a straightforward assessment of Dr. MacGregor's perception of these for each would have enhanced his paper considerably, helping the reader

to understand how he arrived at the final conclusions.

Another serious shortcoming of Dr. MacGregor's paper is the lack of identification of curriculum materials based upon the models which he discussed. He imposed this condition at the outset of his paper as a substantive parameter; however, he did not carry it beyond the discussion of Bruner's *Man: A Course of Study*. No examples of curriculum materials for either the competency-based curriculum model or the conflict-theoretical curriculum model were presented. While the latter might have been difficult to locate, there are widely-known examples of competency-based curriculum materials which he could have identified and analyzed. There are even competency-based curriculum projects that have been carried out since 1960. The use of actual curriculum examples and/or curriculum projects for each of the models would have enhanced the paper considerably. It would have expanded the reader's understanding of how Dr. MacGregor arrived at his final conclusions. It is unfortunate that Dr. MacGregor did not choose to address the curriculum projects. A consideration of both the theoretical basis and the implementation efforts of these projects, their successes and their failures, would have been most appropriate. There are several cautions which could be learned from them by DBAE, not the least of which is the importance of communication in both

the development and implementation phases.

While the written shortcomings in process and analysis may cloud the picture in terms of explicitly showing the reader how he arrived at the lessons to be learned and the cautions to be considered, his thinking was obviously ahead of his pen. One should not be too bothered because certain assumptions have to be made and certain conclusions have to be drawn which are not clearly evident. He achieved his ultimate aim. Indeed, the cautions which he suggests are right on target.

Dr. MacGregor delineates five major lessons to which DBAE should certainly pay attention. One of these is that "in elaborating the parts, teachers and students should not lose sight of the big picture." His gastronomic analogy is excellent and will serve as a reminder that even though the parts of a program are separated and elaborated, it is imperative that any curriculum reassemble the pieces into a coherent and meaningful whole. This is always a problem for any curriculum development effort. Indeed, the ultimate goal of DBAE programs should be to prepare students to enjoy an aesthetic experience and not just eat art soup.

Dr. MacGregor's caution regarding too much central control cannot be underscored enough. The learner, and the teacher as well, should become involved in shaping the direction of the learning experience. I do not believe that working

from a pre-determined curriculum prevents this from occurring if teachers are taught and encouraged, in the process of implementing a curriculum, to appreciate flexibility and insure that it occurs, reflecting the nature of the learner, the nature of the content of the curriculum, and the social situation surrounding the learning experience. It certainly is a serious caution that DBAE planners and implementers must constantly be aware of and be sensitive to. No doubt the early involvement of teachers, as well as curriculum developers, in the DBAE enterprise will go a long way in insuring flexibility and individuality as Dr. MacGregor suggests. While DBAE has emphasized the content aspect of the curriculum enterprise, it has not suggested that the nature of the learner or the nature of the social situation surrounding the learning experience be ignored. Unfortunately, I'm afraid that many people believe that DBAE does ignore these two essential curriculum components.

Without a doubt, Dr. MacGregor's most important caution to DBAE personnel is that "no one can corner the market in knowledge." As Dr. MacGregor points out, the roots of DBAE can be traced in numerous ways to the history of the field. Indeed, "educators who have no formal connection with the program are developing their own versions, based on whatever knowledge they have, or

impressions that they have formed about the nature of the program." Indeed, there are a number of efforts which were begun just prior to or at about the same time as the Getty effort which are very similar to the DBAE approach. Examine the College Board report, the essential elements mandated by the Texas legislature, and others. This should not be surprising when one stops to think about the field of art and what it is about. The possessive and protective attitude which the Getty is perceived to have by many in the field is potentially very destructive. It should be complimented that the concept is being widely considered, probably to a large degree because of its major activity in the area. As Dr. MacGregor points out, they can promote a position and draw attention to the shortcomings of evident alternatives if need be. Dr. MacGregor's discussion of "curriculum ecology" is particularly relevant in regard to his point and should be considered seriously by the Getty.

Dr. MacGregor describes his own suggestion for a model for the implementation and appraisal of educational programs. The analogy to biology is an excellent one and provides a clear frame of reference for understanding his position. From this position he provides the fourth major caution for the Getty: that "the authors of a program are most likely to stick closely to that script, and to be in the least favored position to recognize innovations that would advantageously affect its further development." This is a most important lesson for any curriculum developer to learn and to practice.

The fifth major caution is an important one, too: "curriculum implementation should not proceed as though the curriculum were an inert body of material to be delivered like the morning's mail." My own experiences in curriculum development certainly underscore this position. At the same time, having been a part of a major curriculum development effort in the early seventies, I clearly understand how easily curriculum project developers can become co-opted by this naive position.

His final message for DBAE is that "if it is to succeed," it must "assume the character of curriculum as a participatory and open-ended activity." I could not agree more. We must not repeat once again the adage that history teaches us that history does not teach us.

NAME BRAND, GENERIC BRAND, AND POPULAR BRANDS: THE BOUNDARIES OF DISCIPLINE-BASED ART EDUCATION

There is a name brand discipline-based art education (DBAE), there is a generic disciplined art education, and there are populist brands of art education. The future of art education will be profoundly affected by the manner in which we comprehend the similarities and differences, the sources and genealogies of these three varieties of art education, and then act to capitalize upon the strengths and to avoid the weaknesses we find among them. Let me explain.

Name Brand DBAE
First, I would like to talk about the name brand DBAE. As the officers of the Getty Center for Education in the Arts began to consider the directions that their initiative might take, they were advised by art educators to promote a broadened approach to the teaching of art that would give equivalent rigorous curricular emphasis to art studio, art history, and art criticism. (The fourth component, aesthetics, was added later.) It took a lot of time to say art history, art criticism, and studio art every time the new initiative was mentioned; consequently, the name "discipline-based art education" was born. (The term "discipline-based" had been used in the psychological literature (Feldman 1980) but this was the first time it had been applied to art education.) In addition to DBAE's equivalent emphasis on the four disciplines, this direct descendant of the 1960s curriculum reform movements in art education refers also to the use of

a written, sequentially organized art curriculum that is centered upon works of art, that is implemented jointly by administrators and teachers, and adhered to by all who teach art in the general education program of an entire school system. Comprehensive statements of the theoretical dimensions of DBAE have been made by Eisner (1987) and Clark, Day, and Greer (1986). In practice, more than through definition, DBAE is *currently* identified with Los Angeles County elementary classroom teachers' use of the technique of "aesthetic scanning," the SWRL art curriculum and Chapman's *Discover Art* (1985), and "scripted lessons." In practice, DBAE also carries a heavy load of traditional art educational baggage, and that is why we need to examine DBAE in relationship to both the older discipline-like strands that comprise the generic form of disciplined art education and the always present populist brands of art education.

Disciplined Art Education
The generic form of disciplined art education to which the name brand DBAE is related has roots that are not so easily traceable. Yes, we know that Barkan outlined a curriculum based on art studio, art history, and art criticism in his transitions paper (1964). We know of the 1965 Penn State Conference in which the structure of a disciplined art education was sketched by a community of scholars. We know the theoretical grounding that Barkan, Chapman, and Kern established in

Brent Wilson
Pennsylvania State
 University

the aesthetic education *Guidelines* (1970). We know that in the 1960s and the 1970s the National Assessment of Educational Progress (1981) developed and tested and evaluated student performance throughout the nation in relationship to discipline-like art educational objectives. And we know that school district art programs characterized in *Beyond Creating* (1985) and *Art History, Art Criticism, and Art Production: An Examination of Art Education in Selected School Districts* (Day et al. 1984) had discipline-like characteristics. But where did these ideas come from? To search for originals, as the post-structuralists so eagerly point out, is to be caught in an infinite regress. There was always something that preceded the thing for which we search. That is why a post-structuralist account of generic disciplined art education is useful. For my purpose it suffices to claim that the combined structures of art and education have from the first instance of art education—whenever and whatever it was—contained all of the possible combinations of variables and options that now comprise disciplined art education. These options, present in terms of what is obvious at any given time, and also in terms of what the logically and conceptually derivable opposites and variations of the obvious might be, are like the parts of the mythical *Argo*. When the Argonauts were ordered by the gods to complete their quest for the Golden Fleece in one and the same ship, Jason and his crew realized that their ship would

deteriorate during the long voyage. To guard against this certainty, they slowly replaced each piece of the vessel over the course of the voyage "so that they ended with an entirely new ship, without having to alter either its name or its form." Barthes has claimed that the analogy of the *Argo* is highly useful because:

> it affords the allegory of an eminently structural object, created not by genius, inspiration, determinations, evolution, but by two modest actions (which cannot be caught up in any mystique of creations): substitution (one part replaces another— as in a paradigm) and nomination. . . : by dint of combinations made within one and the same name, nothing is left of the origin: Argo *is an object with no other cause than its name, no other identity than its form* (Krauss 1985).

Art education, like the *Argo,* is a vessel without a creator. Its goals, contents, and practices form a structure made by no one, and the seeming newness of its current statements of goals and methodologies results entirely from selections from among available components and their recombinations and extensions within its structure.

What passes for art history and art criticism today was to be found in the "picture study" movement of eighty years ago. The methods of the best picture study texts reveal practices that are as fully developed and coherent as today's methods

for teaching art history and art criticism. Their sentiments notwithstanding, texts such as Wilson's (1904) and Casey's (1915) do a marvelous job of relating works of art to literature and to historical and social context. The questions for children, the analyses of painting, and the interpretations of their meanings are still enviable in both form and insight. The studio practices relating to drawing, painting, and design that are now a part of DBAE also have their precursors; take a look, for example, at the *Prang Elementary Course of Study in Art Instruction* (Clark, Hicks, and Perry 1899). And even the child art movement, which might be viewed as a reaction to the more disciplined Prang practices, was in place by 1909 (see Colby [1909] for an excellent example). Thus, the creative expression movement that some proponents of DBAE view as the enemy was firmly entrenched within the structure of art education long before Lowenfeld arrived. His brand of creative expressions was, however, so powerful and the social climate, the art world, and educational conditions so receptive that it led to a suppression of many of the aspects of the art educational structure that are just now being reasserted.

Populist Art Education
And now for the third brand of art education, the much less disciplined aspect of the structure of art education that we ignore at our peril. This is the enormous core of what might best be termed

"popular practice." The everyday art instructional practices of the individual and sometimes professionally isolated art teacher and classroom teacher have only a slight relationship to the high-sounding goals that have been proposed for nearly one hundred years by the leaders of art education. These art educational practices with 300-year-old roots that relate to folk handicrafts, holiday art, popular arts, design, decoration, and other school art traditions are a part—a very large part— of the "culture of art schooling." These popular practices that are passed from teacher to teacher, from curriculum guide to curriculum guide over the decades, have almost nothing to do with the art of Bernini, Boccioni, Bartlett, and Benin.

It is important to note that the populist-based school art is not entirely unresponsive to the forces of change, but since its frontline practitioners in art and elementary classrooms do not have regular access to the professional literature (they do not belong to the National Art Education Association), the trickle-down effect is minimal. Moreover, this amorphously shaped, essentially non-ideological behemoth of folk practice nibbles at the ideas that come its way and once the ideas have been digested, they fuse with other populist practices and lose their distinct identity. But once they become a part of popular art educational practice they have a very long life indeed. Consider the persistence of the elements and principles of design (Dow's turn of the

century, once-disciplined, modernist tools for teaching composition) and the creative expression movement associated with Lowenfeld which have by and large been transformed into insipid, trivializing populist practices that pervade nearly the entire field of art education.

But it is not just the manner in which populist notions infiltrate the more disciplined practices that should give us cause for concern. Rather, it is the way the populist practices are openly embraced as components of the more theoretically grounded and disciplined movements in art education. Theories seldom specify the intricacies of practice; consequently, in the absence of specification, populist practices are incorporated into reform movements even though they are incongruent with the basic notions of the change initiatives. For example, the elements and principles of design infiltrated the CEMREL aesthetic education program. And now, inasmuch as some of its practice components are either populist in character or are taught alongside populist components, DBAE is probably threatened by the populist brands of art education. Without consumer protection and vigilance we could end up with a new package design that contains little more than a timeworn ineffectual product.

The Storms of Change
Although the populist practice aspects of art education persist from decade to decade in an essentially predictable fashion, the more disciplined dimensions of art education have emerged, been submerged, and re-emerged in a variety of relationships. And it is only because of the comprehensive set of alignments present in both the generic and the name brand DBAEs that we see them as new and unprecedented. An extension of the *Argo* analogy even helps us to see why DBAE and disciplined art education emerged as they did. As the *Argo* sailed through its long voyage, conditions changed both within the ship and within its surroundings. At times there were storms that placed great stress on the sails and riggings. At other times ocean currents battered the hull and water rotted the deck. And with each new stress, the attention of the crew was drawn to the parts of the *Argo* that needed renewing. While some parts were replaced, others were ignored. The generic disciplined art educational movement of the 1960s can be seen as the art educational branch of the general educational reforms relating to *Sputnik*. The name brand DBAE is an outgrowth, at least in part, of the failed first reform efforts, and also a product of our current conservative call for attention to the basics.

Now I wish to move to a specific analysis of the prospects for name brand DBAE's success and failure considered in light of its relationships to the generic disciplined art education and populist practice. The success of both the generic disciplined art education and name brand DBAE depend upon how their various advocates work

cooperatively with one another, and upon how both deal with the behemoth of populist art educational practice. Let me proceed with a series of points and counterpoints relating to the pedagogical, political-ideological, and regional factors that affect art educational reform.

Point 1: Pedagogical Issues
I shall view pedagogy in the simplest light; it has to do with teachers, their teaching, and what they teach. In theory, name brand DBAE holds the promise of genuine pervasive reform of the way art is taught. There is the prospect that many of the populist recreational and decorative practices might be replaced by activities that could lead students to learn the important meanings and messages of art. DBAE is based upon general principles that have already been endorsed by many leaders of art education and by the National Art Education Association in *Quality Art Education: Goals for Schools*. The officers of the Getty Trust and their consultants wisely based their initial formulation of DBAE upon the larger set of generic ideas of disciplined art education already present in the field. And, since the 1960s, disciplined effort had produced a sizable number of articulate advocates among the leadership of art education who were eager to give the movement a second chance. Moreover, as a result of both the 1960s disciplined movement and various other residual factors, a number of college and university art education programs

were discipline-based long before the term was coined. DBAE was a movement whose second coming was auspiciously timed. It was a movement whose initiatives were based upon comprehensive, insightful inquiry into the processes of art education (Day et al. 1984; McLaughlin and Thomas 1984). There was the recognition that art educational reform would require the assistance of school administrators, advocacy groups, written sequential curricula, and the re-education of teachers. All of these factors were built into the basic plan to change the content and practice of art education.

Counterpoint 1: Pedagogical Problems
The transition from DBAE theory to DBAE practice has been particularly difficult, much more difficult than might have been predicted in 1984 when the ideas became widely discussed in art education, or even in 1985 when *Beyond Creating: The Place for Art in America's Schools* was introduced. During this transitional time two groups of art educators became more or less antagonistic to the aspects of DBAE. First, for understandable reasons, the name brand DBAE has worried both the populist and other proponents of studio-based creative expression. Not only do art teachers perceive that the importance of the very creative expression that they believe to be the essence of art education will be diminished, but they also sense that they will be expected to teach art history, art criticism, and aesthetics (the philosophy of

art) —things that they don't know much about, things that they may not care very much about, things that they do not know how to teach.

Second, there is a more subtle, but equally serious problem. Name brand DBAE has also disappointed former advocates of the broader generic disciplined approach to art education (Hausman 1987). One of the primary reasons for the disillusionment is that the working model of name brand DBAE observed in Los Angeles County is *perceived* to be seriously flawed. To those who have worked so hard to implement DBAE, the adverse response to DBAE as practiced must surely seem unjust. After all, the Getty Summer Institute staff and the administrators in the Los Angeles County school districts have made admirable advances in the institution of their brand of art education in Los Angeles County schools. Classroom teachers can be seen to systematically engage their students with works of art in ways that are rare among generalists. Nevertheless, there are grounds for criticism, and like art criticism, educational criticism has understanding as one of its purposes. Let me criticize just one aspect of DBAE pedagogy (from among several that I might have chosen) that symbolizes the theory-in-practice difficulties faced by those who would institute DBAE in the schools.

High expectations have been raised. DBAE, we read, "focuses on [a] dynamic view of [the] art disciplines including

concepts, methods of inquiry, and a community of scholars" (Clark, Day, and Greer 1987). But in practice, DBAE is currently taught by teachers who, despite their participation in summer institutes and other district-based staff development programs, are still basically ungrounded in the disciplines of art. They teach from an extremely narrow set of conceptions about art and from limited experiences within the world of art. How could it be otherwise?

One of the primary means by which these elementary classroom teachers have been trained to have experiences with works of art is through the process of "aesthetic scanning" (Hewett and Rush 1987). In a few hours (perhaps even a few minutes) of instructional time classroom teachers can learn to scan the sensory, formal, and expressive aspects of a work of art. In the same length of time their students can learn the same scanning technique. And, in the words of two of its proponents, "Successful scanning can occur even though the teacher may know nothing about the work (its subject, its medium, who made it, when and where it was made, or whether art experts consider it 'good'" (Hewett and Rush 1987). To the eyes of observers, DBAE in Los Angeles County is pervaded by aesthetic scanning. Although advocates of the procedure claim that it opens individuals up to the potentially deep dimension of experience with a work of art, it can also be seen as a seductive activity that trivializes experiences with art in much the same way

as the elements and principles of design do. And since all visual works of art are filled with things like contrasting colors, different kinds of shapes, and intersecting lines, and have compositions, moods, and expressive characteristics, "scanners" are continually reinforced by the discovery of evermore delicious examples of the very features for which they were taught to look. At the same time, they are lulled into thinking that they have encountered the most important things that works of art have to offer. Unfortunately, their attention has been diverted away from the subject matter, historic, symbolic, allegorical, thematic, social, political, religious, ideological, and psychological aspects of works of art that are at the heart of the deeper artistic interpretations—features of art that cannot be reduced to a scanning formula.

The irony of aesthetic scanning is that while it places the work of art at the center of art instruction, it focuses attention upon a few aesthetic means rather than upon the larger and vastly more important realm of artistic ends, i.e., interpretations. Although the advocates of aesthetic scanning would probably claim that it is preliminary to other forms of experiences with works of art, such is not necessarily the case. In fact, aesthetic scanning may so direct experience and expectation down one track that there are other more discipline-based inquiry tracks that need not, indeed, should not, commence with aesthetic scanning. In practice aesthetic scanning may diminish

art by mistaking minor artistic means for important artistic ends.

There is an even greater irony. The group act of aesthetic scanning cannot be easily identified with, nor did it originate within, any of the four disciplines of art. It is not art criticism—if art criticism is taken to refer to the *individual* act of *writing* in an insightful, often metaphorical, and expressive manner in order to co-create the character of a single or a related group of works through words. Aesthetic scanning is not history, and it is not aesthetics.

Aesthetic scanning may be seen as an undisciplined substitute for historical and critical inquiry into art. It may also be symbolic of the great difficulties still to be faced when we attempt to devise pedagogical "scripts" (for either classroom teachers or art teachers) that are based upon the disciplined inquiry methods of art historians, art critics, and aestheticians.

Three pedagogical issues that the proponents of DBAE should face are these: first, are there actually shortcuts and easy routes that will make leaders effective discipline-based instructors? Can teachers who are not well grounded in the disciplines of art be readily taught to teach a disciplined art education? Second, if there are no shortcuts, then what is the longer route that might bring teachers to that disciplined pedagogically viable point? And third, if the theory of DBAE offers more than can be delivered in practice, then are there ways of modifying the implicit promises of the theory to correspond to the

realities of practice? DBAE may have an advertising problem. More claims may have been made for the product than the product is capable of delivering.

Point 2: Politics, Ideologies, and Conflicts of Interest

Ideas in art education might be seen as capital. The formulators of these ideas—the curricular theoreticians, the researchers, the evaluators, the supervisors, and the brilliantly intuitive practitioners—"invest" their capital by lecturing and writing articles and books in order to influence others to accept their ideas, to quote them, and to employ them. The "politics" of art education can be seen in individuals' maneuverings to get their ideas situated advantageously in relationship to the ideas of others. Currently the proponents of DBAE are vigorously presenting their ideas, and perhaps with slightly less vigor, so are the proponents of the generic disciplined art education. The populists tend either to make noises from the sidelines or remain silent. They need do little more; after all, what they lack in ideas they compensate for in numbers. An investigative reporter's story might reveal the political maneuverings of DBAE supporters and detractors. But let me bypass the political dimension to focus upon some of the crucial ideological issues that underlie the investment of art educational capital.

The proponents of DBAE have taken care to distinguish their brand from the earlier variety of disciplined art education with strong links to the 1960s movement and from other varieties of art education (Clark, Day, and Greer 1986). At the same time some advocates of the disciplined variety of art education still see the Brunerian structure of the discipline (and teaching the child to acquire an understanding of that structure through the process of inquiring as an art historian, philosopher of art, artists, art critic) as the proper pedagogical process for a disciplined art education. Some think that disciplined art education ought to incorporate the best aspects of child art and creative expression; others see artistic production in terms of the no-nonsense acquisition of skill or design sensitivity. Some see the acquisition of increased social consciousness, of a world view, or of a broadened cognitive orientation to the realities of the world as the principal reasons for studying art. Still others see heightened aesthetic experiences as the greatest good. Some see the use of exemplary models of art, art historical writing, art critical writing, and writing in aesthetics as the principal means by which students might learn to function within the disciplines of art; others still hold the long-standing modernist (and art educational) view that the use of models limits individual initiative and originality. Some see the retention of personal development objectives of art education to be imperative; others may see such objectives as antithetical to the very idea of DBAE.

But perhaps most of these issues might be seen in light of a larger and more profound issues. One of the components of DBAE is aesthetics—the philosophy of art. And just now the philosophy of art is in the process of what Kuhn (1970) would term a "paradigm shift." Aesthetic theory follows and explains events that occur within the world of art. Consequently, as we enter the postmodern era, the aesthetic theories that were employed to rationalize the modernist aesthetic Zeitgeist are giving way to postmodern theories of art and art history. For example, the modernist notion that originality is an artistic imperative is now being philosophically discontinued (Krauss 1985). The art world is no longer expected to proliferate an endless succession of stylistic revolutions. And perhaps most important to our discussion, it is no longer assumed by all philosophers of art that the apprehension of aesthetic qualities is the essential ingredient of art experiences or, for that matter, even essential ingredients of art (Danto 1986).

One of the most lively and heated debates to occur in art education in recent years took place at the 1987 National Art Education Conference. The central philosophical issue at hand was whether or not the modernist aesthetic theories of Beardsley and Osborne (on which Smith [1986] bases his *Excellence* monograph) provide an adequate foundation for the intellectual study of art. In the same vein, art educators who see merit in the work of postmodern critics and philosophers of art

such as Danto (1986) and McEvilley (1984) may also see the aesthetic theory to which DBAE is presently linked as providing a useful tool for understanding many modernist works of art, but not for understanding most premodernist, non-Western, small culture, and postmodernist works. Moreover, the emerging post-modernist theories of art give some evidence of being more broadly applicable to the art of other times and places than modernist theories.

This debate about the philosophy of art is important to DBAE inasmuch as the emergence of a fresh paradigm in art and art education adds a new ideological ingredient with which to contend. Currently DBAE seems ideologically situated somewhere between the modernist and postmodernist philosophies of art. Some of DBAE's intellectual ideals are both postmodernist (and premodernist); its aesthetic theories and some practices are essentially modernist. There is an important contradiction to be resolved, and we should welcome the debate that is sure to follow as the modernists battle to retain their share of the market against the encroachment of the postmodernists.

Counterpoint 2: Conflict Resolution through the Encouragement of Diversity
How is DBAE to fare in the face of conflict in ideologies? *Should* its advocates press for ideological purity among all who use the name DBAE? Or should there be an openness (of the kind suggested by the title

of the 1987 Getty conference, "Discipline-Based Art Education: What Forms Will It Take?")?

Narrow ideological purity seems out of the question inasmuch as the advocates of DBAE hope that curricular reform in art education will be general. If DBAE is perceived to be associated only with one small group of vocal advocates who are closely associated with the Getty Trust, then most art educators will see no place for themselves within the reform movement. If DBAE is to be broadly accepted it will probably have to incorporate a variety of views of art, aesthetics, the philosophy of art, and the purposes of art education—views that are sometimes mutually contradictory but that by themselves may not be antithetical to the basic concept of a broadened, systematic, articulated approach to teaching art criticism and aesthetics, art history, and art studio.

But if DBAE incorporates too wide a variety of views, philosophies, and practices that are essentially contradictory, then the movement will have lost whatever power it might have had to provide a coherent vision of a broadened art education. To make matters worse, if DBAE appears open to a great variety of views, then one of the first intrusions will probably be made by the populist brands of art education. (This is precisely what has already begun to happen in Los Angeles County where in one of the DBAE pilot schools a string print—one made by

dropping a paint-soaked string between folded halves of paper, pressing, and pulling the string out—was boldly labeled "discipline-based art education.") It appears that anything that any teacher of art has ever done can be given the label "DBAE."

DBAE will be a stronger, more valuable, more widely accepted, and more fully practiced movement if it is allowed either to assume and develop the best features of its generic predecessor(s), or if it comes to exist in a variety of acceptable name brand forms. These two possibilities are, perhaps, one and the same.

Although we must continue to refine and develop the theoretical and philosophical aspects of disciplined art education, it is even more important to encourage the holders of a variety of disciplined views to develop disciplined practice models. Once completed the practice models should be presented for criticism by holders of all ideologies. (It is my feeling that the practice models currently associated with DBAE have not been adequately criticized, and it is important to realize that critics of specific DBAE practices do not necessarily condemn the idea of disciplined art education or even of the idea of DBAE.) And most importantly, these models must be perceived to have originated from within the broad field of art education rather than from within a narrow segment. In the long run the only way for those closely associated with DBAE to get the kind of general art education they claim

they want is to allow it to become the property of all discipline oriented art educators. A revolution of the "have nots" against the "haves" will leave the entire field of art education the loser.

Point 3: Regionalism and the Special Teacher of Art

The United States may be one nation but it is a union in which the various regions and states have developed and maintained very different educational practices. Programs tailored to one part of the country will not necessarily function well in other parts. Although there are several dimensions of regionalism and DBAE that might be addressed, I would like to discuss the issue of the elementary specialist art teacher versus the classroom teacher.

In the eastern and midwestern regions of the country, elementary school art is frequently taught by special art teachers. In the mountain and Pacific regions of the country, elementary classroom teachers provide art instruction. The working model of DBAE developed in Los Angeles County has, to date, involved only classroom teachers. Consequently, midwestern and eastern art educators from school districts with elementary art specialists see the current practice of DBAE as either having little or no application to their school systems. Worse, they fear that the movement might undermine their efforts to retain or increase the number of elementary school art teachers. After all, if an effective art education could be

taught by classroom teachers, then special art could be eliminated from all regions of the country.

Counterpoint 3: Regionalism and the Integrated Art Program

Disciplined art education is a concept that has broad application in school districts that have elementary art teachers as well as those that do not. With the development of regional institutes and pilot programs around the country name brand DBAE will probably be adapted to a variety of "delivery systems." Moreover, it is possible to argue that the ideal disciplined art program is one that would be taught jointly by both art specialists and classroom teachers. Let me explain. To teach art studio, art history, art criticism, and aesthetics with adequate coverage and depth within the meager thirty-six class periods that are typically allotted each year to the elementary school art specialist is an enormous, if not an impossible task. If the broadened, disciplined conception of art education is to be implemented, it will have to be through the combined efforts of both the general classroom teacher and the art specialist. For example, art criticism—when taken to be the careful, metaphoric, expressive writing about works of art— might best be accomplished in the general classroom. It is true that classroom teachers feel increasing pressure as more and more subjects and topics are forced into the fixed time of the school day and the school year. And yet with all the competing subjects

that vie for time in the elementary classroom schedule, one of the few subjects that will never lose its place is writing—interpretive writing, descriptive writing, creative writing, expressive writing. And what could serve as better subjects for writing than the most interesting visual objects on earth—works of art.

In both elementary schools that have art specialists and in those without them, the classroom teacher could provide most of the opportunities for writing art criticism. In schools where there is an art specialist, that specialist could take the lead in coordinating the art criticism program by providing reproductions and actual works of art, works articulate with the specialist's program, models for critical writing, and suggestions to classroom teachers regarding the ways that children's art-critical writing might be assessed and evaluated.

Art history might be seen, at least in part, as a dimension of the elementary social studies program. If this is to be successfully accomplished, then we, as a profession, will need to begin working with the publishers of social studies texts who, in effect, determine the social studies curriculum.

Even in schools where there are art specialists, if these important aspects of a disciplined art program were to be taught by classroom teachers, then the specialist would be able to concentrate upon the studio aspects of art instruction, but studio instruction that is based upon

having students re-create in personal, individual, and contemporary terms the major themes, subjects, and ideas of important works of art.

The establishment of comprehensive disciplined art programs that are allotted an adequate portion of the elementary school day will be predicated upon the infusion of art into the general program of the elementary school. But rather than give even a hint that elementary art might be taught without art specialists, the proponents of discipline-based art education should work toward the appointment of an art specialist in every school of the nation. In the western part of the country the specialist may, for now, be a classroom teacher assigned to coordinate the art program in the school. Following a suggestion made by John Goodlad that there be a school "worrier" for each curriculum area, the Provo, Utah schools have appointed classroom teachers to be school art coordinators.

Conclusions

If there were time, I could multiply my points and counterpoints. First, I might have made the point that some proponents of DBAE may be too hung-up on the idea of having an equitable balance of history, studio, criticism, and aesthetics, while not giving enough consideration to what is to be learned through these various discipline related activities. My counterpoint would be that the central core of DBAE is not to be found in equity among the disciplines,

rather it is to be found in the goals that are eventually developed for DBAE. If DBAE is to be a unique form of art education, that uniqueness will be found in the goals that it achieves, not in its instructional methodologies. I might have extended my counterpoint by arguing that a comprehensive discipline-based art education might be achieved by using only one of the disciplines as the carrier for all the other art related disciplines and for the important concepts about art that we wish our students to understand. In other words, I would want to make the counterpoint that having instruction in the four disciplines is not a goal of art education, it is only a means through which art educational goals might be achieved.

Second, I could point to the problems of instigating change in a field that has such an extremely low level of professionalism that most of its practitioners are not members of a professional association, that most practitioners do not have a discipline-based leader in their school system, and that practitioners seldom have professional discussions with other art teachers. How can art teachers practice DBAE if they don't even have ways of finding out about it?

Third, I might make the point that aesthetics is concerned with the philosophy of art and that any good art curriculum should be based upon a well-reasoned theory of art. But I would also want to make the counterpoint that since most art teachers (and their professors) cannot now adequately articulate their own (or anyone

else's) philosophy of art, perhaps it is presently unreasonable to expect that in DBAE aesthetics be given billing equal to studio, history, and criticism until some coherent instructional strategies (based on philosophical issues relating to art) have been developed.

Fourth, I could make the point that we who teach art to young people have much to learn from the theories and practices of artists, aestheticians, art critics, and art historians, to be accompanied by the counterpoint that these keepers of the disciplines are not always very good at telling us to teach their disciplines to our young students. When it comes to pedagogy we are the experts, or we should be, and we should not relinquish our responsibility to mediate between the artists, scholars, critics, and our students.

Fifth, I might make the point that no amount of persuasion and advocacy will bring about a general reform of art educational practice. Perhaps the only way in which a disciplined art education will become pervasive throughout the nation is through the activation of all of the components of the entire system that comprises and influences art education: federal agencies, state departments of education, school administrators, college and university teacher education programs, staff development programs, professional associations, test makers, publishers, etc. I might suggest that state departments of education will have to develop disciplined art education guidelines, monitor written

curriculum guides of local school districts to determine if state guidelines have been implemented, and either conduct evaluations or at least provide and monitor local assessment programs and outcomes to determine whether or not objectives (measured in terms of student attainment) are achieved (Wilson 1986). For a state department of education to take such strong initiatives it will be necessary to resolve some of the ambiguities that exist between state responsibility for general educational standards and local school district curricular autonomy. In short, most school administrators will not begin to establish broadened art programs until they are mandated, checked, and evaluated by state departments of education.

Sixth, I might point out that it is not easy for a college art education major to learn to be an art critic, at least in the academic setting. Few universities and colleges offer courses in criticism of the visual arts. The development of art criticism courses within art education programs may be the most expedient course of action, but such action runs counter to the idea that students should acquire the discipline of criticism from an expert.

Finally, I might try to make more explicit the point that can be read between the lines of my other points—namely that too many art educators seem to think that support from a single source, or a few sources, will solve the problems of art education. It will not. If it is a broadened, disciplined art education that we desire, then we must all become owners of the idea. We must see it as our own. Without a broad base of support and without systematic linkages to the full range of structural components and key players within art education, the field of art education will be weakened and an important idea will be diminished.

If you have been weighing my points and counterpoints you might have detected my shifting back and forth between DBAE partisanship and nonpartisanship. For the record, I am a strong proponent of the generic brand of disciplined art education, an understanding but outspoken critic of the populist brand of art education, and a cautious but critical supporter of name brand DBAE as it is now unfolding. Nevertheless, I am optimistic that DBAE *can* have a profound positive effect upon the field of art education, especially if its manufacturer (and I hope there will be lots of them) will carefully test and fully certify the purity (read *validity*) of the ingredients of which its *practice* is composed; tell us why the product is good for us and our students; and also encourage the consumers of the name brand product to use it in imaginative and inventive ways.

To continue with the mix of metaphors of the title of this paper, for better or for worse, with a fully developed DBAE or without, we will all have a hand in the rebuilding, and rebuilding, and rebuilding of the *Argo* art education.

Bibliography

Barkan, M. 1964. "Transitions in Art Education: Changing Conceptions of Curriculum Content and Teaching." *Art Education* 15(7):15.

Barkan, M., Chapman, L., and Kern, E.J. 1970. *Guidelines: Curriculum Development for Aesthetic Education*. St. Louis: CEMREL.

Casey, W.C. 1915. *Masterpieces in Art*. Chicago: A. Flanagan Company.

Chapman, L. 1985. *Discover Art*. Worcester, Mass.: Davis.

Clark, G.A., Day, M.D., and Greer, W.D. 1986. *Discipline-Based Art Education: Becoming Students of Art*. Los Angeles: Getty Center for Education in the Arts.

Clark, J.S., Hicks, M.D., and Perry, W.S. 1899. *The Prang Elementary Course in Art Instruction*. Boston, New York, Chicago: The Prang Educational Company.

Colby, L.E. 1909. *Talks on Drawing, Painting, Making, Decorating for Primary Teachers*. Chicago: Scott Foresman and Company.

Danto, A.C. 1986. *The Philosophical Disenfranchisement of Art*. New York: Columbia University Press.

Eisner, E. [1987]. *The Role of Discipline-Based Art Education in America's Schools*. Los Angeles: Getty Center for Education in the Arts.

Feldman, D.H. 1980. *Beyond Universals in Cognitive-Development*. Norwood, N.J.: Ablex.

Hausman, J. 1987. "Another View of Discipline-Based Art Education." *Art Education* 40(1):56–60.

Hewett, G.J., Rush, J.C. 1987. "Finding Buried Treasures: Aesthetic Scanning with Children." *Art Education* 40(1): 41–43.

Krauss, R. 1985. *The Originality of the Avant-Garde and Other Modernist Myths*. Cambridge: MIT Press.

Kuhn, T.S. 1970. *The Structure of Scientific Revolutions*. 2d ed. Chicago: University of Chicago Press.

McEvilley, T. 1984. "On the Manner of Addressing Clouds." *Art Forum* 22(10):61–70.

National Assessment of Educational Progress. 1981. *Art and Young Americans: Results from the Second National Art Assessment*. Report No. 10-A-01. Denver.

Smith, R.A. 1986. *Excellence in Art Education: Ideas and Initiatives*. Reston, Va.: National Art Education Association.

Wilson, B. 1986. "Re-creation Versus Creation: An Exposition on the Purpose of Art Education." *Design for Arts in Education* 87(4):24–28.

_____ "Testing and the Process of Change." *Design for Arts in Education* 87(1):6–11.

Wilson, L.L. 1904. *Picture Study in Elementary Schools*. New York: Macmillan.

A RESPONSE TO BRENT WILSON'S "NAME BRAND, GENERIC BRAND, AND POPULAR BRANDS: THE BOUNDARIES OF DISCIPLINE-BASED ART EDUCATION"

Rogena Degge
University of Oregon

Beyond the very useful distinctions of the name brand, generic brand, and popular brands of art education and the many important points and counterpoints Brent has provided, one of the important statements in his paper is a latter point upon which he did not elaborate, and that is "that having instruction in the four disciplines is *not a goal* of art education, it is *only a means*" (emphasis added). It is to this point I direct my ten-minute response. In so doing, I will touch upon some of the pedagogical, regional, and political issues Wilson addresses.

It is a means-goal distinction that illuminates Wilson's pedagogical concerns regarding the trivializing of art. One of his examples is aesthetic scanning. That aesthetic scanning is not clearly a facet of one of the four disciplines, as they have now been defined (Clark, Day, and Greer 1987), is a sufficiently sound point. But the name and process of aesthetic scanning both point to important means-goal issues. Aesthetic scanning has, for example, exposed a confusion about its relationship to, or derivation from, the discipline of aesthetics. The confusion comes from genuine exploratory efforts to merge the name brand and generic brand of discipline-based art education (DBAE) with classroom practice. But more importantly, it has helped us learn some of the difficulties that lay ahead for us in *pedagogically* linking, with integrity, the arts disciplines to learning in our schools. The means-goal distinction can serve us in this effort.

For example, aesthetic scanning is a system, not a goal. It is a teacher-directed *means* created to guide students to apply skills and knowledge which will enable them to discuss the design and expressive properties of art objects. Our goal would certainly not be that we want our children to learn the easy, the trivial, and perhaps the more irrelevant aspects of art. Nor do I think we want it to be that children should learn that design-based concepts are the most important or basic aspects of art learning, and that the deeper, interpretive aspects of art are not. But unless the goals are made clear, such misunderstandings can be expected. The example reminds us that there are several different perspectives in our field regarding what content or aspects of art are to be taught. But why to teach them is also at issue.

Like the *Argo*, discipline-based art education is a vessel of generic means, or content. Unlike the *Argo*, which had a goal or destination outside of itself, art education efforts, with regard to discipline-based art education, do not sufficiently clarify that distinction. A popular brand result is that content is being misconstrued as the goal. That is, that content can be seen as the sum of its own discipline-based parts. The goal, as stated in the monograph, is understanding and appreciating art. However, it was not the purpose of Jason to rebuild the ship just to maintain a seaworthy vessel, but to get the Golden Fleece. Discipline-based art education is not the Golden Fleece, but it *is* a sea-

worthy vessel. This vessel is structurally sound enough, especially in its generic forms, to carry us to various worthy destinations. Such destinations would differ according to pedagogical, political, regional, and cultural needs and values.

Across geographic regions and our profession's political camps, we have respected art education colleagues who currently eloquently speak for particular and different emphases in art curricula. We have been notorious as a field in not recognizing the viability of perspectives other than the one we personally champion. Yet, many of them are sound, and are adaptable particularly to generic forms of DBAE. Of course, one perspective may *contradict* another, and of course some of the *emphases* are different. That is at least partly because they are variously rooted in history and in scholarly research.

But different also are regions and school districts and their goals, and the students and the educators within them. My point is perhaps only an elaboration of Wilson's paper, but it is a crucial one, and that is: If we see discipline-based content as the *means* (the vessel) to a good art education, then our *goals* (destinations) can be loftier. Not only can the goal be understanding and appreciation of art; we can have those that are unabashedly extrinsic and especially designed to serve regional, pedagogical, and political needs and preferences.

A recognition that discipline-based curricula is a *means* to something educa-

tionally important makes it reasonable and even essential that a variety of curricula should be developed as models. These should not only reflect regional and political variation, but also those that we label essentialist, socio-cultural, perceptual; or that value studio or creative expression, and more. All of these and others we might list are also *means* which hold their inherent goals which can be made explicit. And each can be developed, adapted, and extended with internal integrity through relevantly matched, discipline-based content. Within each of these thrusts we have a significant body of theoretical and practical examples to refer to which sorely need to be drawn together, and we have a body of research to guide the construction of curriculum. Developing these kinds of models utilizing art education experts has begun. These models should be highly experimental and critically examined from a range of perspectives. Collectively, diverse goals should be represented in pedagogical, regional, and political realms. Research of these should attend to these same factors.

There are three related and very large challenges (among a ton of others) in our efforts to change the art programs in the elementary and secondary schools to incorporate discipline-based art instruction. One is to help local curriculum developers and teachers clarify their overarching art educational goals so that the content of their instruction is under an umbrella that can guide the nature and selection of

discipline-based content and attendant evaluation. Even if the goal is mainly to develop students' abilities to understand and appreciate art, something *more* must guide the selection of, and the shaping of, content. That could be socio-cultural, essentialist, or another thrust.

The second challenge is to insure that the nature of the umbrella and the selection of the content and evaluation reflect the local, social, and cultural values residing in the community. The third challenge is the risk or inevitability of trivial instruction and miseducation when introducing unfamiliar, unframed, or too framed curricula into a community, a system, a classroom.

Unless our teachers *and citizens* are educated more substantively and more vigorously than we now are able to do in currently designed institutes, teacher preparation, and general education; and until we have diverse excellent model curricula and guidelines *based in research* that hold promise for regional relevance and political potential, then the receptivity to the content and the ability to teach it will be fraught with problems.

The bottom line, of course, is effecting change. Change of the nature that is proposed under the name brand of DBAE must clearly, finally, be a *local matter*. And, we frankly know very little about effective change in art education at national, regional, or local levels. Of course, significant and cooperative efforts from those at the state down to school levels are necessary, and these efforts must be grounded in regional relevance in order to construct art educational goals that are complementary to national, state, and district goals of general education. If discipline-based art curricula are to be anything more than serendipitous content of the popular brand, then we must give a magnitude of effort to developing diverse, meaningful frameworks, or umbrellas, within which visible art education goals can be structured. *Many* more models and resources will be essential if districts are to be able to selectively develop fitting, generic brands of discipline-based art instruction—ones that embrace local, political, and pedagogical uniqueness as well as regional and cultural needs and values. Through carefully focused research of *various* models we might learn something about how to effect change and move into an era of classroom art education practice that substantively incorporates the art disciplines. But from the outset we must see the disciplines as a means, and we must hold out for larger educational goals—ones that advance humanity beyond what art content we know and can appreciate, to how that knowledge might significantly impact and give meaning to the lives of individuals and elevate the humaneness of our civilization.

DATE DUE

5/19/43			
MR 0 7 '05	MAR 8 05		
GAYLORD			PRINTED IN U.S.A.